W9-CFC-344

In Monet's Light
Theodore Robinson
at Giverny

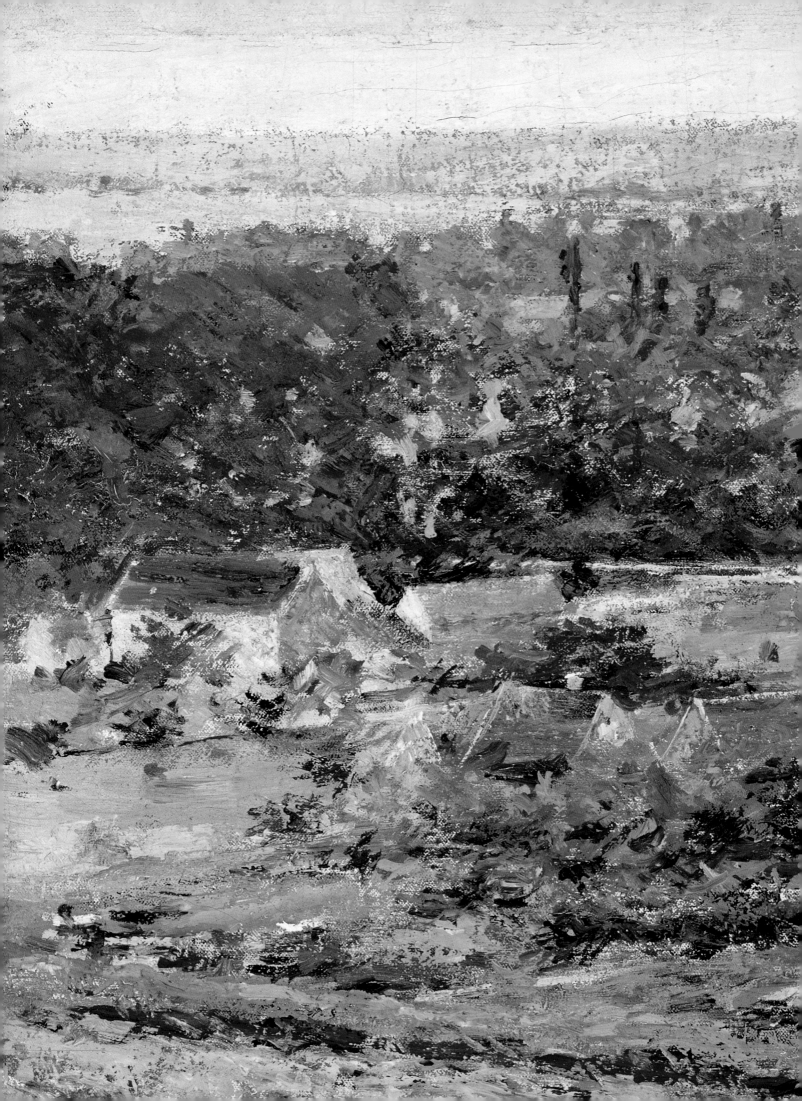

In Monet's Light
Theodore Robinson at Giverny

SONA JOHNSTON

WITH AN ESSAY BY PAUL TUCKER

The Baltimore Museum of Art
Philip Wilson Publishers Ltd

This volume has been published in conjunction with the exhibition *In Monet's Light: Theodore Robinson at Giverny*, organized by The Baltimore Museum of Art, Baltimore, Maryland, and held at:

The Baltimore Museum of Art
17 October 2004 – 9 January 2005

The Phoenix Museum of Art
6 February 2005 – 8 May 2005

The Wadsworth Atheneum
4 June 2005 – 4 September 2005.

The exhibition is generously sponsored by The Rouse Company and the Henry Luce Foundation.

Additional support is provided by the Charlesmead Foundation and the Terra Foundation for the Arts.

Copyright © 2004
The Baltimore Museum of Art
All rights reserved
Published by Philip Wilson Publishers Ltd., 109 The Timber Yard, 7-27 Drysdale Street, London N1 6ND

Library of Congress Cataloging-in-Publication Data

Except for what Section 107 of the Copyright Act of 1976 permits as "fair use," no part of this publication may be reproduced, stored in a retrieval system, or transmitted in any form or by any means, electronic, mechanical, photocopying, recording, or otherwise, without the written permission of The Baltimore Museum of Art.

© The Baltimore Museum of Art

ISBN (softcover edition) 0 85667 587 3
ISBN (hardcover edition) 0 85667 566 0

Designed by Peter Ling
Printed and bound in Italy by Printer Trento Srl

Distributed in the United States and Canada by Palgrave Macmillan,
175 Fifth Avenue, New York, NY 10010

Distributed in the UK and the rest of the world by I.B. Tauris & Co. Ltd,
6 Salem Road, London W2 4BU

COVER
Theodore Robinson, *Val d'Arconville* (cat. no. 39, detail)

BACK COVER
Theodore Robinson Sketching in France (page 55, detail)
Theodore Robinson, *Portrait of Monet* (page 118)

TITLE PAGE
Theodore Robinson, *Giverny* (cat. no. 5, detail)

FRONTISPIECE TO FOREWORD
Theodore Robinson, *The Young Violinist* (cat. no. 21)

Contents

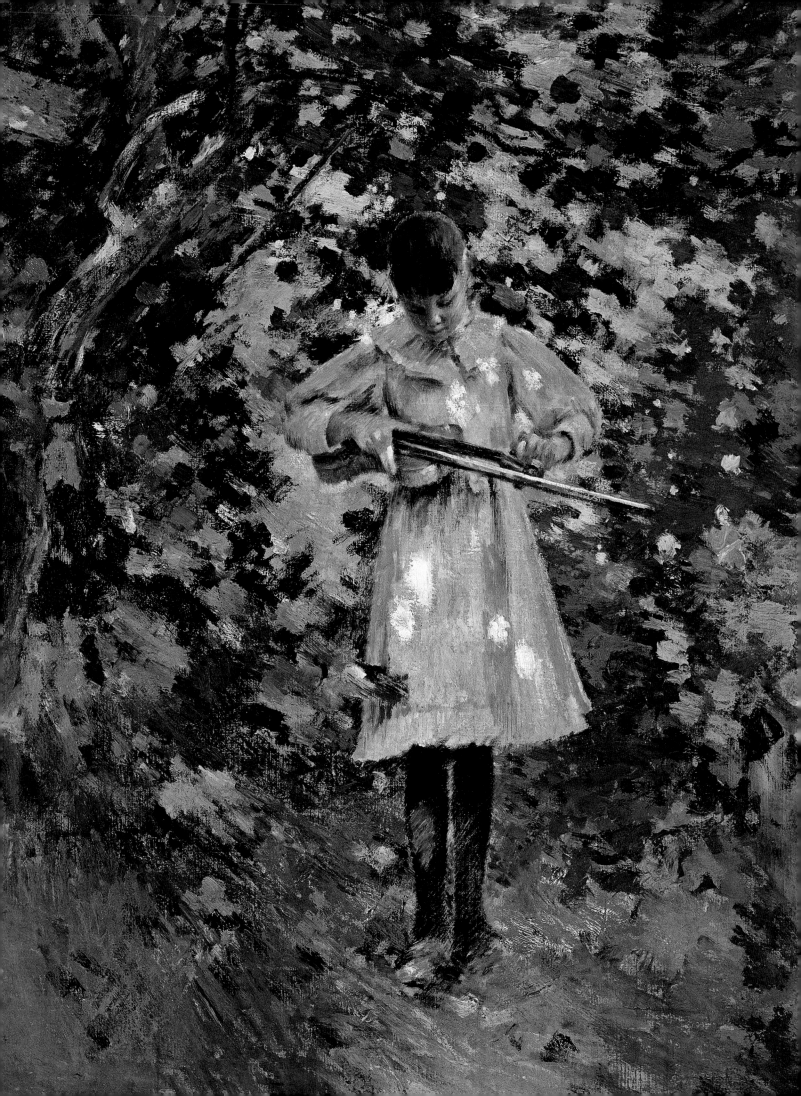

Foreword

The art of American Impressionist Theodore Robinson holds a special place in the history of The Baltimore Museum of Art and in the accomplishments of its curatorial staff. It also looks to the future by celebrating the artistic focus of the Museum—the modern era, from the nineteenth century to the present day—and achieving in its scholarship the BMA's aspiration to organize and circulate exhibitions of national significance.

When BMA donor Etta Cone purchased five of Robinson's paintings at his estate sale in 1898, he became the first artist represented in the renowned Cone Collection, now the best-known feature of the BMA's collection. Robinson's work—itself so French in style and subject—was a harbinger of the remarkable collection of modern French art, particularly by Henri Matisse, formed by Etta and her sister Claribel during the first half of the twentieth century. BMA Senior Curator Sona Johnston, the scholar who has conceived the current show, was inspired by this group of paintings to study Robinson's career. She also organized a monographic exhibition on Robinson at the Museum in 1973, then the first such undertaking devoted to the artist in a quarter of a century. Johnston has gone on to compile a catalogue raisonné of Robinson's work and is at work on an annotated transcription of his four surviving diaries, which are rich in details that illuminate the advent of Impressionism in the United States. This exhibition represents the fruition of a lifetime of study and looking closely and thoughtfully at Robinson's work. We are fortunate to be able to share Johnston's scholarly work, not only with the field, but also with the museum-going public, who will be entranced by this artist's light-filled canvases.

In *In Monet's Light: Theodore Robinson at Giverny* Johnston takes up the most fascinating and internationally significant phase of the artist's career. An acknowledged leader of the Impressionist movement in America, Robinson was among the first of his countrymen to spend extended periods at Giverny in the Norman countryside of France. This exhibition focuses on the evolution of his art during sojourns in the village and on his close association with its most illustrious resident, Claude Monet. Indeed, much is revealed about Monet in Robinson's writings and in correspondence between the two artists published here for the first time. We hope that these materials will be of interest both to those involved with American art and to Monet's admirers as well.

We are deeply indebted to Paul Hayes Tucker, Professor of Art History at the University of Massachusetts Boston, who has explored Claude Monet's extraordinary career and has contributed his knowledge in an essay that discusses the French master's activities during the years of Robinson's Giverny visits. At the BMA, we are fortunate to have dedicated educators, advocates for the needs and interests of our audience; we also benefit from the talents of our exhibition staff, whose imaginative minds always find a new and completely effective way to present each exhibition. Added to these very visible results in the galleries are the unseen efforts of literally dozens of BMA staffers—those who raise the funds that support Museum programs, those who promote and market the exhibition, those who pack, ship, and preserve the art, and of course, those who protect the artworks every day.

We also express our gratitude to those who have so generously offered financial support for this exhibition and the accompanying publication, in particular, The Rouse Company and the Henry Luce Foundation. In addition, we are most grateful to the Charlesmead Foundation and the Terra Foundation for the Arts, which have contributed significantly to this endeavor.

We are pleased that *In Monet's Light: Theodore Robinson at Giverny* will be presented at two additional venues, the Phoenix Art Museum and the Wadsworth Atheneum, Hartford. We welcome these distinguished colleagues as partners in our undertaking and are delighted to have the opportunity to share with them the Impressionist art of Theodore Robinson and the account of his friendship with Claude Monet.

Finally, the experience of an exhibition requires the assembly of a critical group of artworks to tell a story, and, of course, that means these treasures are missed in other institutions and sometimes in homes. To each of the lenders to this exhibition, we offer our profound thanks for your willingness to relinquish these delightful pictures for a tour that will reacquaint another generation of Americans with Theodore Robinson and his work.

Doreen Bolger, *Director*
THE BALTIMORE MUSEUM OF ART

List of Lenders

Addison Gallery of American Art
Phillips Academy, Andover, Mass.

Susan and Herbert Adler

The Art Institute of Chicago, Ill.

The Baltimore Museum of Art, Md.

Ann M. and Thomas W. Barwick

The Butler Institute of American Art,
Youngstown, Ohio

Brooklyn Museum of Art, N.Y.

Canajoharie Library and Art Gallery, N.Y.

Cincinnati Art Museum, Ohio

The Corcoran Gallery of Art, Washington, D.C.

Georgia Museum of Art, University of Georgia,
Athens, Ga.

Florence Griswold Museum, Old Lyme, Conn.

Kennedy Galleries, Inc., New York, N.Y.

Bernard and S. Dean Levy, Inc., New York, N.Y.

Mr. and Mrs. Meredith J. Long

Los Angeles County Museum of Art, Calif.

Maier Museum of Art, Randolph-Macon Woman's
College, Lynchburg, Va.

Robert A. Mann

Mead Art Museum, Amherst College, Mass.

The Metropolitan Museum of Art, N.Y.

Montclair Museum of Art, N.J.

Museum of Art, Rhode Island School of Design,
Providence, R.I.

Muskegon Museum of Art, Mich.

The Nelson-Atkins Museum of Art, Kansas City, MO

The Newark Museum, N.J.

North Carolina Museum of Art, Raleigh, N.C.

The Parrish Art Museum, Southampton, N.Y.

Pennsylvania Academy of the Fine Arts,
Philadelphia, Pa.

Philadelphia Museum of Art, Pa.

The Phillips Collection, Washington, D.C.

Princeton University Art Museum, N.J.

The Ruth Chandler Williamson Gallery, Scripps
College, Claremont, Ca.

Smithsonian American Art Museum, Washington, D.C.

Spanierman Gallery, LLC, New York, N.Y.

Lois and Arthur Stainman

Terra Foundation for the Arts, Chicago, Ill.

Westmoreland Museum of American Art,
Greensburg, Pa.

Wichita Art Museum, Kans.

Yale University Art Gallery, New Haven, Conn.

*We are grateful to the following colleague institutions for
the loans of paintings by Claude Monet to the exhibition.*

The Art Institute of Chicago, Ill.

Columbus Museum of Art, Ohio

Museum of Fine Arts, Boston, Mass.

The Virginia Museum of Fine Arts, Richmond, Va.

Walters Art Museum, Baltimore, Md.

Acknowledgments

Throughout my years of research on Theodore Robinson, countless individuals have offered invaluable assistance, generously sharing their knowledge on various aspects of his life and art. *In Monet's Light: Theodore Robinson at Giverny* draws on this wealth of information accumulated from a wide range of sources including descendants of the artist as well as colleagues working in American art.

BMA Director Doreen Bolger, a scholar in the field of nineteenth-century American painting, generously offered materials on Robinson's close acquaintance, artist Julian Alden Weir, and has enthusiastically supported this exhibition from its inception. Paul Tucker, Professor of Art History, University of Massachusetts Boston, in addition to contributing an enlightening essay on Claude Monet to the catalogue has consistently shared his wealth of knowledge on the French master, and I am grateful for his many suggestions and insights. Ira Spanierman's deep appreciation of Robinson's work and his commitment to advancing scholarship related to the artist is reflected in the frequency with which his name appears throughout this publication.

Several individuals were especially helpful in providing advice and assistance: Anita Duquette, Whitney Museum of American Art, New York; Robert Goldsmith, The Frick Collection, New York; Judy Salerno, Spanierman Gallery, LLC, New York; Dr. William H. Gerdts; Nancy Caisse; Elizabeth Glassman and Cathy Ricciardelli, Terra Museum of American Art, Chicago; Wim de Wit, The Getty Research Institute, Los Angeles; Sophie Levy, Chief Curator, and Katherine Bourguignon, Musée d'Art Américain, Giverny; Judith A. Barter and Gloria Groom, The Art Institute of Chicago; George T. M. Shackelford, Museum of Fine Arts, Boston; John Coffey, North Carolina Museum of Art, Raleigh; Margaret Conrads, The Nelson-Atkins Museum of Art, Kansas City; Eric Zafran and Elizabeth Kornhauser, the Wadsworth Atheneum, Hartford.

Pivotal to the success of this exhibition, which explores a finite period in Robinson's career, is the inclusion of key works of art that document the evolution of his Impressionist style at Giverny. It would have been greatly diminished without the generous support of colleague institutions and of private individuals who are committed to sharing their collections with the

public. In particular, I would like to thank Ann M. and Thomas W. Barwick, Robert A. Mann, Susan and Herbert Adler, Cornelia and Meredith J. Long, and Lois and Arthur Stainman.

As always, the staff of The Baltimore Museum of Art has provided invaluable support in all aspects of this endeavor. Jay M. Fisher, Deputy Director for Curatorial Affairs, devoted many hours to issues related to venues and loans; Melanie Harwood, Senior Registrar, dealt with the often complicated negotiations concerning loans and transport of works of art; Senior Conservator Mary Sebera treated a painting essential to the concept of the exhibition; Karen Nielsen, Director of Exhibition Design and Installation, once again provided a superb setting in which to display the works of art. I also want to express my thanks to departmental colleagues Katherine Rothkopf, Curator of Painting and Sculpture, and Laura Albans, Administrative Assistant, for their support and good humor through all stages of this undertaking. Michelle Boardman, Manager of Creative Services, ably assisted by photographer Jose Sanchez, Matthew Bender, and Lynette Roth, oversaw the production of the handsome publication which brought to fruition by Philip Wilson Publishers Ltd., London. I would like to thank Philip Wilson, Managing Director, Cangy Venables, Managing Editor, Norman Turpin, Production Manager, and Designer Peter Ling for their efforts.

Finally, I would like to acknowledge those who have provided the financial resources to make this exhibition and publication a reality: The Rouse Company, the Henry Luce Foundation, the Charlesmead Foundation, and the Terra Foundation for the Arts. I am deeply appreciative of their great generosity.

Sona Johnston
THE BALTIMORE MUSEUM OF ART

Theodore Robinson, *Bridge Near Giverny* (cat. no. 13, detail)

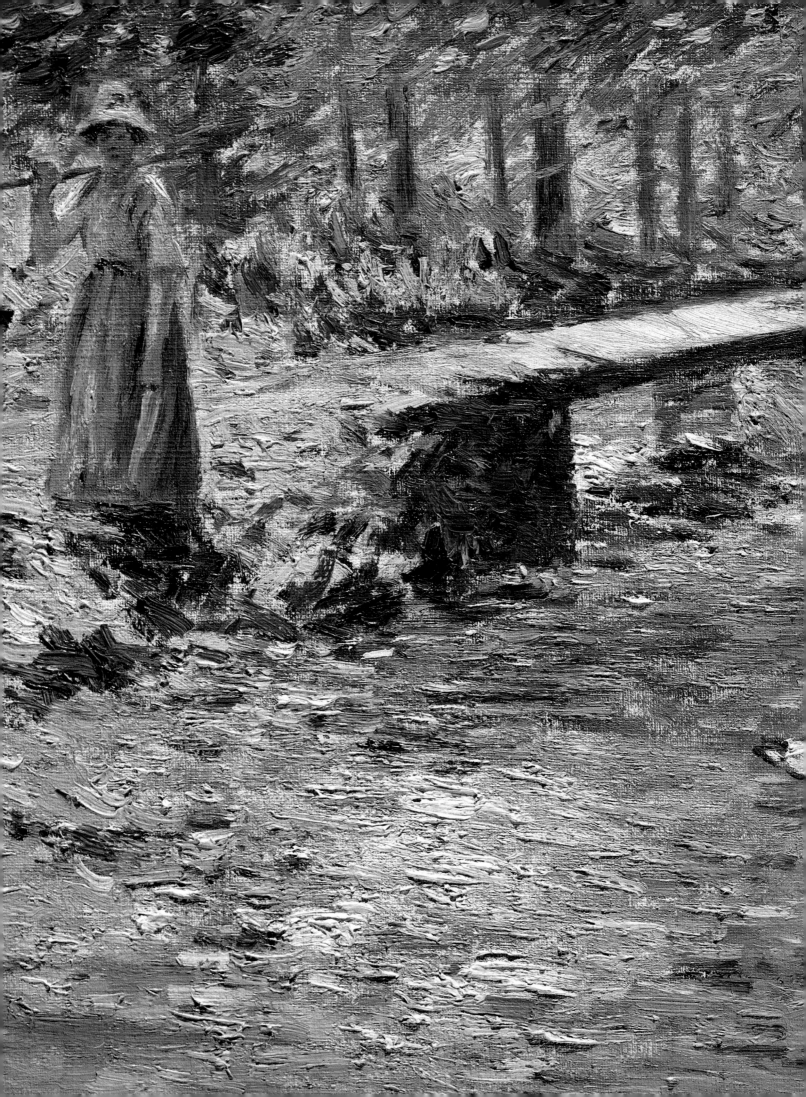

Introduction

In the late 1880s, Theodore Robinson (1852–96) was among a group of American painters who began to visit the small village of Giverny located on the Seine River in the Normandy region of France where Claude Monet (1840–1926) has settled in 1883. One of the first of his generation to embrace the innovative Impressionist movement, Robinson was much admired by his contemporaries including dealers, collectors, and fellow artists. Central to his mature artistic style, which evolved at Giverny, was his close association with Monet whom he befriended in the course of six extended sojourns in the village from the spring of 1887 through the end of 1892. Notations in his personal diary and letters to friends record frequent visits to the French master's home and discussions on matters of mutual interest. Not only did Robinson adopt the fresh brushwork and vibrant palette of the new movement, but, like Monet, he became increasingly attuned to the subtle changes in light and color at different moments through the day and under varying atmospheric conditions.

As the years leading up to his Giverny period were a prelude to the flowering of his personal Impressionist style, those few remaining to him upon his return to America were a coda, his energies diminished by chronic illness that had eroded both vigor and spirit. During the six-year interval spent in the French countryside working in proximity to his good friend, Claude Monet, Theodore Robinson painted his finest works.

Theodore Robinson, *By the Brook*
(cat. no. 30, detail)

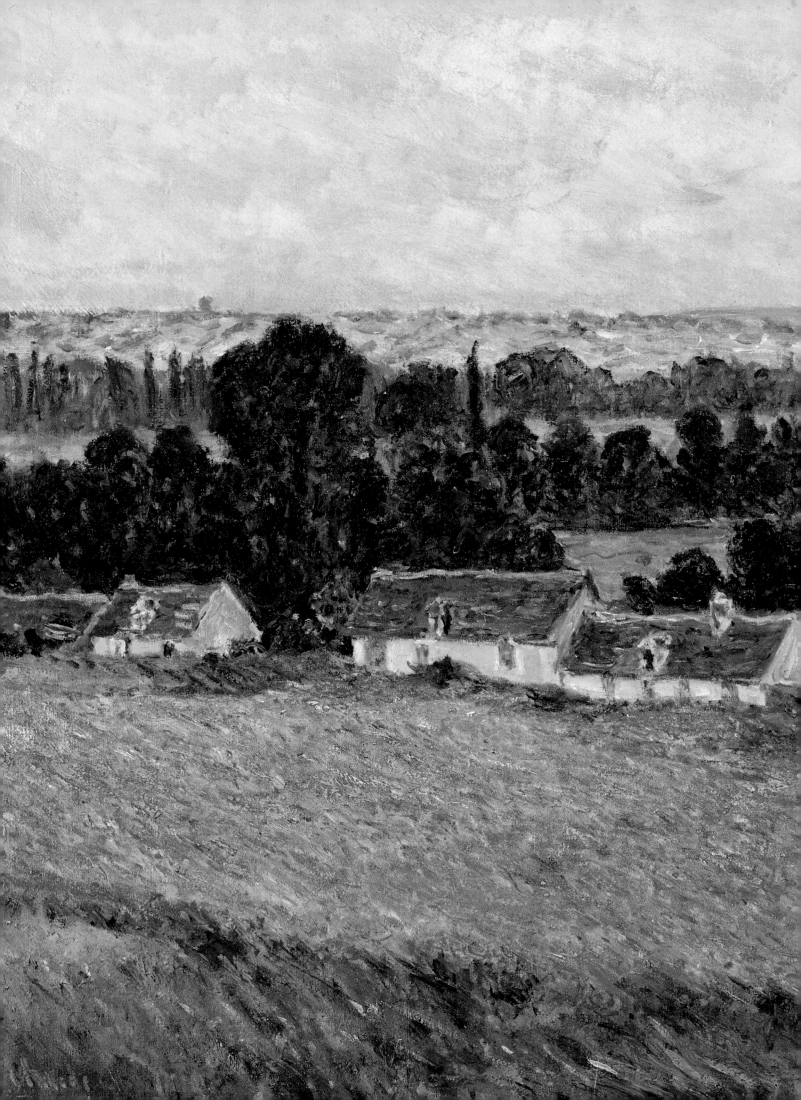

Paul Tucker # Monet, Giverny, and the Significance of Place

There are moments in history, precious and rare as they may be, when the fortuitous metamorphoses into the inevitable and the commonplace magically but assuredly evolves into the extraordinary. Such was the case with Monet's time in Giverny. It began innocently enough in April 1883 when the restless Impressionist left the western Parisian suburb of Poissy to find a new place to live. He chose Giverny, a small Norman farming village almost one hundred kilometers northwest of the capital. Although he had passed near the village many times when traveling by rail from Paris to Rouen or the Normandy coast, he had never been there—had never even heard of it—before he decided to leave Poissy. With only 279 residents in 1883, most of whom worked the land, Giverny was an unassuming collection of simple farms and modest houses that had been host to no notable event, had given birth to no native of distinction, and had developed no lasting product or idea. Quiet and picturesque, it was just like the thousands of other agrarian communities throughout rural France that made the nation's countryside so heartwarming and desirable.[1]

It was precisely Giverny's pastoral charm that seems to have appealed to Monet. And on the 29th of April, at the age of forty-two, he moved into the now-famous pink stucco house that stands near the eastern end of the village, on what today is aptly called the rue Claude Monet. Forty-four years later, just after celebrating his eighty-sixth birthday, Monet died in this same house, his life and work by then inextricably linked to this once unknown place, his decision to move there yielding consequences of startling, but perhaps not unpredictable, significance.

Monet, of course, could never have envisioned this nearly perfect merger of fate and fortune when he arrived in Giverny. As an inveterate traveler, it would not have occurred to him that he would spend the rest of his life there, albeit with various painting campaigns conducted elsewhere in France and beyond. Nor could he or anyone else have imagined that in this humble locale he would produce a magisterial body of work that would both redefine the basic tenets of Impressionism with which he was so closely aligned and, at the same time, chart distinctly new territory for all of modernist art. But that is precisely what happened, which is partly why his moment in Giverny was so meaningful and why he is hailed today as one of the greatest artists of the nineteenth and

Claude Monet, *Field of Poppies*
(Fig. 9, page 57, detail)

twentieth centuries. It also helps to explain why his house and gardens are now among the most visited sites in France.

These facts cloak a number of ironies, however. Given his present, worldwide popularity, for example, it is perhaps surprising to learn that when he succumbed to pulmonary sclerosis on December 5, 1926 in his Giverny bedroom overlooking the flower and water lily gardens that he had so lovingly created, his passing drew considerable attention but not his art. It had long since fallen from favor, his longevity having compromised his legacy. A presence on the French art scene for more than sixty years, the patriarch had outlived all of his Impressionist colleagues (together with his first and second wives, as well as his first born son and two step-daughters).[2] It was therefore only natural that his views of modern Paris and its suburbs, or his odes to the rural beauties of his native land, despite being rendered with continual daring and invention, would have been eclipsed by the efforts of younger, more radical avant-gardes, particularly in the twentieth century. Indeed, by 1926, most of the major art movements of the first two decades—Fauvism, Cubism, Futurism, Orphism, Dada, Neo-Platonism, Rayonism, Suprematism, and Constructivism—had all undergone several evolutionary stages or had been abandoned. It is also worth recalling that Surrealism had already been securely established by the time the aging Impressionist died, its manifesto having been published in Paris two years earlier. Surprisingly as well, perhaps, when Monet was laid to rest, Picasso was thirty-five, Matisse fifty-seven.

It was not until the 1950s that Monet's reputation began to recover and not until the 1970s that his late work from Giverny finally received appropriate attention. It took almost another two decades for his water lilies in particular to become more sought after by collectors than his earlier canvases, a reversal that says as much about the last decade of the twentieth century as it does about the aesthetic value of those remarkable paintings.[3]

It took an equally long period of time for his house and gardens to become a mecca for art lovers and tourists. In the decades after Monet was buried following a simple, secular ceremony, the property fell into disrepair, and in the 1960s, upon the passing of Monet's only direct descendant, his second son Michel, it was given to the Académie des Beaux-Arts which began restoring

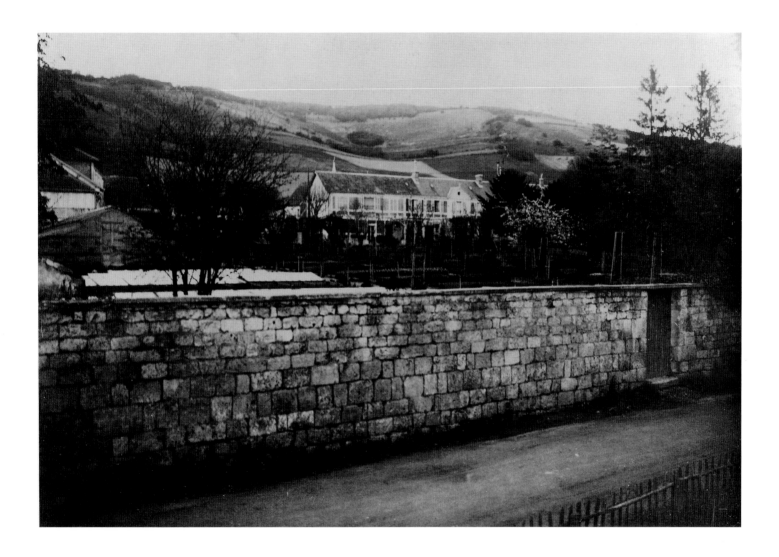

Figure 1
Claude Monet's house at Giverny
French School, 20th century
Archives Larousse, Paris, France

it in the mid-1970s. The refurbished house and gardens opened in May 1980, though it took almost another decade to attract the kinds of crowds they regularly draw now, a mark again of changing times and evolving tastes.

There are two final ironies. The restoration was primarily supported not by French francs from Monet's fellow countrymen and women or by subventions from their government, but by American dollars, collected by the head of the project, Gerald van der Kemp and his American wife Florence, from American devotees of French art, the collectors, philanthropists, and populist publishers Walter Annenberg and Lila Acheson Wallace among others. It underscores the old adage, generally attributed to the ex-patriot Oscar Wilde:

"When Americans die, their souls go to France." In the case of these generous benefactors, however, it should be modified to specify Giverny.

In many ways, these patrons were following their nineteenth-century aesthetic forebears, as American painters were the first to flock to Giverny to work near the master, Theodore Robinson being among the initial group that arrived in 1887. Many rented houses or took up residence at the Hôtel Baudy, down the road from Monet's house. Some, such as Lilla Cabot Perry, leased property right next door to Le Pressoir, as Monet's house was called. Still others, like the painter Mary Fairchild MacMonnies and her sculptor husband Frederick MacMonnies, actually purchased homes in the town. So numerous did the Americans become that Monet began to feel that his little village was being overrun by them and claimed in 1892 that he was going to leave, a threat he quickly retracted.[4]

The last twist in the complicated tale of Monet's years in Giverny is the amount of time he needed to come to terms artistically with his adopted town, unlike his American counterparts who immediately took to the place. Monet did not paint it seriously for nearly two years after he arrived, preferring instead other sites along the Seine (Port Villez and Vernon in 1883) and the shores of the Mediterranean (Bordighera and Menton in 1884). After an extremely productive spate of pictures of Giverny subjects in the first nine months of 1885, he was off again—to Etretat on the Normandy coast, and, in 1886, he left after another brief engagement with the town, traveling first to Holland and then to Belle-Ile in the Atlantic off the coast of Brittany. Eighteen eighty-seven was the first year he stayed put, producing more than thirty pictures of diverse subjects in Giverny, but the following year he left once again on another extended trip to the south of France, this time to Antibes. An invitation to visit the Creuse Valley in the Dordogne similarly dragged him away in 1889. But when he returned from this physically taxing three-month campaign in that rugged area of the country, he finally settled into the town and found subjects to paint over the next ten years that would became hallmarks of his time in Giverny—stacks of wheat under varied light and weather conditions, poplars along the Epte, morning mist rising on the Seine, and, most notably, during the last twenty-six years of his life, his beloved water and flower gardens.

His concentration on these now iconic subjects, while intense and myopic, would nonetheless also be broken by expeditions elsewhere—to Rouen in 1892, 1893, and 1894 to paint that city's gothic cathedral; Norway in 1895 to see his stepson Jacques Hoschedé and immortalize aspects of that Nordic land; London in 1899, 1900, and 1901 to render the Houses of Parliament and the bridges over the Thames; and finally Venice in 1908 to wrestle with that most magical of cities. But Giverny was always close to his heart, and became increasingly so as he grew older, as is amply evident from the voluminous letters he wrote when away from hearth and home.

A practical matter ultimately sealed his commitment to the place. The house he had been renting since he arrived in 1883 came up for sale in 1890, and Monet decided to buy it, though undoubtedly not without some hand wringing. His nervousness would have been understandable. The price was 22,000 francs, a significant amount of money. In addition, although he had lived in more than a dozen locations since leaving his parents' house in Sainte-Adresse in the 1860s, this would be the first home he ever owned. He never regretted signing the contract for the sale, which he concluded on November 19, 1890, and except for his one hot-headed threat to leave because of the influx of Americans, he never made mention of relocating anywhere else again.[5]

Giverny was actually quite conveniently located for Monet, which inevitably was one of its appeals. Trains to Paris ran regularly from Vernon and Mantes; the former lay four and a half kilometers to the west, the latter twenty to the south. The trip from either town was forty-five minutes to an hour, which meant Monet could leave his house in the morning, conduct business in the capital during the day, and be home for dinner at night. It also meant he could receive guests easily, especially as carriages were available to take them to and from the station of their choice. Access to Rouen and the Normandy coast was equally efficient.[6]

Not that he was initially interested in going to Paris frequently or in entertaining. Just the opposite. He told his dealer, Paul Durand-Ruel, in late April of 1883 that he couldn't even think about coming to the city until he got settled (though he broke that resolve to attend Manet's funeral in early May).[7] And he made no mention in any of his early letters from Giverny of wanting to

have visitors, except his dealer, which was more of an obligatory gesture than a full-bodied desire. That is because Durand-Ruel had made Monet's move possible. The ever-wailing artist had claimed poverty and played upon his dealer's sentiments to advance him the rent on his new house, cover his moving costs, and pay back rent on the house in Poissy, which also allowed him to avoid legal proceedings there. All of these expenses came to a total of 4,500 francs, a tidy sum for the time, one that more than merited an invitation from the newly ensconced painter.

Despite his delight with Giverny and his general love of the countryside, Monet could never live too far from the city. In fact, he wasn't in Giverny more than six weeks when he panicked and told Durand-Ruel that he felt he may have made a foolish mistake moving to a place "so far away."[8] In Paris, he marketed his work, made connections, and met friends, maintaining a studio apartment near the Gare Saint-Lazare to facilitate these activities. He may not have wanted to commute after settling into Giverny, but regular appearances in the capital were essential to his success. The same contradiction governed his interest in visitors. He may have avoided them at the beginning of his stay, and always insisted on working alone, but he did not want to live in so remote a location that people could not come to see him. Later letters and newspaper reports reveal that company was too important to his sense of self as well as to the advancement of his career to shun guests altogether.

Even more important than its accessibility, however, was the town's topography. Nestled up against curving hills to the north that were topped by fields and forests, Giverny's narrow streets and humble houses ran on an arc that mirrored this rise of the land, creating a pleasing, understated relationship between the evidence of civilization and the drama of nature. From certain vantage points, one could see how those same hills continued on to greater heights at Les Andelys and La Roche-Guyon farther to the north, where Paul Signac and Paul Cézanne would work in the 1888s and 1890s and where Georges Braque would paint in the early twentieth century. Giverny's southern borders were washed by the waters of the Seine, which, after passing Mantes, turned back on itself until reaching Vétheuil, where it turned again and headed directly south to Bonnières and Jeufosse. There, it straightened out to flow

northwesterly to Port Villez and Giverny. This latter stretch was so attractive that it lured Monet to build a boathouse on one of its small islands to store his boats and painting supplies and enjoy the river's beauty. It was the very first project he undertook after moving to Giverny, one he also seduced his dealer to pay for.[9]

But it was the quiet, agrarian character of the place that ultimately must have convinced him to settle there. Fields surrounded the town, some tilled, others left for pasture. They seemed timeless and enduring and brimming with the possibility of being transformed into art, in contrast to Poissy, which he had come to loathe, calling it "horrible" after being there for only two months.[10] Known today for Le Corbusier's classic modern house, the Villa Savoie of 1929, Poissy is located just north of Saint-Germain-en-Laye, twenty-seven kilometers west of Paris. It stretches along the left bank of the Seine, which is dotted with islands after completing a loop around the forest of Saint Germain on its way north to the Channel. Monet moved there in December 1881 from the more rural Vétheuil, which lies thirty-seven kilometers farther to the north, because Vétheuil did not have a suitable school for his eldest son Jean, who was fourteen at the time. Monet had been enormously productive in Vétheuil, painting more than one hundred and seventy pictures during his three years there. The seventeen months in Poissy would be just the opposite; they yielded only four canvases, emphasizing Monet's quip to his dealer, "Poissy has hardly inspired me."[11]

Why Monet so disliked the town is difficult to say, as according to contemporary guidebooks of the region it was a pleasant enough place with plenty of history. In addition, the house Monet rented—la villa Saint-Louis—was rather grand, comprising three stories with lots of rooms. Located right on a branch of the river, at the end of the boulevard de la Seine, it afforded attractive views as well as plenty of comfort. Part of the problem may have stemmed from the fact Poissy was considerably larger than Vétheuil, 5,400 residents as compared to approximately 600. More problematic, however, was his family situation, which became quite complicated in the late 1870s when two of his most important patrons, Ernest and Alice Hoschedé, fell on hard times.[12] Ernest had run into the ground the very successful wholesale fabric firm

he inherited from his father and had to declared bankruptcy, losing everything, including the family's apartment in Paris and their chateau in Montgeron, for which Monet had recently painted four immense decorative panels. Homeless with six children—Marthe (1864–1925), Blanche (1865–1947), Suzanne (1868–99), Jacques (1869–1941), Germaine (1873–1968), and Jean-Pierre (1877–1961), the Hoschedés turned to Monet and his wife, Camille, for help. The two families decided to pool their resources and rent a house in Vétheuil together, creating a *ménage à douze*. The Hoschedés were staunch Catholics, but that did not prevent this rather curious merger from occurring; nor did it stop Alice and her children from staying with Monet and his two children after Camille died in September 1879. By then, Ernest had been spending much of his time in Paris in an apartment leased by his mother, which made the Monet-Hoschedé *mélange* even more curious, something that began "loosening tongues throughout the neighborhood," according to Alice.[13]

It is clear from Monet's letters that the widowed painter had real feelings for Alice and wanted very much to continue their relationship if they were going to leave Vétheuil.[14] When Monet proposed Poissy, Alice agreed to accompany him with her children though without Ernest. It was the first public demonstration of Monet's commitment to Alice and her offspring, and of her to him, bonds that would deepen in profound and inexplicable ways in the years to come. But it also meant that they were living openly in sin, which would have left them vulnerable to more blatant criticism from neighbors and shopkeepers than they may have received in Vétheuil, a condition Monet would have found difficult to tolerate. Their move to Giverny two years later may therefore have been prompted as much by these social tensions as by Monet's desire for a more pastoral setting. In either case, it represented their further separation from Ernest and the ultimate solidification of the Monet-Hoschedé families. From this moment onwards, there was no doubt about who was the head of the household and no hesitation on Monet's part about shouldering those responsibilities, a commitment that culminated when Alice and Monet got married in 1892 following Ernest's death the previous year.[15]

The Giverny house they moved into was ideal—spacious, stately, and only a kilometer from the Seine. Most important, perhaps, it sat on two and a

half acres of walled-in land that also contained several barns and outbuildings that would eventually be converted into studio and living spaces. The former occupant had planted a kitchen garden on the land closest to the house. Monet wasted no time in transforming some of it into the beginnings of his sumptuous flower garden. Practicality was partially sacrificed for the delights of sensory pleasure, though he declared to his dealer that he was concurrently developing still life motifs that he could "pick for rainy days," always conscious of the conflict between his desire to work outdoors and nature's unpredictability.[16] The construction of his water lily garden, a project that was far more expensive and time consuming than ripping out vegetable patches to plant perennials, would have to wait until the following decade when he was the official owner of the original two and a half acres and was able to purchase additional land to create that aquatic paradise.

The only drawback to the property was the fact it was lined on the south (and when he bought the additional land for the water lily garden, divided in two) by Departmental Route number 5 that ran from Giverny to Vernon and by a railroad that paralleled this thoroughfare. Every day, four times a day, a train rumbled down the tracks, slicing through Monet's pastoral ideal. This obvious and persistent reminder of the modern world that Monet was in theory attempting to escape didn't seem to bother the new occupant of the house; he never complained about it during all of his years there. The dirt road was a different matter. Regularly trafficked, it produced clouds of dust that settled on his flowers. Monet eventually became so upset by this that he offered to help pay to have the road paved. This meant he did not have to instruct his gardeners to dunk his water lilies to restore them to their pristine beauty, a command he gave every morning during their blooming season, a mark of his fastidiousness and his devotion to his motifs.[17]

Such concerns, of course, were far from his mind when he first arrived. Even with the difficulties that the move entailed, or perhaps because of them, he could not suppress his enthusiasm for the area. "I am enchanted with the countryside," he told his dealer on May 7, just a week after he moved in.[18] Less than two weeks later, he reiterated his pleasure to the critic Théodore Duret. "I am in ecstasy," he cried. "Giverny is a splendid place for me."[19] Given this

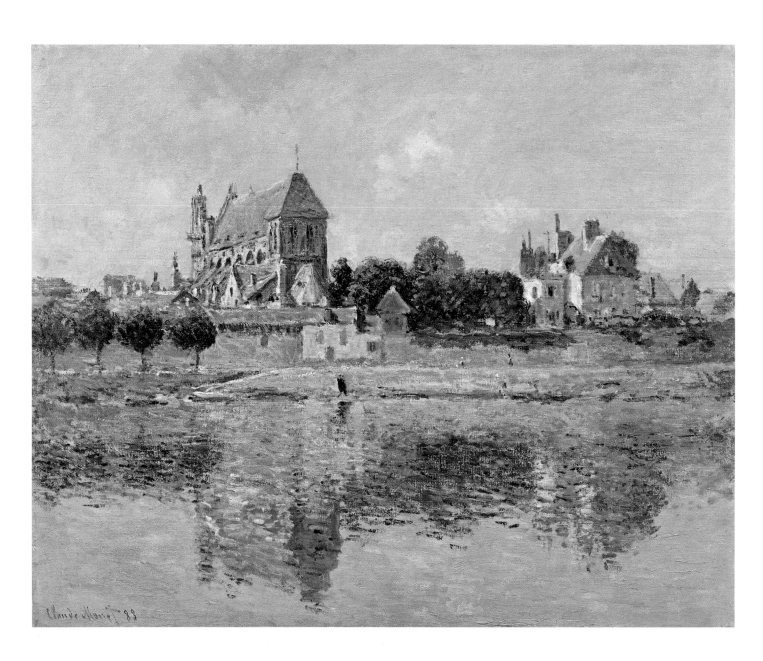

consistent, heartfelt reaction, it is somewhat surprising that he did not immediately set out to paint sites in Giverny. Instead, he turned to the Seine, completing half a dozen views of Vernon from across the river (Fig. 2) and a similar number of paintings of the waters near Port Villez to the south, both within easy walking distance of his house. Perhaps he was thrilled to have the opportunity to work on his favorite river again, the stretch of the Seine at Poissy having failed to move him. Perhaps he was trying to recover some of the

Figure 2
Claude Monet, *View of the Church at Vernon*, 1883, Oil on canvas [W.843], Yoshina Gypsum Co., Ltd. (deposited at Yamagata Museum of Art)

poetry he had found at Vétheuil, as many of these early views of Vernon recall his paintings of that town. But perhaps he was doing what he often did— cautiously feeling his way through a new locale to discover its particular points of interest. He admitted as much in July 1883 when he told Durand-Ruel that "one must always take a certain amount of time to familiarize oneself with a new landscape."[20]

He began one big ambitious canvas, however, that, while left unfinished, suggests he was also looking back beyond Vétheuil to paintings of contemporary life that he initiated in the 1860s and brought to a climax in the 1870s during his time in Argenteuil (Fig. 3). Measuring 116 cm x 136 cm, it was the largest canvas he had attempted since the four decorative panels he completed for the Hoschedés in 1876, and the first figure painting since that same robust moment. Only when he turned to the genre again in 1887 did he choose to work on an equally heroic scale.[21]

Figure 3
Claude Monet, *Luncheon under the Canopy*, 1883, Oil on canvas [W.846], Private collection

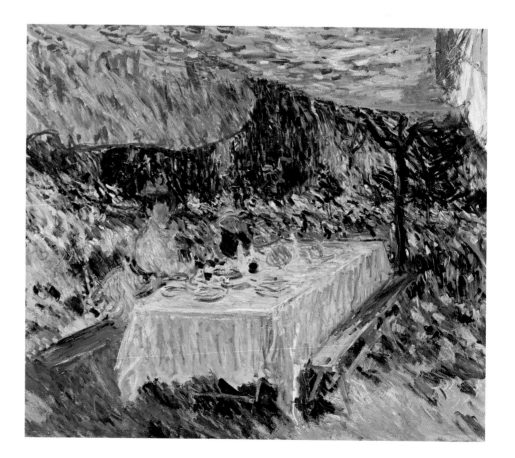

This huge painting depicts the beginnings of a "déjeuner au jardin" with two people seated at a partially set table under a white, wind-blown canopy. In addition to being a leap back in time, the picture is both strange and baffling. The canopy flutters above the figures without being tied to any evident supports. Alice Hoschedé and Michel Monet sit alone at the table. Where is Jean, who would have been fifteen by then? Or the other Hoschedés? Not that Monet intended the painting to be a family portrait. But it still is odd that such a big canvas would contain only two figures, especially when family issues had been in the forefront for so long (and would remain one of Monet's paramount concerns throughout his years at Giverny). Why he started it in the first place is equally perplexing, as is its abandonment, but it is an important reminder that Monet had not completely given up on the idea of producing figure paintings, despite having devoted himself almost exclusively to landscapes since the late 1870s.

That devotion had taken a particularly personal turn prior to his move to Giverny, a development that began when he started to work along the Normandy coast in 1881, first in Fécamp, and then, over the next two years, in Pourville, Varengeville, and Etretat.[22] Having grown up along this coastline, he was in many ways rediscovering its multiple offerings—sheer cliffs and turbulent waters, rock-strewn beaches and romantic sunsets, precariously perched churches and abandoned custom houses, as well as the fishermen's ageless engagement with the sea. So powerful was Monet's attraction to these primal, though familiar, subjects he painted over one hundred canvases of them between 1881 and 1883, to the virtual exclusion of other motifs.

It is therefore a mark of Giverny's appeal that Monet did not return right away to these emotive sites that had sustained him since leaving Vétheuil, but instead stayed at home until the end of 1883, painting a dozen views of Vernon and Port Villez, four of which he sent off to Durand-Ruel in November, with another six following in December.[23] Measured, balanced, and carefully executed, these pictures breathe an air of quiet contentment, their simple poetry expressed without compositional drama or painterly bravado, as if the unassuming character of the Giverny area immediately had had its effect.

Monet may well have stayed put even longer if the opportunity had not arisen in late December 1883 to join Renoir on a trip to the Mediterranean, an

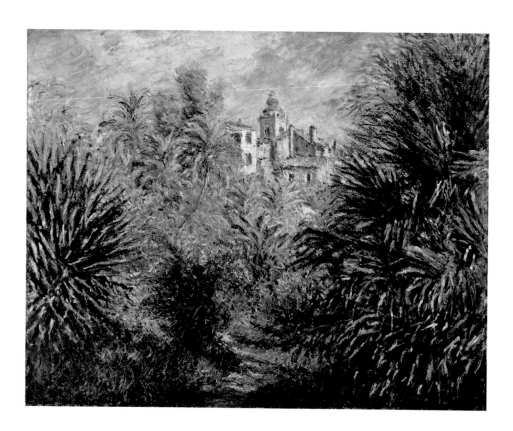

Figure 4
Claude Monet, *Moreno Garden at Bordighera*, 1884, Oil on canvas, [W.865], Norton Museum of Art, West Palm Beach, Florida
Gift of R. H. Norton, 53.134

arrangement that may have been prompted by Ernest Hoschedé's desire to spend Christmas with his children.[24] It was the first time Monet had been to the South since his brief, mandated military service in the early 1860s, though this time he traveled much more extensively, beginning in L'Estaque to see Cézanne and then covering the nearly 380 kilometers from Marseille to Genoa. So impressed was he with the exotic qualities of the region, which were radically different from his own native North, that he returned in January the following year, planning to stay a few weeks in the Italian resort of Bordighera. Three months later in early April, after numerous complaints from Alice about his extended absence, he came back to Giverny with forty-six paintings in various states of completion. They included views not only of the "delicious . . . enchanted land" of Bordighera, as he described it, but also of Vintimille to the west, Monte Carlo in Monaco, and Menton, across the border in France, most of which were rendered with heightened color and rich surfaces that contrast with the more sober views of the Seine that he had completed in Giverny just before departing (Fig. 4).[25]

Contrasts of subject, style, and effect, established with unprecedented clarity by these two campaigns within twelve months of Monet's arrival in Giverny, would come to characterize the artist's work for the remainder of the decade, and would distinguish it from his previous efforts. Sometimes these contrasts manifest themselves rather pronouncedly, as is evident from a comparison of two paintings he completed in the summer of 1884 when he took up his brushes and paints to focus on local motifs, in this case, the confluence of the Epte and the Seine, and haystacks standing in a poplar-lined field (Figs. 5 and 6). The two pictures could hardly be more different. The

Figure 5
Claude Monet, *Confluence of the Epte and the Seine*, 1884, Oil on canvas, [W.898]

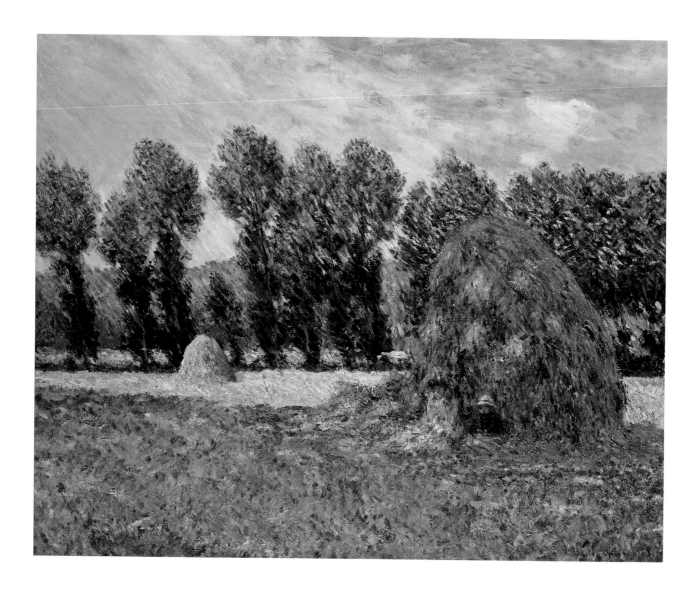

Figure 6
Claude Monet, *The Haystack*, 1885, Oil on canvas, [W.994], Ohara Museum of Art, Kurashiki, Okayama, Japan

former is dense, enclosed, centrally focused, and mysteriously charged; there is no evidence of the human here. Indeed, the undergrowth is so thick that it severely limits the spatial recession in the view while making the site appear to be almost as exotic as those that Monet had painted in the South, the Valley of Sasso in particular. The latter is open, airy, spacious, and readable. Its horizontal orientation speaks of tradition and continuity, appropriate for its agrarian subject, while its rhyming of shapes and forms accentuates the harmony that Monet wanted to suggest, all of which strongly contrasts with the push and pull of the Epte against the Seine and those two bodies of water

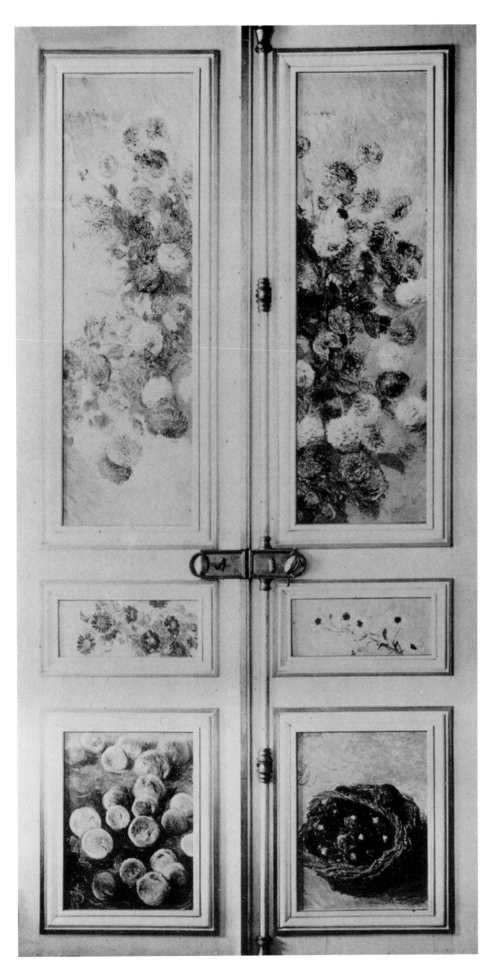

Figure 7
Claude Monet, Decorative Doors for
Durand-Ruel's salon, 1883–85, [W.937-42]
Private Collection

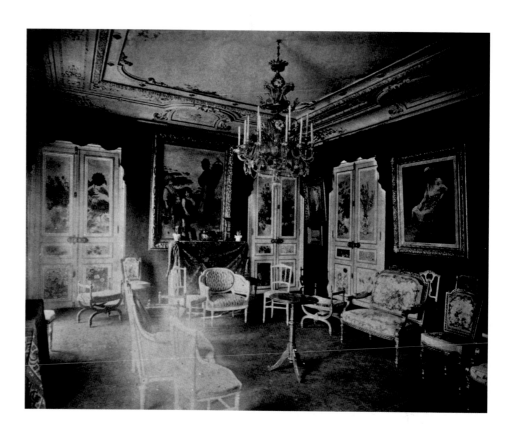

Figure 8
Photograph of Durand-Ruel's salon at
35 rue de Rome

against the foliage above. Even the way the two pictures are painted could not be more dissimilar. The former is dominated by highly individualized touches of paint that describe the complex skeins of leaves and branches as well as the rushing waters of the Epte, which are so different from those of the Seine. In the stack picture, paint is applied with greater restraint and regularity. Brushstrokes, while still apparent, move in more logical patterns across the surface, just like the light, which is much more consistent than the furtive chiaroscuro Monet employs in the river view.

At other times, the contrasts are subtler, as with the three-dozen decorative panels that Monet completed between 1883 and 1885 for the doors of Durand-Ruel's main salon in his Parisian apartment on the rue de Rome. While each door follows the same format—two long vertical rectangles at the top, two short horizontal ones in the middle, and two nearly square panels at the base, the fruits and flowers Monet depicted are a true potpourri—lemons and oranges or peaches and apples on four base panels, with azaleas and

anemones on two others and differently colored tulips appearing elsewhere. Chrysanthemums and sunflowers fill two top panels, with dahlias and gladioli on two more. None of the panels shares the same illusionary space; each is highly individualistic and discontinuous with the next. Even when he selects the same species of flower, he establishes striking differences. For two bouquets of dahlias that appear in two top panels, for example, he sets one bunch in a radically cropped vase, while making the other so dense and truncated that no container is visible. In two bottom panels of tulips, more vases appear in one panel than in the other, while both panels are depicted from divergent vantage points. In two top panels of privets, the flowers themselves are contrasted—a red and a pink blossom in one versus a white one in the other. He goes even further here, however, and selects two radically opposed vases for these privets, placing them on two different tables, one that angles back into space, the other that runs on a strict horizontal across the scene.[26]

Clearly, Monet wanted to create a lively, decorative scheme for this important commission, one that would force the viewer to perceive the ensemble not as a tightly integrated whole but as a unique collection of highly individualized parts. This strategy would accomplish at least two things: it would attest to his skills at rendering quite different still life forms, and it would underscore his general inventiveness as an artist, both of which would impress any open-minded person who had the opportunity to see this remarkable room.

Of course, it was as a landscape painter that Monet ultimately wanted to make his name. Thus, it is not surprising that after settling in Giverny, it was in this genre that he most revealed his commitment to creating a body of work distinguishable by contrasts. And nowhere is this more apparent than in the canvases he produced during two separate excursions, one to Belle-Ile in 1886, the other to Antibes in 1888 (Figs. 9 and 10).

Even more than the two Giverny pictures of the haystacks and the confluence of the Epte and Seine, these canvases define striking extremes. In one, nature is ferocious, dangerous, and ever changing. In the other, it is serene, inviting, and consistent. In figure 9, the overcast scene is rendered with a somber palette of dark blues, purple-grays, and blacks that are made ominous by the frothy whites of the waves. In figure 10, the world is aglow thanks to the

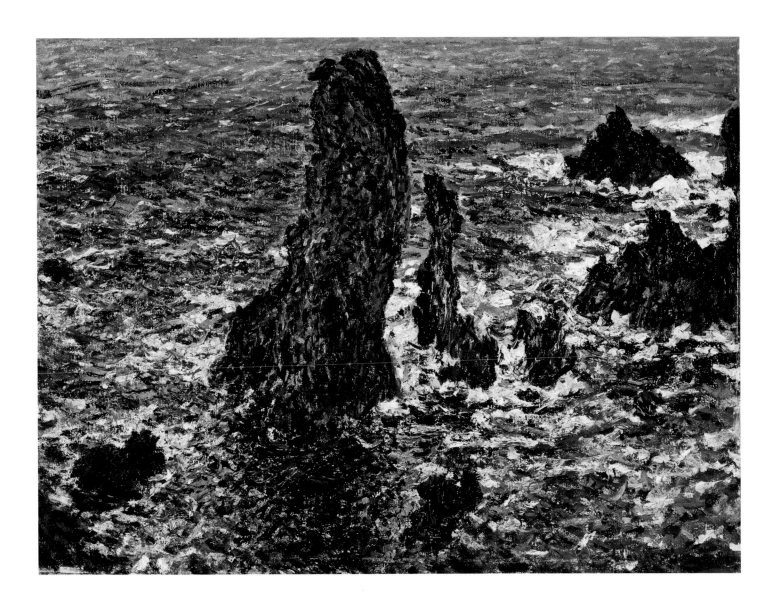

Figure 9
Claude Monet, *Pyramides at Port-Coton, Belle-Isle*, 1886, Oil on canvas [W.1084], Pushkin Museum, Moscow, 3310

brilliant, light-infused pastel tones of the sky that fill the view, so pleasing to the eye that they made Degas decry Monet, his Impressionist rival, as a mere decorator when Monet exhibited a suite of Antibes scenes in Paris in June and July of 1888.[27] The volcanic, pyramid rocks in the Belle-Ile picture rise out of the Atlantic like valiant warriors engaged in an ancient battle with the sea, while the lithe trees along the Mediterranean twist and turn like graceful dancers on a stage of natural splendor. The former are drawn with sharp, almost staccato-like

33

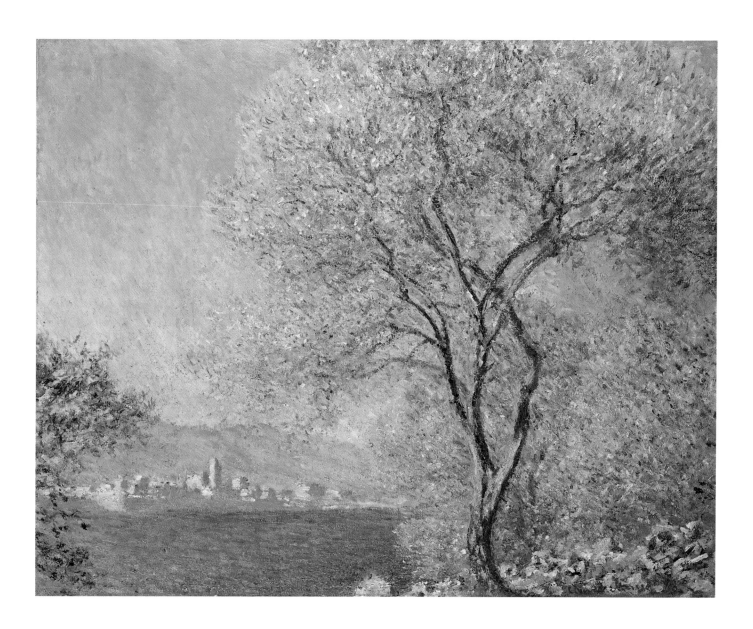

Figure 10
Claude Monet, *Antibes Seen from La Salis*,
1888, Oil on canvas, [W.1168], Toledo Museum
of Art, Purchased with funds from the Libbey
Endowment, Gift of Edward Drummond
Libbey, 1929.51

markings of the brush, the latter with a range of carefully controlled touches, all
set against a background of such uniformity that the whole almost appears to be
an artfully contrived theater set.

These basic divergences essentially derive from the sites Monet chose
to render, namely the extremes of the nation—the fickle, more violent, less
accommodating North filled with challenges and contingencies versus the
steady, seductive, magical South that lures you into reverie while transporting

you across time and space to the glories of a seemingly attainable idyll.

Why did Monet go to these extremes? What advantages did they offer, and how did they contribute to the advancement of his career? In addition, what happened when he returned to Giverny? What role did his newly adopted home play, at least during the years he expended on these fundamentally divergent efforts?

Monet himself did not provide any answers to these questions, despite having written over 2,000 letters during his lifetime. He never explained his work or revealed his intentions with that kind of specificity. But it is evident that he had adopted this *modus operandi* beginning with his trip to Bordighera and that he had stuck with it for these initial years in Giverny: the question is why.

In part, it was fortuitous, the result of rediscovering the South and finding it exhilarating. In part, it was a way to satisfy his wanderlust, a desire that had always been with him, but that increased exponentially in this fifth decade of his life. As he grew older, these more diverse and challenging sites were appealing because they broadened his perspective on the world and enriched his sense of self. Although he rarely liked to socialize with people he encountered when away, he always seemed to enjoy the social adventure, often to Alice's disquiet. Occasionally, he met people who would play key roles in his life, as occurred on Belle-Ile where he encountered the art critic, Gustave Geffroy who would become one of his staunchest supporters and, later, his chief biographer. More important perhaps, these extremes allowed him to test his painterly mettle in unprecedented ways. Having more or less abandoned his quest of nearly twenty years to render contemporary life as a new form of history painting, he needed to find sites and subjects that would provide a parallel set of problems and generate a similar level of interest. Moreover, by limiting his output primarily to landscape painting, he had to develop a range of material that would be sufficiently engaging for the avant-garde art collector. Giverny's offerings were charming. And he responded accordingly, painting between 1883 and 1888 more than one hundred pictures of its streets and crowning church; poppy, oat, and hay fields; stands of willows and poplars along the Epte; flowering orchards; and isolated stretches of the Seine. Many of these paintings are utterly beguiling; some contain aspects of what he would develop in the

1890s into his classic Giverny canvases; a few are spectacular, such as the hoar frost he captured so astonishingly in the winter of 1885 (Fig. 11). But most are rather pedestrian, at least by Monet's standards. And some are surprisingly uninteresting. It was as if the ease of living in such a pastoral retreat with its simple topography and pervasive calm conspired against him, reducing his seemingly relentless urge to devise endlessly novel pictorial strategies in front of continuously challenging sites and subjects. Giverny, in short, for the first few years of his stay at least, was an appropriate and much-needed haven for Monet, a place for nurturing and renewal, not high drama and experimentation. For the latter, he could go elsewhere, a practice he would soon reconsider.

Monet understood Giverny's seductive power. And it worried him, particularly when he felt obliged to scrape down and repaint canvases he started there.[28] Chief among Monet's concerns, besides providing for his united family, was his keen desire to continue propagating the importance of Impressionism. When he decided to return to the Salon in 1880 after a ten-year absence, a move made largely with the hope of increasing his audience and ultimately his sales (an important consideration given the newly combined Monet-Hoschedé households), he was roundly criticized by some of his fellow Impressionists. A mock funeral notice even appeared in the Parisian daily, *Le Gaulois*, announcing the group's anticipated mourning for the death of one of its former members.[29] His response was unequivocal. "I am still an Impressionist and always will remain one," he declared to the journalist Emile Taboureux in a long interview he gave to bolster his cotaneous one-person show held that summer in the galleries of the new monthly journal, *La Vie moderne*.[30] But by then, Impressionism had been around for almost twenty years and was in some danger of becoming less avant-garde and more mainstream, a fate Monet might have embraced on the one hand and found repugnant on the other. What he seems to have recognized after his trip to Bordighera was the opportunity not only to challenge himself and keep Impressionism fresh, but also to make his style responsive to areas of the country that had escaped his discerning eye and hand. Born in Paris, Impressionism had essentially been an urban art form, engaged with the tensions of modernity and with the immediate and the mundane in the capital and its outlying suburbs. By traveling more widely

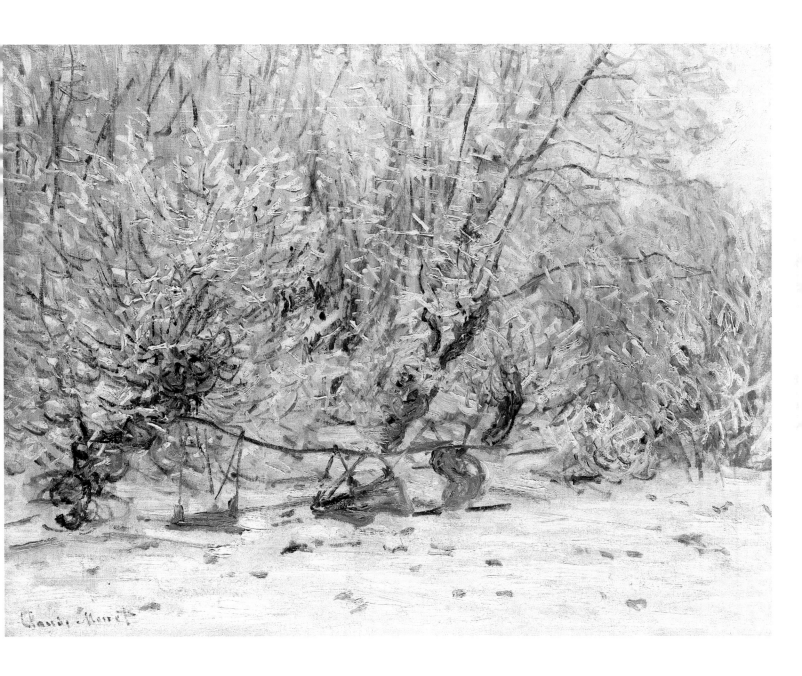

Figure 11
Claude Monet, *Hoar Frost*, 1885, Oil on canvas, [W.964], Private Collection

and painting more diverse sites, Monet could expand Impressionism's realm, thereby making it allegiant to the nation as a whole, a development that eventually occurred.[31]

There were other stimulants for this strategy, one of the most important being younger artists: some were beginning to imitate the Impressionists, although in much more prosaic fashion; others were taking the core tenets of

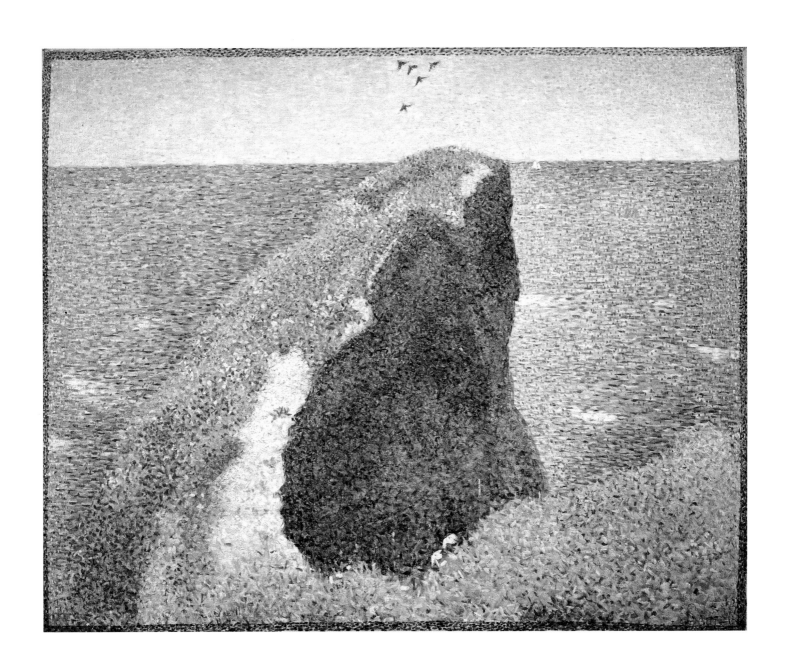

the movement and skillfully adopting them to very different ends. While many
of the former artists have long since disappeared from the history of the period
(people like Paul Rossert and Vittorio-Matteo Corcos, or the older Joseph
Caraud and Gabriel Anable de la Foulouze, all of whom deserve further
attention), various members of the latter group quickly rose to prominence.
Among them were Paul Gauguin and Georges Seurat, both of whom, by 1884,

Figure 12
Georges Seurat, *The Bec du Hoc, Grandcamp*,
1885, Oil on canvas, Tate Gallery, London

had begun to participate in major exhibitions in Paris, often with considerable success. That was certainly true of Seurat, whose huge *Bathers at Asnières* was exhibited in Paris that year and was followed by the equally large *Sunday on the Island of the Grand Jatte* of 1884–86. The latter was actually shown in the eighth and last Impressionist exhibition, together with eight other paintings and drawings by him that were immediately seen as the beginning of a new radical movement that had the potential to upstage the older Impressionists.[32]

Monet did not participate in the latter exhibition, using the excuse that he was already committed to a show at Georges Petit's gallery, the upscale competitor of Durand-Ruel. But he saw the exhibition and immediately felt the pressure of his younger rivals. That summer of 1886, just after the eighth Impressionist exhibition closed, he started a group of figure paintings that were clearly prompted by Seurat's novel masterpiece of forty-plus figures enjoying various forms of modern leisure on a brilliant summer day. And then he left for Belle-Ile, where he carried in his mind images of Seurat's landscapes that had been included in the show, such as *The Bec du Hoc* (Fig. 12), which may have served as a touchstone for his views of the pyramid rocks. In these and many other points of contact with emerging painters, Monet clearly wanted to emphasize the vitality of Impressionism, its ability to capture the evanescent qualities of light and air, its power to portray the passing of time and the instantaneous, and its suggestions of the artist's heartfelt engagement with his motif. To Monet, Seurat's paintings seemed cold and mechanical, the product of a calculating, rational mind, not the result of the indefinable dynamic between eye, hand, and heart that was central to Impressionism. As such, Impressionism seemed closer to nature itself, which Monet later defiantly declared "is not made up of little dots."[33]

There are many other instances in which Monet was clearly taking on these talented upstarts, though nowhere more so than in *Bend in the River Epte*, of 1888 (Fig. 13). Here, he covers three-quarters of the canvas with a myriad of energized touches of paint, most of which possess an individuality and a concomitant regularity that recall Seurat's dots. At the same time, they stand as inventive extensions of his own Impressionist stroke. For unlike Seurat's dots, Monet's touches seem to embody the very effects he was attempting to render—

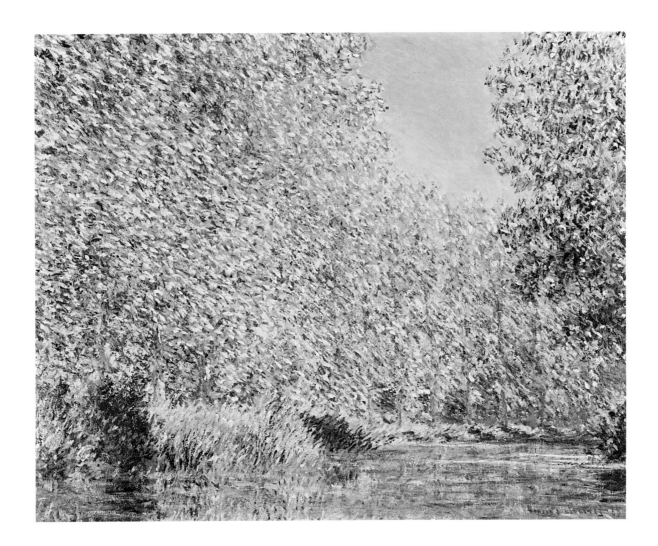

Figure 13
Claude Monet, *Bend in the River Epte*, 1888, Oil on canvas, [W.1209], Philadelphia Museum of Art: William L. Elkins Collection, 1924

the wind rustling through the foliage, the leaves moving singly and in unison, light flickering over the scene as a whole, everything palpable, sensed, and felt.

When summer gave way to fall in 1888, and the farmers of Giverny began to harvest their fields of wheat, Monet found the ideal subject to demonstrate his abilities and thereby flaunt his Impressionist style (Fig. 14). Unlike the casually heaped up piles of hay that he had painted many times before in Giverny, as in figure 6, these stacks are carefully constructed with bound sheaves arranged in an ascending, interlocking circle to create the base of the stack. This base is then thatched with a conical top and left standing all winter to allow the wheat to be more easily separated from the chaff in the

spring.[34] Rising fifteen to twenty feet and standing relatively close to Monet's property, these stacks were proud testimony to time, tradition, and the fertility of the soil. Rendering them at various times of day, under different light and weather conditions, Monet could demonstrate the keenness of his eye and the dexterity of his hand, while creating believable poems about the profundity of painting when dealing with nature's incalculable beauty.

This initiative would be interrupted by yet another invitation to travel, this time from Gustave Geffroy who wanted to visit the poet Maurice Rollinat in Fresselines, an obscure village that lay at the confluence of the Petit and Grande Creuse Rivers in the central part of France. Thinking he would be gone for a week to ten days, the painter joined the critic, leaving his art supplies at home. Two weeks later, he returned to Giverny to retrieve those materials, so

Figure 14
Claude Monet, *Stacks of Wheat, Morning Effect*, 1888–89, Oil on canvas, [W.1215], Alfred Atmore Pope Collection, Hill-Stead Museum, Farmington, Connecticut

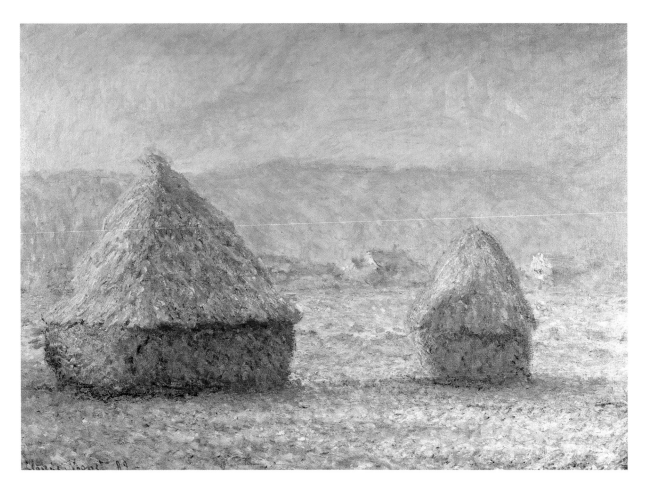

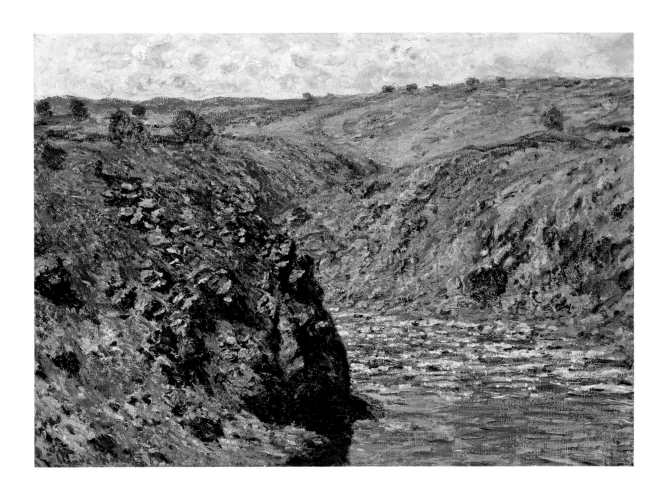

moved was he by the primal powers of the place. Two months later, in mid-May 1889, he came back to his wife and family with twenty-four new paintings (Fig. 15). These haunting, elegiac views of this rugged region of the country could be considered his first completed series, as they extend to an unprecedented degree Monet's inclination, made evident early in the decade, to paint several pictures of the same site or subject. The series includes no fewer than ten views of the bend in the combined rivers with towering hills in the foreground and their mates folding one into another in the distance. Monet exhibited seven of these canvases in a major retrospective, held with Auguste Rodin, in the summer of 1889. Critics singled them out for their drama and uniqueness as a group, undoubtedly increasing Monet's desire to get back to his stacks.[35] And when they began to rise on the Giverny landscape in 1890, he immediately set to

Figure 15
Claude Monet, *Valley of the Creuse. (Sunlight effect)*, 1889, Oil on canvas, [W.1219]
Museum of Fine Arts, Boston, Julia Cheney Edwards Collection, 25.107

work, eventually producing a total of thirty canvases of these forms that lead from summer to winter and constitute his most ambitious project to date.

He knew he was on to something even before he exhibited fifteen of these stack paintings to considerable acclaim in May of 1891, as that spring, before the show opened, he began a new series of paintings of poplars along the Epte. And no sooner had he put fifteen of those in front of an enthusiastic public at the end of February 1892 than he turned his attention to the façade of Rouen Cathedral. He had found a way of operating that greatly refined the contrasts that had dominated his work of the 1880s. Instead of vacillating between extreme motifs, he now narrowed his range and increased his reach, allowing his ever-agile Impressionist style to capture increasingly subtle effects of nature on the same site or subject. When Theodore Robinson saw the *Cathedrals* for the first time, he felt they were "colossal."[36]

He was not misguided. Nor was he alone. Critics who saw them concurred, claiming these and Monet's subsequent series paintings were not only remarkable but worthy of making Monet France's leading landscape painter. "Transport these . . . stacks and cathedrals around the world," declared one writer in 1900, "and no matter where these paintings will be, the spectator, whoever he is, will admire and envy a country where the hand of man . . . built such monuments in the middle of such beautiful sites. Glory thus to the artist who with the aid of a few lines and some dashes of color can so grandly synthesize the land where he lives."[37] Not surprisingly perhaps, one of the most important mandates that Monet by example gave his American admirers in Giverny was to find significant subjects in their own country and to devote their efforts to immortalizing them, a challenge some artists, like Robinson, deeply appreciated after learning the value of place from the man they had come to revere.[38]

NOTES

Abbreviations for frequently cited references:

AH Alice Hoschedé
DR Paul Durand-Ruel
W Daniel Wildenstein, *Claude Monet. Biographie et catalogue raisonné*
w. Wildenstein's ordering of Monet's letters

1 All literature on Monet's time at Giverny is indebted to Daniel Wildenstein's essential *Claude Monet. Biographie et catalogue raisonné* (Lausanne, Bibliothèque des arts, Vol. I. 1840–81 [1974]; Vol. II. 1882–86 [1979]; Vol. III. 1887–98 [1979]; Vol. IV. 1899–1926 [1985]), which has been translated and reprinted by Taschen Publishers and the Wildenstein Institute in Paris, 1997. All references here are to the original volumes, as the newer edition does not contain any of Monet's letters. One of the most detailed accounts of Monet's life in Giverny is Claire Joyes, *Monet at Giverny* (London: Mathews Miller Dunbar, 1975). Equally useful is Charles Stuckey, *Claude Monet, 1840–1926*, exh. cat. (Chicago: The Art Institute of Chicago, 1995.)

2 Camille Monet died in 1879; Alice Hoschedé Monet in 1911; Jean Monet in 1914; Suzanne Hoschedé in 1899; and Marthe Hoschedé in 1925.

3 On the Monet revival see Michael Leja, "The Monet Revival and New York School Abstraction," in Paul Tucker, ed., *Monet in the 20th Century* (New Haven: Yale University Press, 1998), 98–108; Clement Greenberg, "The Later Monet," *Art News Annual*, 26 (1957): 132–48, 194–96, reprinted in *Art and Culture* (Boston: Beacon Press, 1961), 37–45. The first important exhibition of Monet's late work in the United States occurred in Saint Louis and Minneapolis in 1957, with a subsequent show at The Museum of Modern Art in New York and the Saint Louis Art Museum in 1960. The next major exhibition, which concentrated more extensively on twentieth-century material, was at the Metropolitan Museum of Art in New York in 1978. The most important recent show was *Monet in the 20th Century*, held at the Museum of Fine Arts, Boston and the Royal Academy of Arts, London in 1998–99.

4 See w.1139 to AH, 10 March 1892, W.III, 264–65. Monet voiced earlier complaints about the Americans. See w.1425 to Gustave Geffroy, 20 June 1888, W.III, 298. On the American invasion of Giverny see William H. Gerdts, *Monet's Giverny: An Impressionist Colony* (New York: Abbeville Press, 1993); William H. Gerdts, *American Impressionism* (New York: Abbeville Press, 1984); Lilla Cabot Perry, *Informal Talk Given by Mrs. T. S. Perry to the Boston Art Students' Association in the Life Class Room at the Museum of Fine Arts*, Wednesday, 24 January 1894 (Boston: Boston Art Students' Association, 1894); David Sellin, *Americans in Brittany and Normandy, 1860–1910* (Phoenix: Phoenix Art Museum, 1982); and *Claude Monet and the Giverny Artists* (New York: Slatkin Galleries, 1960). On the first American collectors of Monet see Frances Weitzenhoffer, "The Earliest American Collectors of Monet," in John Rewald and Frances Weitzenhoffer, *Aspects of Monet* (New York: Harry N. Abrams, 1984), 72–91.

5 On the sale of the house see W.II, 20 and note 191–94. His concern about buying the house is implied in a letter to Durand-Ruel in which he says he wants to move on the deal but is "going to have to ask [him] for quite a bit of money," 3–4,000 francs it turned out. See w.1079 to DR, 27 October 1890, W.III, 259.

6 An early riser, Monet could be in Durand-Ruel's gallery by 9:30 am. See w.350 to DR, 2 May 1883, W.II, 229.

7 On the invitation to Durand-Ruel see w.352 to DR, 7 May 1883, W.II, 229; on not coming to the city see w.348 to DR, 29 April 1883, W.II, 228.

8 See w.358 to DR, 10 June 1883, W.II, 229.

9 See w.356 to DR, 5 June 1883, W.II, 229.

10 See w.234 to AH, 8 February 1882, W.II, 214.

11 See w.234 to DR, 6 February 1882, W.II, 213.

12 On the Hoschedés see Hélène Adhèmar, "Ernest Hoschedé," in Rewald and Weitzenhoffer, as in note 2, 52–71.

13 Letter from AH to Ernest Hoschedé [28 December 1879] as cited in W.I, 105 and translated in the new edition, W.I, 151.

14 On Monet's commitment to Alice see especially w.334 to AH, 19 February 1883, W.II, 227.

15 Monet's marriage to Alice was prompted not so much by Ernest's death as by Suzanne's wedding to Theodore Butler. Alice wanted Monet to walk her daughter down the aisle as the legally recognized stepfather.

16 See w.356 to DR, 5 June 1883, W.II, 229.

17 On paving the road see w.3017 (1836b) to A. Collignon, 20 July 1907, W.V, 212.

18 See w.352 to DR, 7 May 1883, W.II, 229.

19 See w.354 to Théodore Duret, 20 May 1883, W.II, 229.

20 See w.362 to DR, 3 July 1883, W.II, 230.

21 There are some differences of opinion about the date of this gigantic canvas. Wildenstein maintains that it was begun in 1883 because Germaine Hoschedé (now Madame Salerou) identified the two figures as Michel and Alice. Michel would have been five at the time, which he felt coordinated well with his appearance in the picture. Virginia Spate claims it dates to 1886 because she believes Michel looks older than five. She also feels the broader handling relates better to the images of Camille on a hill that Monet completed in 1886. See Spate's *Claude Monet: Life and Work* (New York: Rizzoli, 1992), 175 and note 56. The problem is further complicated by a painting of the same subject from virtually the same vantage point that John Rewald attributed to John Singer Sargent. See Rewald's *The History of Impressionism* (New York: The Museum of Modern Art, 1961), 552. The attribution of this painting to Sargent, however, has been discounted, raising further questions about the date of the work, no less who painted it. See Richard Ormond, *John Singer Sargent* (London: Yale University Press, 1970), 41, note 90.

22 On these and subsequent campaigns along the Normandy coast see Robert L. Herbert, *Monet and the Normandy Coast: Tourism and Painting, 1867–1886* (New Haven: Yale University Press, 1994), and Richard Thompson, *Monet and the Sea, Vétheuil and Normandy, 1878–1883*, exh. cat., (Edinburgh: National Gallery of Scotland, 2003).

23 See w.380 to DR, 9 November 1883, W.II, 231.

24 This suggestion was made by Stuckey, as in note 1, 210. On Monet's campaigns on the Mediterranean see Joachim Pissarro, *Monet and the Mediterranean*, exh. cat., (Fort Worth, Texas: Kimbell Art Museum, 1997).

25 For Monet's reaction to Bordighera see w.404 to AH, 3 February 1884, and w.403 to Théodore Duret, 4 February 1884.

26 To underscore Monet's conscious effort at diversity and contrast see Gustave Caillebotte's radically different scheme for a similar decorative project, illustrated in Stuckey, as in note 1, 224.

27 Degas's comments about Monet as a decorator were recorded by Pissarro. See John Rewald, ed., *Camille Pissarro: Letters to his Son Lucien*, 4th ed. (London: Rutledge Keegan Paul, 1970), 8 & 10 July 1888, 126–27.

28 See w.362 to DR, 3 July 1883, W.II, 230.

29 For the notice in *Le Gaulois* (of 24 January 1880) see W.I, 107–08, and Stuckey, as in note 1, 69–70.

30 Emile Taboureux, "Claude Monet," *La Vie moderne* (12 June 1880), 380–82; W.I, 115. Monet knew he would be criticized, as he made clear in a letter to Théodore Duret prior to the Salon opening. See w.173 to Théodore Duret, 8 March 1880, W.I, 438.

31 These and other issues are discussed at greater length in my *Monet in the 90s: The Series Paintings* (New Haven: Yale University Press, 1990), 14–37.

32 See Félix Fénéon, "Les Impressionnistes en 1886 (VIIIe Exposition impressionniste)," *La Vogue* (13–20 June 1886): 261–75, reprinted in Ruth Berson, *The New Painting: Impressionism 1874–1886, Documentation. Volume I. Reviews* (San Francisco: Fine Arts Museums of San Francisco, 1996), 441–47. Paul Signac, Seurat's primary follower, showed not fewer than eighteen paintings and drawings at the same exhibition.

33 For the quip to Lilla Cabot Perry see Cecilia Beaux, *Background with Figures* (Boston, 1930), 201, cited in Sellin, as in note 4.

34 Herbert was the first to note the differences between the two different types of stacks and their different meanings. See Robert L. Herbert, "Method and Meaning in Monet," *Art in America*, 67, no. 5 (September 1979): 90–108.

35 These pictures were part of Monet's important, joint exhibition with Auguste Rodin, which was widely covered by the press. See Steven Z. Levin, *Monet and his Critics* (New York: Garland Press, 1976), 95–116, and Tucker, as in note 31, 53–55.

36 Theodore Robinson Diary, 1892, Frick Art Reference Library, New York.

37 Charles Saunier, "Petit Gazette d'art: Claude Monet," *La Revue blanche* 23, no. 181 (15 December 1900): 624.

38 On this important point, see Barbara Weinberg, *American Impressionists*, exh. cat. (New York: Metropolitan Museum of Art, 1996), 29, where she writes: "When the American Impressionists began to escape the confines of academic training in the late 1880s and the 1890s, the radical Monet, who was outspokenly committed to representing his native countryside, was the principal French artist who inspired and reinforced their devotion to native subjects." Robinson affirms this as well. See, for example, his diary entry for 20 February 1893 in which he writes: "This interests me, the liking for landscape (both in nature and art) in America. It is very genuine and widespread, and is a good way to be—something good will come from it if it is directed and taught, as the canvases of Monet and others are doing, no at least beginning to do." Quoted in Weinberg, 57. Or see Robinson's letter to Hamlin Garland of 14 November 1895 in which he states: "I've got to go back to what is my country. I am only beginning to see its beauties and possibilities and to feel that affection for a country, so indispensable to paint it well." Quoted in Weinberg, 58. A further entry from Robinson's diary underscores this point. "At that time [in the 1880s] anything that pleased him [Monet], no matter how transitory, he painted, regardless of the inability to go further than one painting. Now it is only a long entwined effort that satisfies him, and it must be an important motif, one that is sufficiently *entrainant* [captivating]. 'Obviously one loses on the one hand if one gains on the other. One cannot have everything. If what I am doing no longer has the charm of youth, I hope that there are more successful qualities so that one could live longer with one of these paintings.' He agreed with me that it was a pity one could not always paint freely, all sorts of things, without thinking too much of their importance." Quoted in Stuckey, as in note 1, 223.

Theodore Robinson and Claude Monet

Sona Johnston

Prior to his first extended stay at Giverny in 1887, Theodore Robinson pursued formal artistic training at the Chicago Academy of Design (1869/70) and, in the early 1870s, at the National Academy of Design in New York under Lemuel Everett Wilmarth (1835–1918), who was the first American to study with the academic painter, Jean-Léon Gérôme (1824–1904), at the Ecole des Beaux-Arts in Paris. In 1876, like multitudes of aspiring young artists, Robinson was drawn to the French capital to continue his studies. At the independent atelier of Charles-Emile-Auguste Carolus-Duran (1838–1917) on the Boulevard Montparnasse, he encountered several of his countrymen, including John Singer Sargent (1856–1925), Will Hicok Low (1853–1932), James Carroll Beckwith (1852–1917), and Birge Harrison (1854–1929). Friendships with Beckwith and especially Low would continue throughout his life. Late in the same year, he entered the Ecole to pursue further instruction with Gérôme. These early efforts were rewarded in 1877 when he exhibited for the first time at the Paris Salon, writing to his mother, "My picture is accepted and I tremble with joy."[1] Robinson would continue to exhibit at the Salons of 1880, 1887, 1888, 1889, and 1890. In catalogue listings for 1887 through 1890, he would indicate that he was also a pupil of painter Benjamin Constant (1845–1902).

During the summer months, Robinson, like other art students, made excursions to various locales in the environs of Paris. In 1877, at Grèz-sur-Loing on the edge of the Fontainebleau forest not far from Barbizon, he was among a group of young English-speaking artists and writers in residence that included Robert Louis Stevenson (1850–94). In an article describing the colony written many years later, Birge Harrison, also present that summer at Grèz, recalled fondly:

> The one who always stands out most vividly in my own mind and memory is my beloved chum and studio-companion, Theodore Robinson, who is now taking his place . . . as one of our American old masters. . . . His infectious laugh I can hear to this day, and the subdued chuckle with which he met the little daily contretemps of existence was a tonic and an inspiration to those around him.[2]

Robinson returned to Grèz the following summer before setting out with fellow

Theodore Robinson Sketching in France, (Fig. 8, page 55, detail)

Ecole student, Kenyon Cox (1856–1919), on an extended journey across northern Italy to Venice (Fig. 1). Writing home in December 1878, Cox, already back in Paris, speaks of Robinson's physical frailty brought on by severe asthma, a chronic, debilitating condition that would impose considerable limitations on his activities throughout his life:

> Robinson has come back from Venice very much used up. He caught some sort of fever there and was sick for some days in a little German hotel, waiting for money to leave with, confined to his bed, unable to eat anything . . . and almost afraid he should never get out alive. He is very thin and feeble, but I hope if he takes care of himself and lives better he will come round.[3]

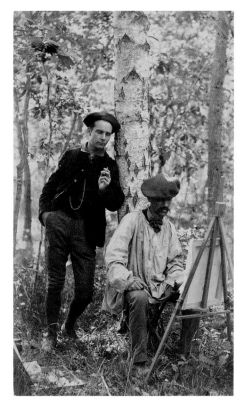

Figure 1
Theodore Robinson (seated) with Kenyon Cox, n.d., Albumen print, Terra Foundation for the Arts, Gift of Mr. Ira Spanierman, C1985.1.25

His student days over, the artist returned to America late in 1879. Plagued by financial difficulties, he spent extended periods with his family in Evansville, Wisconsin. In 1881, through his close friend, Will Low, who had observed from letters the need "to extricate Robinson from his surroundings where . . . he was fast relapsing into a vegetable state,"[4] he secured a teaching position in New York at Mrs. Sylvanus Reed's Boarding and Day School for Young Ladies. Shortly thereafter, he entered the employ of the artist/decorators, John La Farge (1835–1910), and later Prentice Treadwell of Boston, working on mural projects in New York City, Albany, Boston, and Newport, Rhode Island. The emphasis on draughtsmanship and on the careful rendering of form and volume inherent in these architectural decorations can be observed in much of Robinson's own production from the early and mid-1880s. Figures are strongly drawn, solid, and at times, almost sculptural.

A further influence in these formative years grew from his admiration for Winslow Homer (1836–1910), whose broadly treated genre scenes reinforced his own realist tendencies. Several compositions painted on Nantucket during the summer of 1882 record island life in a manner reminiscent of Homer's rural subjects (Fig. 2). Although he would continue to hold Homer in high regard, acquiring a watercolor by him in 1894,[5] it was Robinson's initial European experiences that most certainly served to broaden his perspectives regarding his own artistic ambitions. In a letter to Cox written in the spring of 1883 from

Newport, Rhode Island where he was at work on mural decorations, he revealed:

> Since I began to draw years ago, my ideal was Winslow Homer, that is,
> country life and work, mostly out-of-doors. I have nearly gotten rid of
> the desire to do "American" things—mostly because American life is so
> unpaintable—and a higher view of art seems to me to exclude the
> question of nationality. I would like to try a little flight into something
> Biblical or Mythological.[6]

With the exception of a work titled *The Flight into Egypt*, exhibited at the
Society of American Artists in New York in 1888 (no. 98), there is no indication
that he pursued such subject matter.

In the spring of 1884, Robinson had accumulated sufficient funds to
return to France and pursue his career. He settled in Paris, although the precise
circumstances of his arrangement remain unclear. That he readily immersed
himself in the vigorous artistic life of the city is evident in correspondence with

Figure 2
Theodore Robinson, *Nantucket*, 1882, Oil on
canvas, Collection of The Columbus Museum,
Columbus, Georgia, Museum Purchase

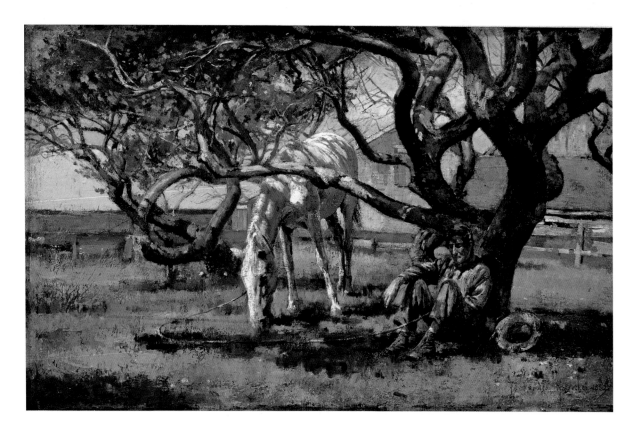

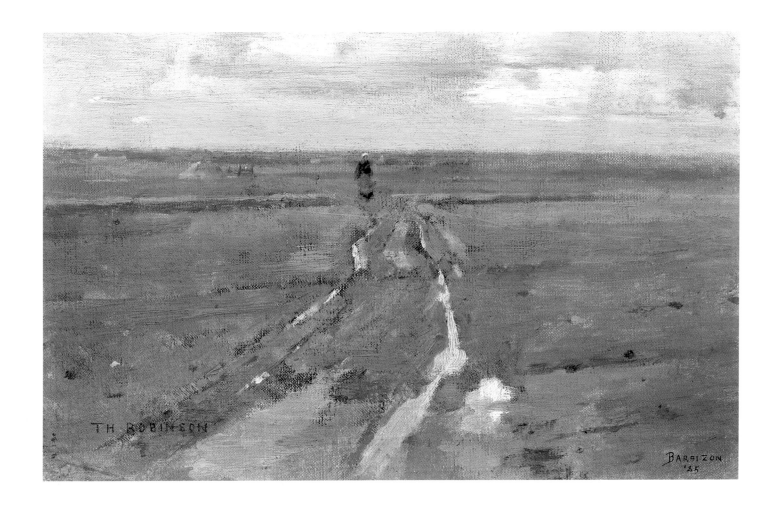

Figure 3
Theodore Robinson, *Barbizon*, 1885, Oil on canvas,
Private Collection

Cox, where he speaks of seeing mutual friends and visits to the Louvre and to various exhibitions taking place in the city. In a letter dated July 3, 1886, he noted, ". . . I agree with you about the impressionists—there is an ex. Rue de Seze with some fine Monets, admirable in color and luminosity I know one or two picture dealers who prophesy great success in the near future for the impressionists and are making a kind of propaganda and are buying up their work."[7] The show to which he refers, the Fifth International Exhibition, opened in mid June at the Georges Petit Gallery, 8 rue de Sèze and included twelve recent works by Monet. The annual series of expositions had been initiated by Petit in 1882. He must surely have also attended the eighth and final Impressionist exhibition that took place from May 15 to June 15 at the Maison

Dorée, a popular restaurant located at the corner of the rue Lafitte and the boulevard des Italiens.

Through the mid-1880s, both inscribed works and correspondence with friends and family reveal that the artist continued his excursions into the countryside, notably to Barbizon on several occasions and other locales as well.[8] A small group of somewhat loosely painted views taken in and around the village represents his initial foray into the genre of pure landscape (Fig. 3). Not drawn to the verdant setting of the nearby Fontainebleau forest, he chose instead to record the broad, expansive plain surrounding the hamlet as well as more intimate glimpses of the buildings and lanes within its confines. A visit to the village of Boissise-la-Bertrande on the Seine River southeast of Paris is documented by a delicately executed composition showing the riverbank seen from across the water that he rendered in both oil and watercolor.[9]

In the spirit of these explorations, Theodore Robinson is generally thought to have made his first visit to the Norman village of Giverny on the Seine River halfway between Paris and Rouen in 1885 as related by Pierre Toulgouat, a descendant of Claude Monet:

> . . . in 1885, his [Monet's] friend, De Conchy, came to visit him, accompanied by the young American painter, Theodore Robinson—and Robinson, particularly, was to remain a faithful Givernois, until his death, painting there when he could and writing longingly of it when he had to be away.[10]

Although little is known of the landscape painter Ferdinand Deconchy (1859–1946), or the circumstances under which he and Robinson met, he was apparently often at Giverny, seeking Monet's advice regarding his artistic efforts; he also frequented the south of France, settling there in 1892.[11]

Of the numerous descriptions of Giverny given through the years, one of the most eloquent is that provided by Robinson's close friend, Will Low, who wrote in his memoir, *A Chronicle of Friendships* (1908):

Giverny, as a hamlet struggling along an unshaded road, offers little at first glance that is picturesque. Through the valley which it dominates runs the Seine, and between the village and the larger river runs a small stream, the Epte, with pleasantly shaded banks enclosed between broad meadows gracefully bordered by long lines of poplars. Its greatest charm lies in the atmospheric conditions over the lowlands, where the moisture from the rivers, imprisoned through the night by the valleys bordering hills, dissolve before the sun and bathe the landscape in an iridescent flood of vaporous hues.[12]

A later, somewhat less poetic account is also applicable, the village having changed very little since the late nineteenth century:

Giverny, unlike most Norman towns, is a two-street town—two parallel streets, the Route Basse and the Route du Roi, both curving slightly as they follow the base of the hill which dominates the town, and tied together by a network of narrow alleys, each just large enough for a farm wagon to trundle through. The houses are of stone, stucco-covered, and since the town is preeminently a farming town—and since in France, by a

GIVERNY, près Vernon
Vue prise sur la Côte

Phot. A. L., Vernon

Figure 4
A. Lavergne, Vernon, Vintage postcard *GIVERNY près Vernon (Eure) – Vue prise sur la Côte*, n.d., Courtesy Musée d'Art Américain, Giverny, Terra Foundation for the Arts

Figure 5
A. Lavergne, Vernon, Vintage postcard, *GIVERNY (Eure) — Paysage d'automne*, before 1910, Courtesy Musée d'Art Américain, Giverny, Terra Foundation for the Arts

custom that dates from the turbulent Middle Ages, farmers live in the security of the town and drive daily out to work in their fields—most houses have a kind of walled barnyard, with a grange and poultry shed, all forming part of the property (Fig. 5)."[13]

It was this setting that attracted Claude Monet to the village in the spring of 1883 together with his somewhat unorthodox "family" that included his two young sons, Jean and Michel, by his first wife Camille Doncieux (1847–79), whose premature death had left him a widower. The bankruptcy in 1878 of Ernest Hoschedé (1838–91), a wealthy businessman and early supporter of the Impressionists, who, with his wife, Alice (1844–1911), had befriended the Monets, led to the conjoining of the two families including six Hoschedé children. Following Ernest's death, Claude Monet and Alice Hoschedé would marry.

Firm documentation places Robinson again at Giverny at the end of June 1887 when the Canadian painter, William Blair Bruce (1859–1906),[14] informed his mother, with considerable enthusiasm, of his summer plans:

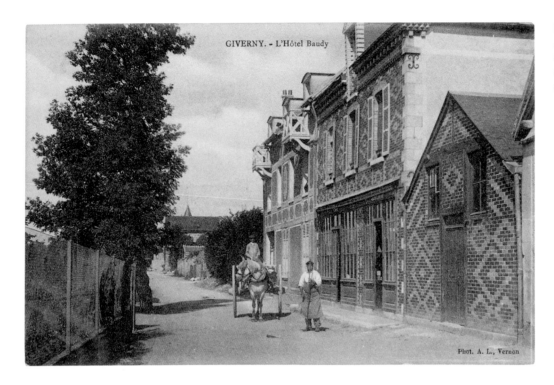

Figure 6
A. Lavergne, Vernon, Vintage postcard,
GIVERNY (Eure) – L'Hôtel Baudy,
Courtesy Musée d'Art Américain,
Giverny, Terra Foundation for the Arts

I have unconsciously let the time slip by without giving you a word of the new settlement which we have formed here in this most beautiful part of France, the river Seine running by almost at our door. The village is far, far ahead of Barbizon in every respect. We have rented a large and well furnished house for a year, and find it much more comfortable than any hotel could be, there are six of us in the arrangement so it comes not too expensively upon us individually.

He continues:

Mr. Robinson's father is dead, he will not go to America however for some time, but will remain in France. Mr. Taylor [Henry Fitch Taylor, 1853–1925] is here, one of the party, and with Mr. Wendel [Theodore Wendel, 1859–1932] and Mr. Metcalf [Willard Metcalf, 1858–1925] form our household. We expect Mr. Carey will turn up in the middle of August.[15]

In September 1887, Robinson would extricate himself from this arrangement and move to the Hôtel Baudy where he became the second guest to register at the

Figure 7
Theodore Robinson, *Portrait of Madame Baudy*,
1888, Oil on canvas, Private Collection

hostelry: Robinson, Theodore, 35 ans, Irasburg (Etats Unis), 18 septembre – 4 janvier 1888 (Fig. 6).[16] Subsequent entries in the register indicate that he took lodging at the hotel from May 12 to December 12, 1889, from May 19 to November 3, 1890, and from April 6 to November 20, 1891. In 1888 and 1892, the year of his final visit, he apparently stayed elsewhere as his name does not appear in the hotel register, although he notes in his diary on September 19, 1892, that he has moved into the hotel where he would remain until his departure from Giverny on December 2.

The center of artistic life in the village, the Hôtel Baudy, established in 1887, accommodated visiting artists with simple bedrooms, studios, a billiard room, and a dining room in which proprietress, Angélina Baudy (1853–1949), served traditional cuisine supplemented with dishes to please her primarily American clientele (Fig. 7). In a somewhat entrepreneurial spirit, she also became an agent for the Paris art supply firm, Lefevre and Foinet, providing canvas and paint to her enthusiastic young lodgers.[17]

Throughout the period, 1887–92, Robinson generally returned to New York for the winter months, although in 1890–91 he made an extended

Figure 8
Theodore Robinson Sketching in France, n.d.

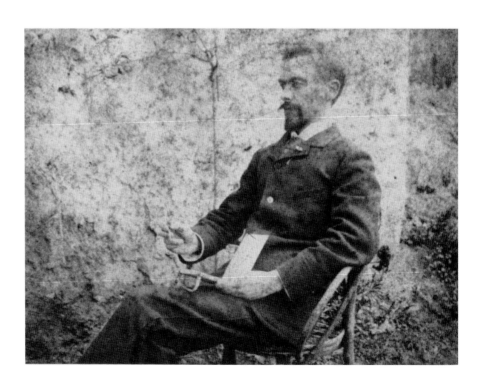

journey to Italy and the Mediterranean coast, visiting Capri, Rome, nearby Frascati, and Antibes. It is possible that he was inspired to make such a trip in part by Monet's sojourn of several months at Antibes in 1888.

Scant documentation exists as to the precise nature of Robinson's association with Claude Monet in the late 1880s. It is possible that their previous encounter in 1885 as well as Robinson's age—he was several years older than most of the Americans who descended upon Giverny beginning in the summer of 1888—may have set him apart from his countrymen in Monet's mind (Fig. 8). It is well known that Monet, irritated by the influx of these newcomers, kept to himself; his life revolved largely around his extended family, various domestic rituals, including the care of his copious gardens, visits from good friends, mostly artists, writers, and critics, and of course, his painting. Of those who formed the American colony, Robinson, Bostonian Lilla Cabot Perry (1848–1933), a visitor for the first time in 1889 with her family, and Theodore Earl Butler (1861–1936) of Columbus, Ohio, who married Monet's stepdaughter, Suzanne Hoschedé (1868–99) in 1892, and following her death, her sister Marthe (1864–1925) in 1900, were most certainly closest to him.

While little may be known regarding their personal relationship at this time, Robinson was clearly immersed in investigations of Monet's unique vision of nature and the innovative methods he was evolving to record these observations. This is most certainly demonstrated by his own emerging Impressionist style. His palette gradually lightened and he expanded his selection of subject matter, now drawn from the real world around him. Obviously taken with the setting of the village, its expansive meadows stretching along the Seine and the cluster of low houses nestled at the base of the hillside, he painted several landscapes taken both from across the river plain and from the sloping hills above the hamlet, these views recalling similar compositions by Monet from the mid and late 1880s (Fig. 9). In these works, he began to explore the effects of light as it falls upon the terrain or illuminates a figure posed out-of-doors in a natural setting. The smooth, uniform application of paint and the emphasis on line as taught in the academic studios of Paris gradually succumbed to a full range of expressive brushstrokes.

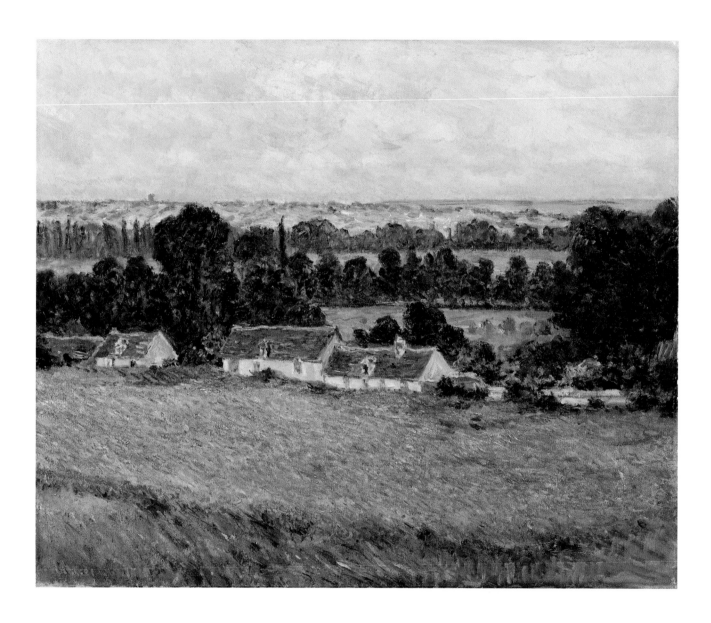

Figure 9
Claude Monet, *Field of Poppies,* Giverny, 1885,
Oil on canvas, [W.997] Virginia Museum of Fine
Arts, Richmond Collection of Mr. and Mrs. Paul
Mellon

Robinson's investigations of Monet's art are further revealed in a laudatory article prepared for the September 1892 issue of *Century Magazine.* A letter dated May 9, 1890 to editor Richard Watson Gilder (1844–1909) concerning changes to the manuscript suggests that it may indeed have been written somewhat earlier than the date of publication. Singling out the French artist as "the most aggressive, forceful painter, the one whose work is influencing the epoch the most," he continues, "there is always a delightful sense of movement, vibration, and life. One of his favorite sayings is 'La Nature

ne s'arrete pas.' Clouds are moving across the sky, leaves are twinkling, the grass is growing. Even the stillest summer day has no feeling of fixedness or of stagnation; moving seas, rivers, and skies have a great charm for him."[18]

Among the illustrations in the article is a delicate charcoal drawing of Monet by Robinson inscribed with the date 1890 and based on a photograph that he took probably a year or so earlier (Fig. 10). In portraying the French artist leaning on a cane, somewhat portly, his features fixed in a serious expression if not a frown, Robinson achieves the veracity in his subject that he applauds as a major aspect of Monet's art:

> He is a realist, believing that nature and our own day give us abundant and beautiful material for pictures: that, rightly seen and rendered, there is as much charm in a nineteenth-century girl in her tennis or yachting suit and in a landscape of sunlight meadows or river-bank, as in the . . . nymph with her appropriate but rather dreary setting of "classical landscape."[19]

Robinson's reliance on photographs as preliminary studies for compositions may have had its inception early in his artistic career. It has been noted that in 1875, prior to his first journey abroad, he advertised in the Evansville, Wisconsin area where he spent his youth, that he could draw crayon portraits based on photographs. He again offered similar services during a brief visit to Evansville in 1879 following his return from his first trip abroad.[20] This practice, not uncommon among artists of the period, was undoubtedly reinforced during his tenure in the employ of John La Farge who utilized a variety of techniques incorporating photographs in the creation of his easel paintings as well as his decorative murals.[21]

Ample evidence exists of Robinson's continuing use of photography during his Giverny years. Justifying the practice, he once confided in a letter to his family: "Painting directly from nature is difficult as things do not remain the same, the camera helps retain the picture in your mind."[22] Surviving photographs reveal that he employed such images mainly for figural works, the extent of his dependency varying. In some instances, he appears to rely heavily on the prototype, drawing a grid of squares both on the photographic study and on the

Figure 10
Theodore Robinson, *Claude Monet*, 1890,
Charcoal on paper, Collection Ann M. and
Thomas W. Barwick
(See cat. no. 22)

fresh canvas or sheet of paper in order to transfer a composition precisely from one to the other. Curiously, in as least a couple of instances, he faithfully transcribes imperfections or flaws in the photograph to the support, as in *Gathering Plums* from 1891 (cat. no. 31), where the hands of the woman on the ladder picking fruit are blurred in both images.

Other works based on similar preliminary studies reveal slight variations, mainly for compositional considerations. In the small oil painting, *Two in a Boat*, from 1891 (cat. no. 29) and in a related watercolor painted the following year (Private Collection), both of which display faint traces of a transfer grid corresponding to the photograph, he has eliminated one of the skiffs behind the figures, thus giving more prominence to the young women. Evidence also exists that he depended on photographs as *aide-mémoirs* to assist in recalling particular aspects of a subject or a locale when it could no longer be directly observed.

Following a journey to southern Italy and the French Riviera from December 1890 through March 1891, Robinson returned to Giverny refreshed and eager to resume his artistic pursuits. Earlier, in an enthusiastic letter to Monet from Frascati near Rome, he had recalled pleasing aspects of the *campagna*, stressing, however, "I still feel it is not as nice as France."[23] Monet, concerned about his friend's delicate constitution, had responded with genuine warmth:

> I was very happy to hear from you, it was really thoughtful of you. Although you don't mention if you are in good health, I suppose this is a good sign and that you will soon be back here "frisky" and eager to start working again. I hope you will bring back plenty of studies of the beautiful places you describe in your letter.[24]

Writing from the Hôtel Baudy to artist friend J. Alden Weir in May 1891, Robinson also alluded to his failing health:

> My last summer was rather broken up by illness, this one I hope will be a good one. I am feeling well and immensely interested in work, and am getting a kind of clear head, a definite idea of what I want, that I hadn't a short time ago, and a certain confidence—I hope not too great—in my own judgment and opinion.[25]

Indeed, his paintings from this eight-month period in 1891 demonstrate a broader range of subject matter and an obvious delight in continued explorations of the elements of color and light. Compositions are more varied, and forms are loosely painted, defined not by line but through a build-up of pigment in an abundant assortment of brushstrokes. Unlike Monet, who drew upon his extended family to serve as models for figural works, Robinson relied on local townspeople as subjects, often recording them as they went about their daily activities, seemingly unaware of his presence. *In the Orchard* (cat. no. 49) captures the moment when a young woman and a child have paused momentarily in the course of their stroll beneath flowering fruit trees. Similarly, *The Watering Place* (cat. no. 27) portrays a man identified by the artist as Père Trognon, a Giverny inhabitant, stopping at a shallow stream to allow his horse to drink.

A pair of closely related canvases, one of which is inscribed with the date 1888, reveals that Robinson had also begun to investigate the effects of varying conditions of light and atmosphere on a particular view (cat. nos. 45, 46). He would continue these explorations through his remaining years at Giverny. In 1891, he focused on dual images of a single stack of grain seen across a meadow, presumably inspired by Monet's on-going involvement with the subject (cat. nos. 47, 48). He must surely also have been aware of the series of fifteen representations of a specific arrangement of grainstacks recorded through the course of a single day that fellow American, John Leslie Breck, painted during the summer.[26]

Theodore Robinson had become somewhat of a fixture in the town by the spring of 1891, as is apparent in a chatty letter to Thomas Sergeant Perry in which he speaks of the general state of the village, describes Monet's progress on his extensive gardens, and assures Perry that everything is in readiness for the arrival of the Perry family for the summer.[27] Boston painter, Lilla Cabot Perry, together with her husband and three daughters, Margaret, Edith, and Alice, made their first visit to Giverny in 1889. They returned for extended summer sojourns through 1909. Very much part of the American colony, Lilla Perry also enjoyed a cordial relationship with Monet that she would recall in an article authored shortly after his death in December 1926.[28] It is likely that

Boston's enthusiasm for Impressionism and Lilla Perry's admiration for Robinson's art spurred her to help organize a joint exhibition of his paintings together with those of Theodore Wendel who worked at Giverny in the late 1880s. Held at the Williams & Everett Gallery in April 1892, it did little to advance Robinson's reputation in her native city. Indeed, Perry would lament the fact that she was the sole purchaser of a work by the artist from the show.[29]

While correspondence and memoirs of friends and relatives can yield valuable information regarding the life of an individual, much of Robinson's daily routine, thoughts on art, frustrations, and most intimate feelings are chronicled in a personal diary that he zealously maintained for much of his adulthood. Extant volumes covering the last four years of his life begin on March 29, 1892 and continue through early April 1896.[30] Nearly all of the first volume is devoted to his final visit to France, a sojourn of more than six months. This portion of the journal is remarkable not only for its revelations about his own activities, but for what it tells of the day-to-day pursuits of Claude Monet and his family.

On May 22, 1892, Robinson arrived at Le Harve from New York, boarded a train for Rouen where he stopped to visit the museum, then continued on to the town of Vernon, noting in his diary, "at 5.20, reached Vernon and to Giverny afoot by the river."[31] The following day, he visited Monet and was most graciously received. Although he mentions seeing a number of views of Rouen cathedral painted by the French artist during the previous winter and early spring, he describes them in greater detail in a letter to his friend, Weir:

> I saw Monet Monday, and a doz. or so canvases he did at Rouen last winter. They are the cathedral mostly the façade, filling up well the canvas, and they are simply colossal. Never I believe has architecture been painted so before, the most astonishing impression of the thing, a feeling of size, grandeur, and decay, an avoidance of the banal side of the subject. They are at all times of the day, one fog, and the tower gradually becomes less visible as the eye ascends, a large grey day (façade), several of sunlight—charming—but making you think of Venice or Palermo, the

south. One beauty—early morning—a light rosy sky behind, the front all blue and purple Isn't it curious, a man taking such material and making such magnificent use of it (Fig. 11).[32]

He concludes on a personal note, "Monet was cordiality itself—it's very pleasant to think that I have a place in his affections."[33] Within the week, Robinson was at work in Vernon near the arched bridge crossing the Seine, lamenting of himself that he had lost his "grip" but was not discouraged as "There is a good deal of courage and <u>valeur</u> in the old man."[34]

Diary entries through the month of June reveal Robinson very much immersed in the artistic life of the village. Regular visits with Monet continued, and theories on painting discussed at length. Writing to Weir some three years later, he would recall with amusement, if not a certain affection, a comment made by Alice Hoschedé that indicates the informal nature of his association with the family:

> Calling once upon the Monets, Mme. M. was chiding her husband for the long loafing he was indulging in, and pointed to me in a joking way, as an example, "Mr. Robinson has had time to cross the Atlantic and paint a lot of pictures and be ill!"[35]

At the middle of the month, Robinson traveled to Paris for a few days to see Will Low and his wife who had recently arrived from New York with letters and news of mutual acquaintances. He also visited an exhibition at the Goupil Gallery on the Boulevard Montmartre of works by Berthe Morisot (1841–95) whom he pronounced "a charming talent."[36] Most importantly, June 1892 marked the beginning of a group of three canvases in which he would attempt to record the same view under different atmospheric conditions, these paintings representing the nearest he would come to replicating Monet's series concept (cat. nos. 57, 58, 59). He selected a vantage point in the hills above the town looking towards Vernon on the opposite side of the river, and on June 4 described the panorama and the task he set for himself:

> Commenced a Vue de Vernon most charming in the morning sunlight. I will try two canvases, one, the later, will try by cloud shadows, to have the

Figure 11
Claude Monet, *Rouen Cathedral, Façade*, 1894, Oil on canvas [W.1356], Museum of Fine Arts, Boston, Juliana Cheney Edwards Collection, 39.67

river light against its banks—foreground and parts of meadow beyond in shadow. Cathedral and parts of bridge, etc., in bright sunlight—like the old landscapes in the battle pictures at Versailles![37]

A subsequent entry written a few days later notes the start of the third canvas:

Commenced a "Vue de Vernon" grey day beautiful and still.[38]

As work on the series progressed through the summer, Robinson's efforts to capture the desired effects in each of the three compositions continued unabated. Although the challenge was certainly artistic, it proved to be physical as well. On July 12, he appeared especially disheartened:

Am afraid I am losing time on my vues—they are perhaps too large for me—or I get tired carrying my stuff so far—at any rate, they drag terribly and the weather has been variable and cold and I've perhaps lost my enthusiasm.[39]

A week or so later, however, with atmospheric conditions more favorable, he reported making progress, in particular, on the two canvases that document the effects of full and partial sunlight on the terrain.[40]

Other compositions were begun at different locales throughout the town, the figural works often portraying various Giverny residents engaged in a range of activities. Comments made in his diary reveal that he occasionally worked both from the model and from a photographic study:

Until this p.m., there have been several almost cloudless days—I have tried to profit by them—working on my "Audrey" a.m. from a photo of Marie, using a girl from Vernonnet—a tiresome little beast.[41]

Of particular note in this entry is the reference to a woman named Marie. That Robinson had a deep affection for this elusive figure is readily apparent; she is not only mentioned regularly in his diary and in correspondence, but from the mid-1880s was his most frequent model in Paris and at Giverny. She is recognizable from her distinctive physiognomy and from a certain grace with which he invariably portrayed her, whether playing the piano, sewing as she

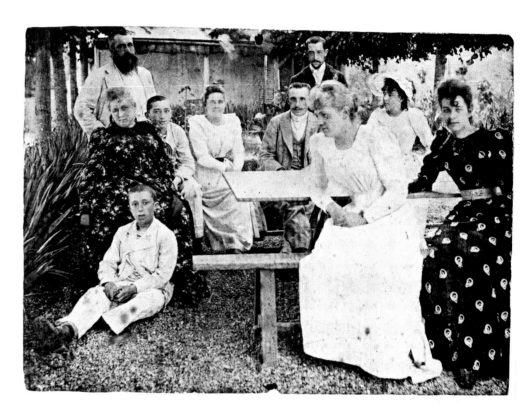

Figure 12 (above left)
Theodore Robinson, Suzanne Hoschedé, 1892

Figure 13 (above right)
Theodore Robinson, The Monet Family, 1892

tends cows, or simply reading a book. The earliest known image of Marie is a delicate watercolor inscribed *Paris, 1885*, in which her head and shoulders are silhouetted against verdant foliage (cat. no. 35). He would correspond with her until his death, but her identity remains unknown.

On July 9, Robinson indicated that he had taken two photographs, one of "Mlle. Suzanne" Hoschedé (Fig. 12) and the other of "Monet and the family," noting that Jean (1867–1914), Monet's eldest son by Camille Doncieux, had just arrived from Alsace (Fig. 13).[42] Jean, seated in the center behind the table, would marry Alice's daughter, Blanche (1865–1947), to his left, in 1897.

Jean had undoubtedly been summoned to Giverny in order to be present at two significant family events. The first was the marriage of his father to Alice Hoschedé. Monet's deep affection for his first wife, Camille, is manifested by the numerous portraits he painted of her prior to her premature death in 1879. It is thought that he displayed *Springtime*, which depicts Camille seated serenely beneath a canopy of lilacs, in his Giverny studio (Fig. 14). While Robinson quite probably knew this work, he chose to comment in his Diary (July 3, 1892)

Figure 14
Claude Monet
Springtime, c. 1872
Oil on canvas, [W.205]
The Walters Art Museum, 37.11

on Monet's compelling image of Camille on her deathbed which hung in the French artist's "chamber," calling it "extraordinary for impression and verity" (see Appendix, Diary of Theodore Robinson, note 10). With the death of her husband the previous year, Alice, now free to marry, was seemingly further motivated by the impending nuptials of her daughter. Suzanne Hoschedé was engaged to an American, Theodore Earl Butler, one of the young artists who arrived in Giverny in the late 1880s. Monet's considerable apprehension about sprinsuch a union had prompted rather extensive investigations into Butler's circumstances and general character. Among those responding to Alice

Hoschedé's inquiries was Robinson, whose letter in Butler's favor she apparently forwarded to Monet working on his cathedral series at Rouen. His concerns, however, were not assuaged:

> That letter from Robinson is really quite delightful and touches the heart but as far as I'm concerned . . . she damn better think it over while waiting for inquiries to be completed, but to marry a painter, if he is not somebody, is downright frustrating, especially for a person of Suzanne's nature.[43]

Attempting to reassure her fiancé upset by the delay in their nuptials, Suzanne tried to clarify the situation:

> M. Monet intends to marry Maman, and in order to make things more regular, they both want it all to be done in time for our wedding, so that M. Monet may assume the responsibility he is eager to have and to replace my father in escorting me to the altar, and also to be more at ease with our family. It's a big secret that I'm entrusting to you, and you must promise to speak of it to no one.[44]

Indeed, Monet's wedding to Alice took place on July 16, 1892, and in the evening, Robinson, together with Ferdinand Deconchy, and friends, Gustave Caillebotte (1848–94) and Paul Helleu (1859–1927) dined quietly with the newlyweds.[45]

A diary entry dated some four days later describes the second much anticipated occasion at which Monet at last fulfilled his familial obligation:

> A great day—the marriage of Butler & Mlle. Suzanne. Everybody nearly at the church—the peasants—many almost unrecognizable—Picard very fine. The wedding party in full dress—ceremony first at the mairie—then at the church. Monet entering first with Suzanne. Then Butler and Mme. H.—considerable feeling on the part of the parents—a breakfast at the atelier—lasting most of the afternoon.[46]

Writing to Thomas Perry a few days later, Robinson disclosed further details, noting that Monet looked "very well" in "swallow-tail."[47]

Eager to commemorate an aspect of this joyous celebration, the artist, some two weeks later, began a composition that shows the wedding party proceeding from the *mairie* (town hall) visible behind the wall on the right towards the church of Sainte Radégonde at the western end of the village (cat. no. 34). The sloping hills above the Seine valley, so often a vantage point for Robinson's Giverny views, are visible in the distance. Although he commented in his letter to Perry and in his diary as well that it rained periodically throughout the afternoon, he recalled the morning as bright with sunshine as the figures strode along the road. It is possible that Butler escorted Suzanne, enveloped in a voluminous white veil, from the civil ceremony at the *mairie* to the church where Monet then took over, accompanying her to the altar.

By mid-August, mindful of the summer drawing to a close, Robinson renewed his efforts to make the time remaining at Giverny productive. Disposed towards somewhat harsh self-criticism, he lamented in a letter to Weir that he was "too much inclined to dawdle, stain . . . and scrape around—getting ready instead of pitching-in-man-fashion."[48] Hoping to rectify another perceived shortcoming, he expressed determination to work more spontaneously from nature, "to do a thing directly and at one sitting—getting as much as possible."[49] Given the range and accomplishment of the works produced during this last extended stay in the village, such criticism seems unjustified. Moments in nature have been carefully observed and set down on canvas, whether recording the bride and groom in brilliant sunlight striding towards the church on their wedding day, or portraying his beloved Marie glancing up from her book in *La Débâcle* (cat. no. 44), or capturing the ephemeral shadows cast by clouds on the Seine valley landscape.

On September 15, Robinson wrote in his diary, "A call from the Master who saw my things." He noted Monet's comments about specific works, in particular his unenthusiastic response to figural compositions, undoubtedly a reflection of the French master's own diminishing interest in the genre which had evolved through the late 1880s. He was, however, pleased at the praise given to his Seine valley view that bathed the panorama in a gray, even light: "he [Monet] said it was the best landscape he had seen of mine." Clearly

encouraged, he added, "En somme, not a bad summer if one has one good thing as he considered my 'Vue.'"[50]

Five days after Monet's visit, Robinson, still searching for appealing motifs, described a prospect he had observed while walking to Vernon on the opposite side of the Seine: ". . . the fields by the river full of <u>mauves</u> most beautiful, with little stubby willows and the town in the background."[51] Diary entries through the first weeks of October affirm that he had returned to the concept of paired paintings; he began two canvases at the locale, one representing the landscape in bright sunlight and the other as it appeared on a "grey" or cloudy day (cat. nos. 51, 52). On October 19, he made a final visit to his "Champs de Mauves," as he had named the spot, and worked to complete the compositions.[52]

During the weeks remaining prior to his departure for America, the artist attempted to finish other paintings begun in the course of the summer and autumn, always waiting for the appropriate atmospheric conditions before returning to specific canvases. The inevitable seasonal changes proved discouraging, however, and he expressed regret at having remained at Giverny so long:

> It is hardly worthwhile, waiting so much for effects, as one has now to do—the country besides is sodden and I will leave with (almost) pleasure. Decidedly, another year I will stay no later than Nov. 1st—or even earlier—it is too damp and I lose time besides endangering my health.[53]

Early on December 1, 1892, Ferdinand Deconchy arrived at the Hôtel Baudy, and he and Robinson went on to the Monet house for breakfast. Critic and novelist Octave Mirbeau (1848–1917) was also present, and is described in Robinson's diary somewhat humorously as a man who "stoops a little and damns most every thing and everybody in a most interesting fashion."[54] Discussions ensued on a wide range of topics, and the visit concluded on a positive note: "A charming send off and cordial good wishes by the family, Deconchy and Monet for my return."[55] Although Robinson and Monet would correspond until Robinson's death in April 1896, the two artists never met again.

Life in New York soon settled into a routine. Robinson continued to send paintings to exhibitions at the Society of American Artists, the American Water Color Society, as well as to the National Academy of Design and the Pennsylvania Academy of the Fine Arts, where he also taught a class during the winter of 1895. A steady flow of friends and collectors, eager to see the results of his years at Giverny, called at his studio at 11 East 14th Street, and his diary tells of their comments and reactions to his recent work. Notable among these was Potter Palmer of Chicago (1826–1902), who came at the suggestion of friend and advisor, Sara Hallowell. The artist noted the event in his diary: "Potter Palmer called, said he came on Miss Hallowell's say—he was agreeably simple in his ways and words . . . he wanted 'to buy pictures he wouldn't lose on' . . . would come with Mrs. Palmer in Feb. or March—put my card in his hat, and bid me good day."[56] There is no indication that this second visit occurred. Other prominent visitors included patrons of contemporary American art William T. Evans (1843–1918) and George A. Hearn (1835–1913). In 1893, Hearn would purchase one of the three panoramic Seine valley landscapes (cat. no. 57),[57] and at the artist's 1898 Estate Sale, Evans acquired a painting from the same series (cat. no. 59).[58]

Now somewhat of a celebrity in the New York art world, Robinson also received respectful calls from younger artists. In a slightly wistful tone, he wrote of one such visitor, "Call from an admirer, a young art student, Busbie. It reminds me of my coming to New York and calling on Homer—only this boy has a confidence and ideas. Far ahead of mine at that time."[59] Jacques Busbee (1870–1947), a native of North Carolina, studied both at the National Academy of Design and the Art Students League. Letters from Robinson to Busbee written early in the spring of 1893 imply that he had engaged the young artist to look after his studio and day-to-day affairs while he made an excursion of several weeks first to Virginia and then Chicago to tour the World's Columbian Exposition prior to its public opening in May.[60] Robinson continued to correspond with Busbee, the younger man clearly eager to grasp and apply the "theories" of Impressionism to his own art. This correspondence, which continued through the end of 1895, provides a unique overview of Robinson's working methods as transformed by his experiences at Giverny in close contact with Monet.[61]

During the summer of 1893, while at Greenwich, Connecticut, where he remained for several weeks painting with his friend Henry Fitch Taylor, the artist cautioned Busbee "not to work on a motif when the effect had changed too much—to work all over the canvas and keep it going all together." He continues, "Don't separate 'values and color.' Consider your canvas a mosaic ground and you are playing with a lot of colored bits—moving them around until finally they are as near right as you can make them." He concludes on an encouraging note that surely speaks to his personal philosophy toward his own art, "And I think you'll arrive at that happy state when you hardly know why or how you 'do it' but are strongly impressed by some beauty in nature and quietly put down a translation, more or less faithful, as your talent will allow."[62]

These thoughts regarding method are remarkably close to Monet's pronouncements made to Lilla Cabot Perry: "Try to forget what objects you have before you, a tree, a house, a field or whatever. Merely think, here is a little square of blue, here an oblong of pink, here a streak of yellow, and paint it just as it looks to you. The exact color and shape, until it gives your own naïve impression of the scene before you."[63]

And when Busbee became disheartened with his continuing efforts, Robinson provided encouragement, counseling the young artist to "draw, draw, draw, every thing and all sorts of things This is a necessary foundation for all art—even the most evanescent or amusing" but also cautioned, mindful perhaps of his own experiences, "make up your mind for a long siege and avoid a woman entanglement, otherwise you are doomed . . ."[64]

Both diary notations and correspondence with friends do little to answer the lingering question as to whether Theodore Robinson intended to return to France following his departure late in 1892. While certain comments suggest that he looked forward to working in Giverny again, others, such as that made in his journal midway through his last summer, reveal a desire to explore fresh territory: "I must not return to Giverny—but try a new field—if only Gamilly [near Vernon]—it will be inspiring—new things—that I have never seen before."[65] Once back in America, the financial crisis of the early 1890s and his increasingly fragile health became compelling reasons for curtailing further travel abroad. There are also clear indications that his frequent excursions from

New York into the countryside to visit friends, paint, and occasionally to teach, were indeed efforts to find a locale at home that could furnish the visual stimulus and convivial ambiance that Giverny had provided.

In a letter to Monet from New York dated early in 1896, the artist describes with considerable enthusiasm various aspects of his birthplace in rural Vermont. Drawn to the area the previous summer, he spent an extended period painting, teaching a class, and in general, becoming familiar with the region. Clearly aware of Monet's epicurean interests, he explains the processes involved in producing a Vermont staple, maple sugar, adding, "All of this is done in the forest—the snow falling and you can imagine for yourself the quite picturesque scenes, the people of the region, the sleighs, the oxen, etc., a blue sky." He concludes, " I really hope to see you one of these days, but when? First, it is necessary that I do something here. So while waiting until that day, I will tell you good-bye, and I ask that you give my best regards to your family."[66]

In the same letter, he reveals his intention to return to Vermont in April, in less than a month's time, when there would still be snow and he could work "tranquilly." These plans and aspirations, however, were never to be realized. In his memoir, Will Low recalled with sorrow, when he learned that Robinson had died:

> Accustomed to his coming unannounced and departing without warning,
> I had thought nothing of his not appearing . . . for a week or ten days
> when on the afternoon of April 2, 1896, a messenger summoned me
> from my work with the news of his sudden death. A friend, who is also
> a physician, had seen him in the morning . . . and half an hour later, he
> had expired as a candle, burning brightly down to its socket, flickers and
> goes out.[67]

Following his death, close friends rallied. Low and Weir made arrangements for the funeral that was held on April 4 at the Society of American Artists on West 57th Street. J. Carroll Beckwith sent word to Monet, and the news spread through the village.[68] Two weeks later, Lucien Baudy, writing to Low's wife from the hotel, expressed his deep regret:

My dear Lady,

I heard your sad news with great sorrow for, frankly, Mr. Robinson was a friend (a man so gentle, so kind), all of the current boarders here (they knew him) are like us, very grieved by this loss.

Mr. Robinson owes us nothing. When he left, he told us, I will leave some things, and when I return, we can agree that I give you something for the trouble of keeping these things. But we have housed them in the attic loft. Yesterday, Mme. Baudy had a look. There is a trunk in which there are a few old dirty things which were undoubtedly for his models, two old overcoats, two old pairs of shoes, two old easels, some photographic plates and about fifty studies (partly canvases, 10–12, and none signed).

I do not believe that these could be of much value, but none the less, it is all at your or his family's disposal.

Baudy[69]

NOTES

1 The painting exhibited was listed as *Une jeune fille* (no. 1819). It is probably the same work as that entitled *Mimi*, which is inscribed *Paris, 1877* (Private Collection). The quotation is found in Pearl H. Campbell, "Theodore Robinson, A Brief Historical Sketch," *Brush and Pencil* (September 1899): 288.

2 Birge Harrison, "With Stevenson at Grèz," *Century Magazine* 93 (December 1916): 307.

3 Kenyon Cox to his parents, Paris, 15 December 1878, in H. Wayne Morgan, ed., *An American Art Student in Paris, The Letters of Kenyon Cox, 1877–1882* (Kent, OH and London: The Kent State University Press, 1986), 141–42.

4 Will H. Low, *A Chronicle of Friendships* (New York: Charles Scribner's Sons, 1908), 283.

5 Abigail Booth Gerdts, Director, Spanierman Gallery/CUNY/Goodrich/Whitney Record of Works by Winslow Homer, identified this work as *Woman Cutting Hay*, watercolor; Collection: Frye Art Museum, Seattle, Washington.

6 Theodore Robinson to Kenyon Cox, 31 May 1883, Kenyon Cox Papers, Avery Library, Columbia University, New York (hereafter cited as Kenyon Cox Papers).

7 Theodore Robinson to Kenyon Cox, 3 July 1886, Kenyon Cox Papers.

8 Robinson was at Barbizon in summer of 1884 shortly after his return to France and continued to visit the village through the spring of 1887.

9 See *On the Seine*, 1886, oil on canvas, Private Collection, and *On the Seine*, c. 1886, watercolor, Private Collection.

10 Pierre Toulgouat, "Skylights in Normandy," *Holiday* 4 (August 1948): 67.

11 In his memoir, Jean Renoir credits Deconchy with suggesting that his father, aged and suffering from severe arthritis, move to Cagnes-sur-Mer on the Mediterranean coast; Auguste Renoir would paint there from 1906 until his death in 1919. See Jean Renoir, *Renoir, My Father*, trans. Randolph and Dorothy Weaver (Boston-Toronto: Little, Brown and Company, 1958), 332–33. Deconchy was also the brother-in-law of Louis Bonnier (1856–1946), the architect chosen by Monet in 1920 to design a pavilion on the grounds of the Hôtel Biron in Paris (now the Musée Rodin) to house his famed water lily panels that were eventually installed in the Orangerie in the Tuileries gardens. See Daniel Wildenstein, *Monet or the Triumph of Impressionism*, I (Cologne: Taschen and Wildenstein Institute, 1996), 413–14.

12 Low, *A Chronicle of Friendships*, 446–47.

13 Toulgouat, "Skylights in Normandy," 68.

14 It is possible that Robinson and Bruce, a landscape, figure, and marine painter, met in Paris or at Barbizon in the mid 1880s. Bruce returned to Hamilton, Ontario late in 1885 but was back in Paris in January 1887.

15 William Blair Bruce to his mother, Janet Bruce, 24 June 1887, in Joan Murray, ed. *Letters Home: 1859–1906, The Letters of William Blair Bruce* (Moonbeam, Ontario, Canada: Penumbra Press Book), 123. The sixth member of the group may have been Arthur Astor Carey (1857–1923), a grandson of John Jacob Astor, who spent much of the 1880s in Europe after graduation from Harvard in 1879. Among his many cultural interests were music, literature, and art.

16 The Hôtel Baudy Guest Register is in the Department of Prints, Drawings, and Photographs, Philadelphia Museum of Art.

17 Claire Joyes, "Giverny's Meeting House, The Hôtel Baudy," in David Sellin, *Americans in Brittany and Normandy, 1860–1910* (Phoenix: Phoenix Art Museum, 1982), 101.

18 Theodore Robinson, "Claude Monet," *Century Magazine* 44 (September 1892): 696, 698.

19 Robinson, "Claude Monet," 698.

20 See Ruth Ann Montgomery, "Evansville's Photographers," Available online http://my web page.netscape.com/ruthannmontgomer/local-photographers.html.

21 For an overview of La Farge's use of photographs, see James L. Yarnall, "John La Farge's *Portrait of the Painter* and the Use of Photography in his Work," *The American Art Journal* 18, no. 1 (1986): 4–20.

22 Mrs. R. J. Antes, "Artist's Biography," *Evansville Review* (Wisconsin), 4 & 11 February 1943.

23 Theodore Robinson to Claude Monet, 6 January 1891, see Appendix, Correspondence.

24 Claude Monet to Theodore Robinson, 26 February 1891, see Appendix, Correspondence.

25 Theodore Robinson to Julian Alden Weir, 3 May 1891, Weir Family Papers, Department of Archives and Manuscripts, Harold B. Lee Library, Brigham Young University, Provo, Utah (hereafter cited as Weir Family Papers).

26 For a discussion of this series by Breck titled *Studies of an Autumn Day*, see William H. Gerdts et al., *Lasting Impressions: American Painters in France, 1865–1915* (Evanston, IL: Terra Foundation for the Arts, 1992), 146–47.

27 Theodore Robinson to Thomas Sergeant Perry, 9 June 1891, Archives, Museum of Fine Arts, Boston.

28 Lilla Cabot Perry, "Reminiscences of Claude Monet from 1889 to 1909," *American Magazine of Art* 18 (March 1927): 119–25.

29 Meredith Martindale et al., *Lilla Cabot Perry, An American Impressionist* (Washington, D.C.: The National Museum of Women in the Arts, 1990), 30.

30 These four volumes of Theodore Robinson's Diary are in the collection of the Frick Art Reference Library, New York. They were a gift from John I. H. Baur in 1956. Baur, who organized a major retrospective exhibition of Theodore Robinson's work in 1946 at the Brooklyn Museum of Art, acquired them from Mrs. C. F. Terhune, a niece of the artist.

31 Robinson Diary, 22 May 1892.

32 Theodore Robinson to Julian Alden Weir, 25 May 1892, Weir Family Papers.

33 Ibid.

34 Robinson Diary, 29 May 1892.

35 Theodore Robinson to Julian Alden Weir, 28 May 1895, Weir Family Papers.

36 Robinson Diary, 18 June 1892.

37 Robinson Diary, 4 June 1892.

38 Robinson Diary, 9 June 1892.

39 Robinson Diary, 12 July 1892.

40 Robinson Diary, 23 July 1892.

41 Robinson Diary, 27 July 1892.

42 Robinson Diary, 9 July 1892.

43 Claude Monet to Alice Hoschedé, 9 April 1892, Daniel Wildenstein, *Claude Monet: Biographie et catalogue raisonné* 3, letter no. 1151, 266 (Lausanne: Bibliothèque des arts, 1979), as quoted in Richard H. Love, *Theodore Earl Butler, Emergence from Monet's Shadow* (Chicago: Haase-Mumm Publishing Company, Inc., 1985), 109.

44 Claire Joyes, *Claude Monet, Life at Giverny* (London: Thames and Hudson, Ltd., 1985), 66.

45 Robinson Diary, 16 July 1892.

46 Robinson Diary, 20 July 1892.

47 Theodore Robinson to Thomas S. Perry, 23 July 1892, Thomas Sergeant Perry Papers, Special Collections, Miller Library, Colby College, Waterville, Maine.

48 Theodore Robinson to Julian Alden Weir, 14 August 1892, Weir Family Papers.

49 Robinson Diary, 10 August 1892.

50 Robinson Diary, 15 September 1892.

51 Robinson Diary, 19 September 1892.

52 Robinson Diary, 19 October 1892.

53 Robinson Diary, 20 November 1892.

54 Robinson Diary, 1 December 1892.

55 Ibid.

56 Robinson Diary, 23 January 1893.

57 Robinson Diary, 25 May 1893.

58 See Robinson Estate Sale, American Art Association, New York, 24 March 1898, no. 39. Numerous annotated catalogues of the sale record Evans's purchase of the painting.

59 Robinson Diary, 11 February 1893.

60 In Virginia, Robinson was the guest of John Armstrong Chanler (1862–1935) and his wife, novelist Amélie Rives. Like Arthur Carey, Chanler was a descendant of John Jacob Astor, traveled extensively, and was living in Paris in the late 1880s where he and Robinson may have met. A somewhat eccentric individual, he was especially interested in providing financial assistance to young American artists abroad and, in 1891 established a Paris Art Fund for this purpose. See Lately Thomas, *A Pride of Lions*, (New York: William Morrow and Company, Inc., 1971), 118–32.

61 Transcripts of fifteen letters from Theodore Robinson to Jacques Busbee, previously owned by Busbee's widow, are in the Archives of the North Carolina Museum of Art, Raleigh. Originals of these documents are unlocated and presumed lost.

62 Theodore Robinson to Jacques Busbee, 6 July 1893, Archives of the North Carolina Museum of Art, Raleigh (hereafter cited as North Carolina Museum of Art).

63 Lilla Cabot Perry, "Reminiscences of Claude Monet from 1889 to 1901," *The American Magazine of Art* 18 (March 1927): 120.

64 Theodore Robinson to Jacques Busbee, 26 May 1895, North Carolina Museum of Art.

65 Robinson Diary, 25 July 1892.

66 Theodore Robinson to Claude Monet, 6 February 1896, see Appendix, Correspondence.

67 Low, *A Chronicle of Friendships*, 476–77.

68 Beckwith Diary, 5 April 1896. J. Carroll Beckwith Papers, 1871–1983, Archives of American Art, Smithsonian Institution, Washington, D.C., Reel 4800 (original documents, Collection: National Academy of Design, New York).

69 John I. H. Baur Papers, unprocessed, Archives of American Art, Smithsonian Institution, Washington, D.C.

Catalogue of
the Exhibition

Although he had painted a small group of landscapes at Barbizon in the mid-1880s, Theodore Robinson did not actually pursue this genre until his arrival at Giverny in the autumn of 1887. For an academically trained artist who had focused mainly on figural imagery, the setting of the small village nestled in the Seine valley must have offered both challenges and opportunities as he sought to record his perceptions of the natural terrain. His earliest representations are expansive views showing the town bathed in a subdued, uniform light. Colors are realistic though muted, seemingly observed through the soft mist that often settled in the valley. Generally taken from the broad river plain or from the hills above the village, these works invariably employ a high horizon.

Many of Robinson's landscapes of the locale include some aspect of the town itself. The compact, rectilinear shapes of the architecture are in contrast to the irregular forms inherent in nature and give a distinct solidity to his compositions. These elements also provide a means to convey a specific condition or effect such as a snow-covered roof in winter or an expanse of wall illuminated by sunlight.

As the artist pursued his explorations of Giverny and its environs, he often returned to specific locations, painting again a particular site albeit from a different vantage point. The juxtaposition of certain buildings or the contour of a hill silhouetted against the sky become familiar through such repetitive imagery and serve to further define the locus.

Through the late 1880s until his final departure from France in December 1892, Robinson became progressively immersed in Impressionist theory, broadening his technical vocabulary as he recorded the transitory effects of light and atmosphere on his subjects. Adopting a palette higher in key and employing a wide range of brushstrokes, he evolved a distinctly personal style in response to his increasingly refined observations of nature.

Previous page: Theodore Robinson, *Saint Martin's Summer, Giverny* (cat. no. 46, detail)
Right: Theodore Robinson, *French Farmhouse* (cat. no. 3, detail)

The Village and Its Surroundings

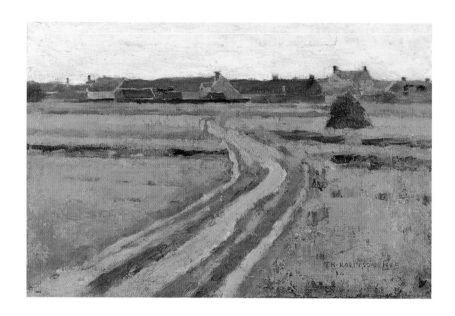

Figure 1
Theodore Robinson, *Macherin*, 1885, Oil on canvas,
Spencer Museum of Art, The University of Kansas:
William Bridges Thayer Memorial, 1928.1782

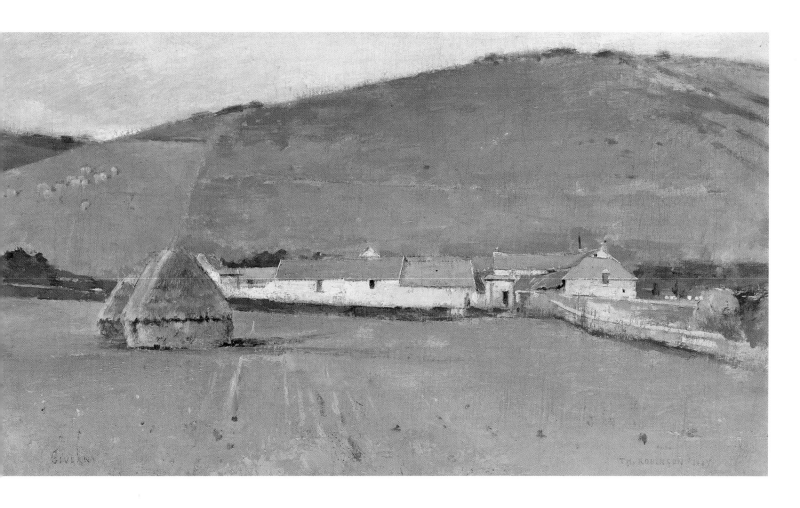

1 GIVERNY
1887
Oil on canvas
14 x 23 ³/₄ in. (35.6 x 60.3 cm)
Inscribed lower right: *TH. ROBINSON 1887*;
lower left: *GIVERNY*
Private Collection

The somewhat grayed tonalities, the stacks of grain in the plowed field, and the faint curl of smoke discharging from the chimney of the house on the right suggest that this is an autumnal scene painted shortly after the artist's arrival for his first extended visit to Giverny from September 18, 1887 to January 4, 1888. The summary treatment of both the expansive plain in the foreground and the cluster of farm buildings recall similar elements in the artist's Barbizon landscapes from the mid-1880s (Fig. 1).

2 **VALLEY OF THE SEINE, GIVERNY**
1887
Oil on canvas
16 ¼ x 13 in. (41.3 x 33 cm)
Inscribed lower left: *Giverny 1887*; lower
right: *Th. Robinson*
Los Angeles County Museum of Art, Gift
of the 2001 Collectors Committee,
M.2001.72

The cultivated fields on the hillside
above the town have been reduced to
diagonal bands of soft color, imparting
a distinct abstract quality to this
landscape. Two figures, one in the
foreground at the base of the hill, and
the other barely visible on the road
above, serve as references in defining
the foreshortened space. Robinson
consistently employed a high horizon in
his compositions, and the sky here has
been confined to a small angular
passage at the upper-left corner of the
canvas. The markedly vertical format is
rare in the artist's production.

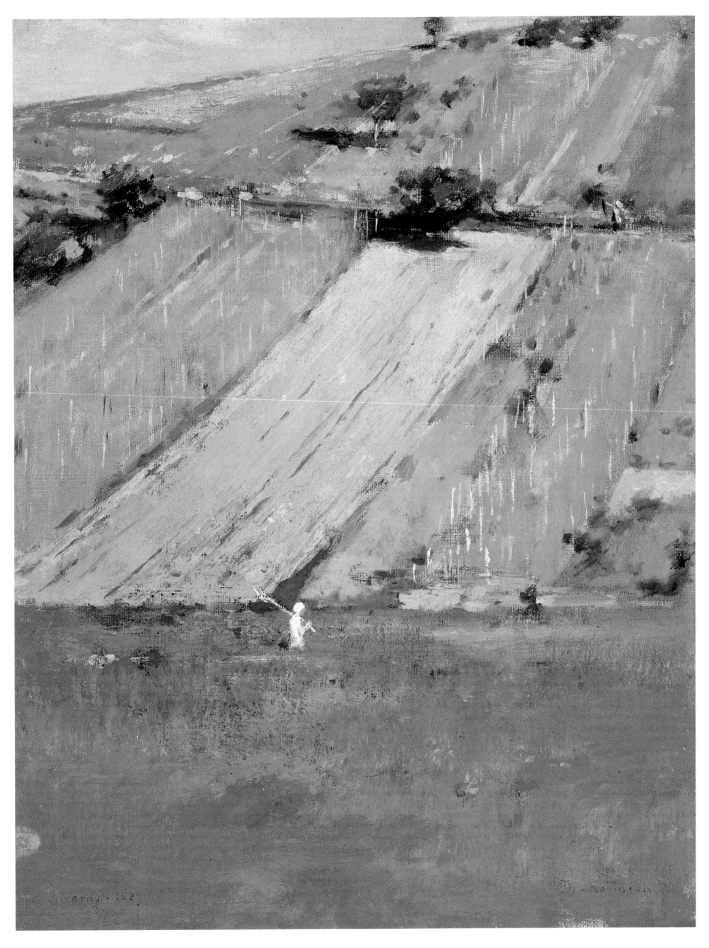

GIVERNY. - Ferme de la Dîme

Phot. A. L., Vernon

Figure 1
A. Lavergne, Vernon, Vintage postcard, *GIVERNY –
Ferme de la Dîme*, before 1905, Courtesy Musée
d'Art Américain, Giverny, Terra Foundation for
the Arts

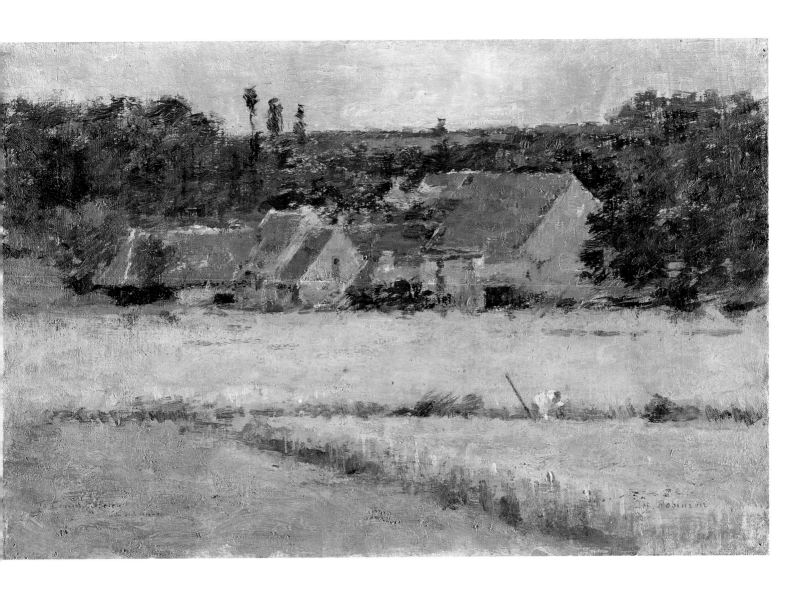

A diffused light prevails in this somewhat less expansive view of a cluster of farm buildings bordering a field of grain. The structures might well represent a complex known as La ferme de la Dîme located towards the western end of the village (Fig. 1). Using a variety of brushstrokes, the artist conveys the range of textures which make up the landscape from the vertical pattern of the grain growing in the foreground to the foliage surrounding the architecture. A lone figure bent over at work in the field recalls those in *Valley of the Seine, Giverny* (cat. no. 2) and similarly provides a point of reference and scale in the composition.

The inscription in the lower-left corner refers to Helen Cheney, a daughter of Robinson's cousin Agnes. The artist spent the summer of 1895 near his birthplace in rural Vermont with the Cheney family.

3 FRENCH FARMHOUSE
c. 1887
Oil on canvas
11 x 16 in. (27.9 x 60.5 cm)
Inscribed lower right: *Th. Robinson*; lower left: *To Cousin Helen/with best wishes*
Private Collection

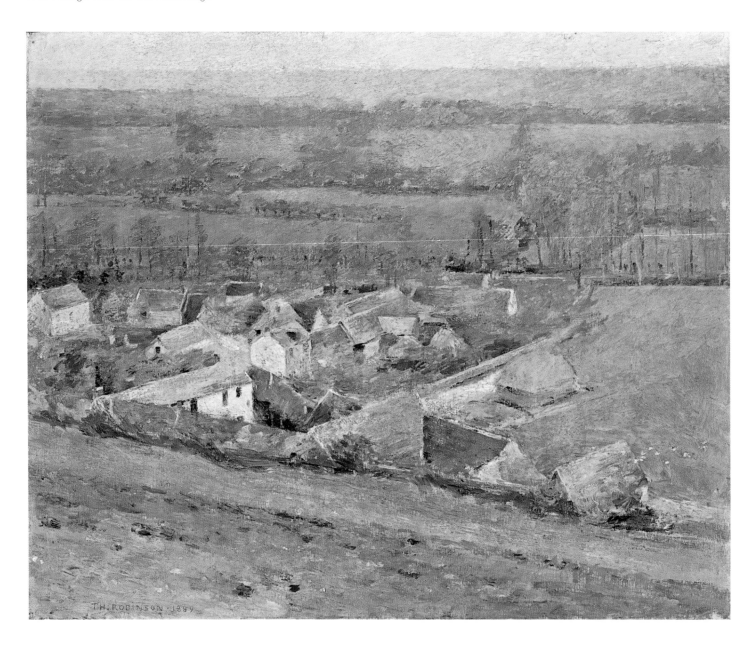

4 A BIRD'S EYE VIEW

1889

Oil on canvas

25 ³/₄ x 32 in. (65.4 x 81.3 cm)

Inscribed lower left: *TH. ROBINSON–1889*

Lent by The Metropolitan Museum of Art,

Gift of George A. Hearn, 1910, 10.64.9

Around 1889, Robinson began to paint panoramic views of Giverny from high in the hills rising above the village. Typically, colors are low in key and become more muted as the landscape extends towards the horizon. Here, beyond the complex of buildings stretches the vast river plain, its crop fields separated by rows of trees. Very seldom does the artist look directly down on a site but rather presents a vista with a distinct diagonal thrust, thus emphasizing the expanse of land. The large U-shaped structure abutting the hill in the foreground may be the Ferme de la Côte, a property belonging to the Ledoyens family of hotel proprietor, Angélina Baudy. The representation here is similar to that in an undated postcard photograph taken from approximately the same location; however, it is not known whether Robinson relied on such an image for this work.

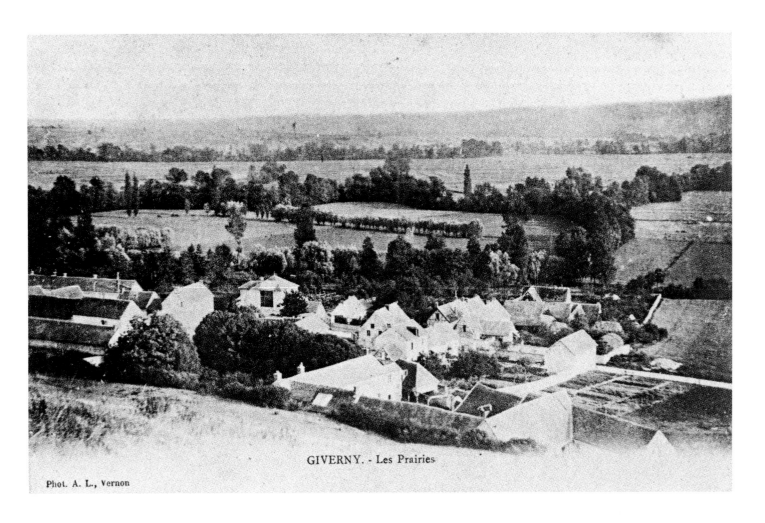

GIVERNY. - Les Prairies

Phot. A. L., Vernon

Figure 1
A. Lavergne, Vernon, Vintage postcard, *GIVERNY — Les Prairies*

5 **GIVERNY**
c. 1889
Oil on canvas
15 ½ x 22 in. (40.6 x 55.9 cm)
The Phillips Collection, Washington, D.C.

Although similar to *A Bird's Eye View*
(cat. no. 4), this composition, painted
from a lower vantage point, is less
panoramic. Enveloped by a uniform,
gray light, the landscape is nonetheless
higher in key. Using a broad range
of tones, the artist has applied his
pigments in expressive strokes that
capture partic-ular characteristics of
the topography.

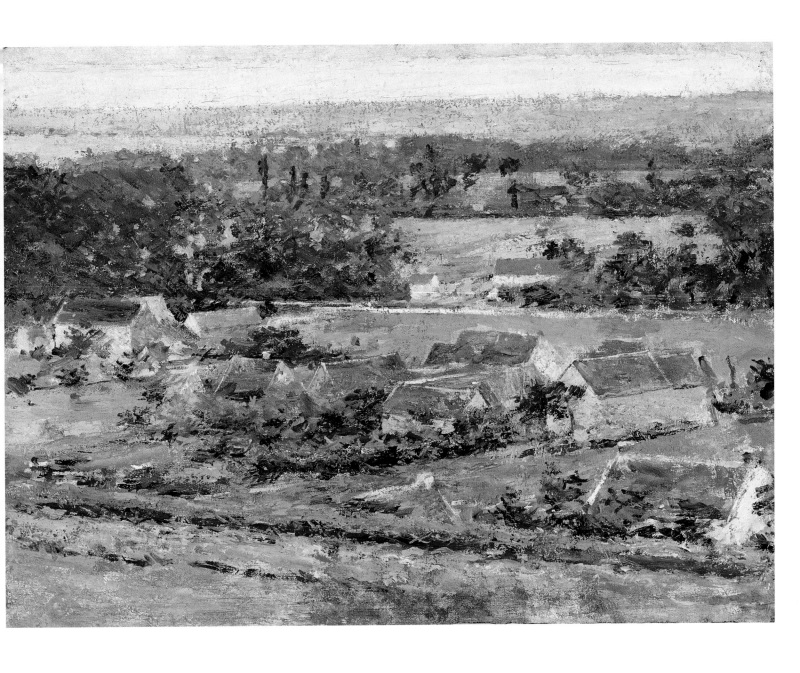

Figure 1
A. Lavergne, Vernon, Vintage postcard, *GIVERNY
(Eure) – Travaux des Champs*, before 1910,
Courtesy of Musée d'Art Américain, Giverny,
Terra Foundation for the Arts

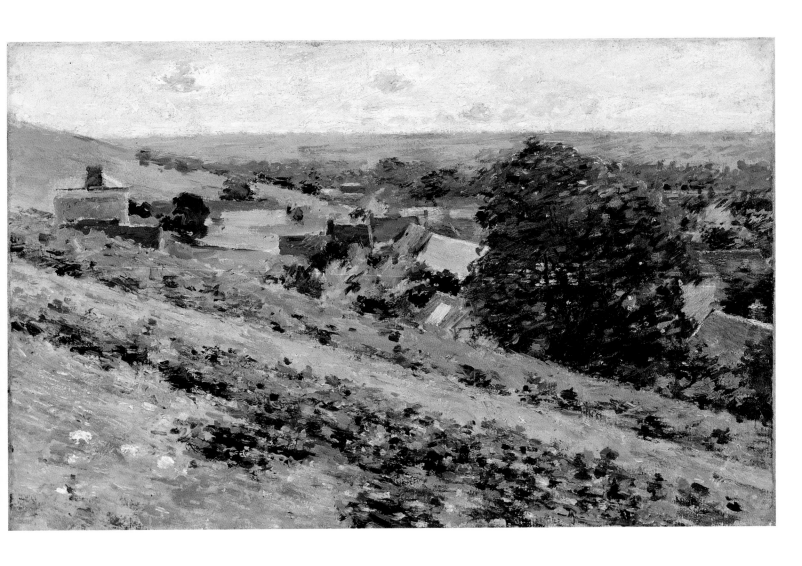

6 FROM THE HILL, GIVERNY
c. 1889
Oil on canvas
15 ⁷⁄₈ x 25 ⁷⁄₈ in. (40.3 x 65.7 cm)
Terra Foundation for the Arts, Daniel
J. Terra Collection, 1987.6

In his ongoing search for differing perspectives from which to depict the village, Robinson ventured into the hills towards its western boundary to paint this view. The building at the far left, with its rose-colored walls, distinctive white trim, and chimney set in the center of the sloping roof is the *mairie* (town hall) which can also be seen in *The Wedding March*, painted in 1892 (cat. no. 34). Towards the middle of the hillside, a roof with a large skylight suggests the presence of an artist's studio. As observed frequently in such prospects, the rich, vigorous application of paint in the foreground is gradually reduced to delicate bands of pale, cool tones towards the horizon.

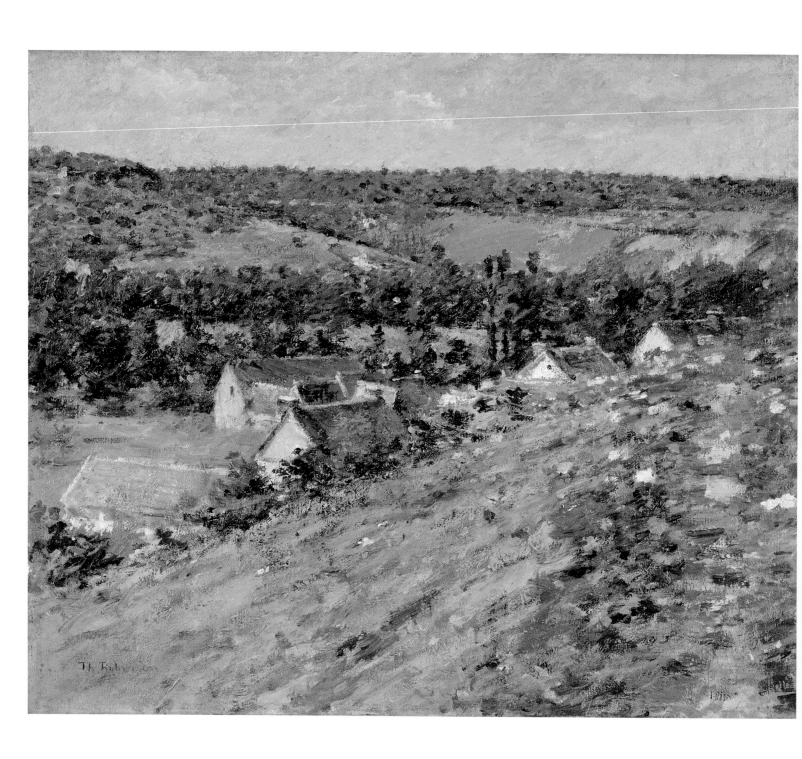

7 GIVERNY
c. 1888
Oil on canvas
18 ⅛ x 21 ⅞ in. (46 x 55.6 cm)
Inscribed lower left: *Th. Robinson*
Philadelphia Museum of Art, Gift of Lucie
Washington Mitcheson in memory of
Robert Stockton Johnson Mitcheson for
the Robert Stockton Johnson Mitcheson
Collection, 1938

On occasion, Robinson ventured beyond the village into neighboring locales
in search of new motifs. Although the general characteristics of the landscape
remained the same, a slightly different vista must have proved refreshing. The
site shown here is the valley of Arconville, located on the opposite side of the
Seine River between Vernon and the small community of Port Villez. The strong
diagonal foreground plain observed in similar compositions gives way to a cluster of
rooftops in the valley with rolling hills beyond. The view is documented in another
painting in which the artist has posed his close friend and model, Marie, reading
on the hillside (cat. no. 39).

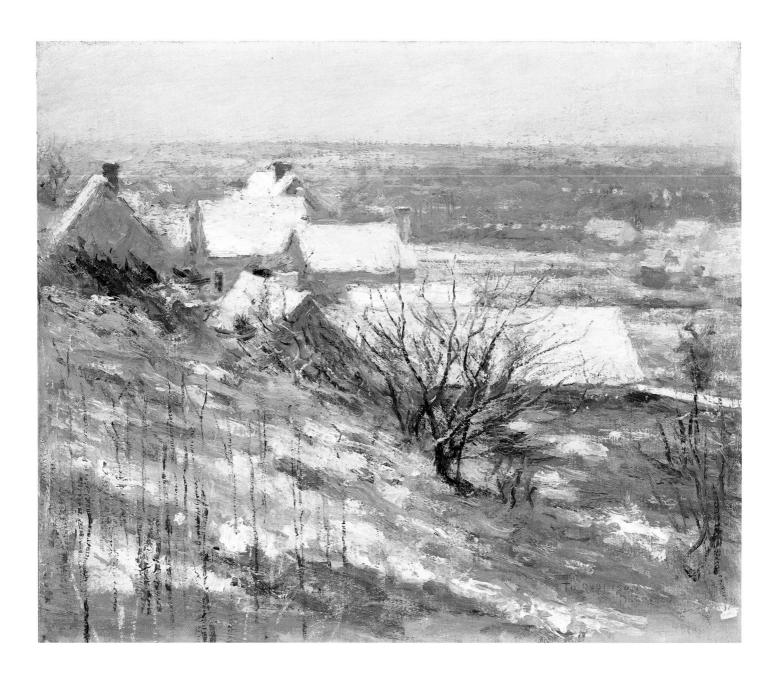

8 WINTER LANDSCAPE
1889
Oil on canvas
18 ¼ x 22 in. (45.7 x 55.9 cm)
Inscribed lower right:
TH. ROBINSON/DEC. 1889
Terra Foundation for the Arts, Daniel
J. Terra Collection, 34.1980

According to the Hôtel Baudy Guest Register, Robinson's stay at Giverny in 1889 extended from May 12 to December 12, and the inscription on this work indicates that it was one of the last canvases he painted during his third extended sojourn in the village. Such winter subjects are rare in his production, and the palette he employed with its cool green and mauve tones reinforces the sense of chill inherent in the season. Equally expressive are the barren trees on the hillside and the delicate vertical strokes in the left foreground that suggest vegetation in a similar dormant state.

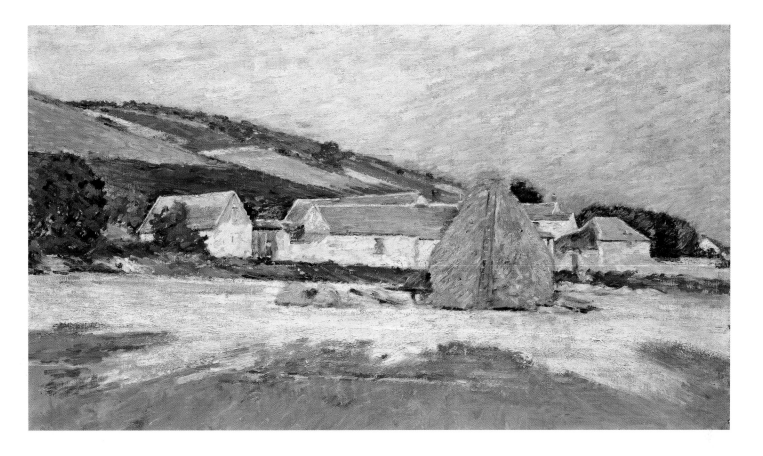

9 A FARM HOUSE IN GIVERNY
c. 1890
Oil on canvas
23 x 40 in. (58.4 x 101.6 cm)
Private Collection
(Baltimore only)

Deepening shadows in the immediate foreground imply that this composition represents a late afternoon view of a complex of farm buildings at the foot of the hillside. The prominent placement of the stack of grain within a broad setting recalls Claude Monet's representations of similar subjects that preceded his monumental series of 1890–91. In its brilliant tonalities and strong expression of sunlight and shade, the painting marks a noticeable departure from earlier views of the village that typically display a much more even, enveloping light and subdued color.

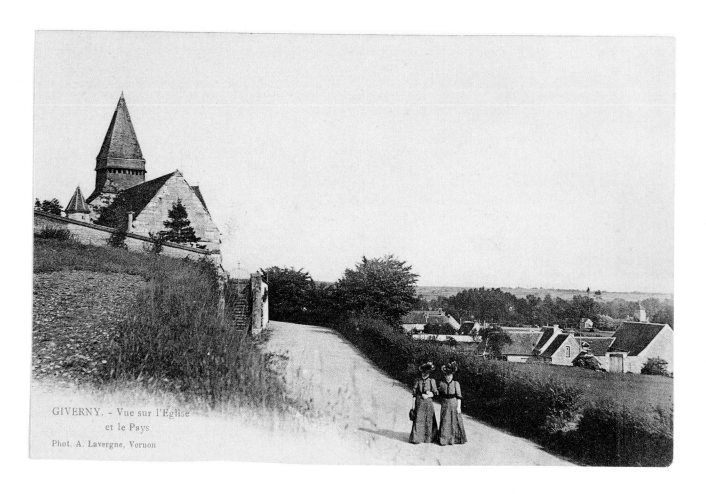

Figure 1
A. Lavergne, Vernon, Vintage postcard,
GIVERNY – Vue sur l'Eglise et le Pays, undated,
Courtesy of Musée d'Art Américain, Giverny, Terra
Foundation for the Arts

10 OLD CHURCH AT GIVERNY
1891
Oil on canvas
18 x 22 ⅛ in. (46 x 56.2 cm)
Inscribed lower right: *Th. Robinson/1891*
Smithsonian American Art Museum, Washington, D.C., Gift of William T. Evans

A portion of the western elevation of the Norman church of Sainte Radégonde with its distinctive conical steeple is visible through luxuriant summer foliage. The slope of the hillside in the foreground falls away, emphasizing the depth of the view. This perspective is further enhanced by the difference in scale between the larger church structure with the top portion of its steeple cut off and the much smaller building to the right. The cemetery adjacent to the church became the burial place of members of the Monet/Hoschedé family, including, in December 1926, Claude Monet.

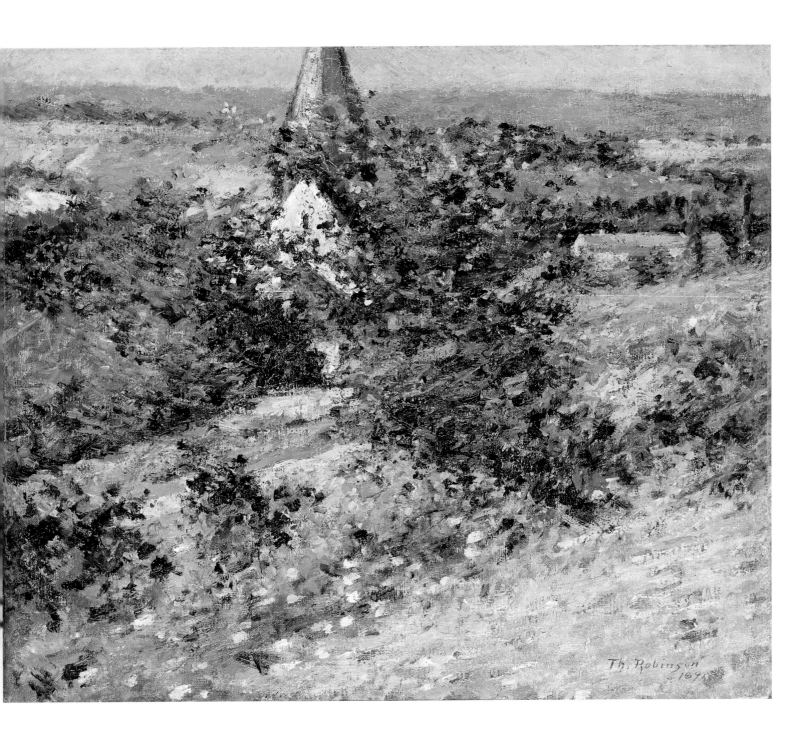

11 **THE BROOK**
c. 1891
Oil on canvas
20 x 21 ½ in. (50.8 x 54.6 cm)
Inscribed lower left: *Th. Robinson*
Mead Art Museum, Amherst College,
Amherst, Massachusetts.
Gift of Charles H. Morgan, AC 1968.24

In the proximity of the Seine at Giverny,
two tributaries, the Epte and the smaller
Ru, provided attractive opportunities to
observe reflections on water. These
meandering streams bordered by
willows, poplar trees, and low shrubbery
afforded an intimacy that was in contrast
to the panorama of the broad river
valley. Robinson occasionally employed
such settings in figural representations;
however, the focus here is the lush
greenery and the quiet stretch of water,
the passing clouds overhead mirrored on
its still surface.

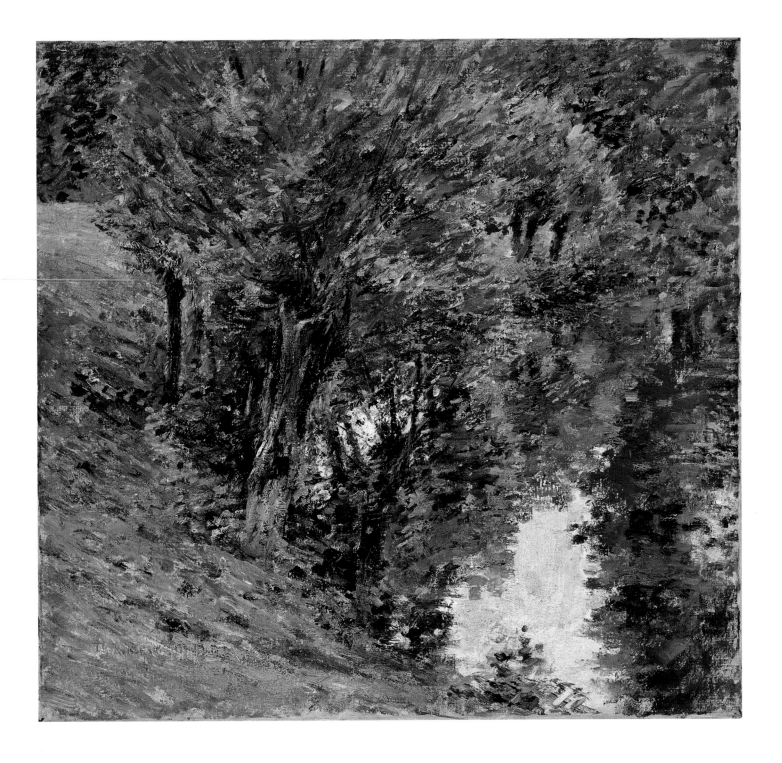

Figure 1
Theodore Robinson, *Group of Ducks*, c. 1891,
Photograph, Private Collection

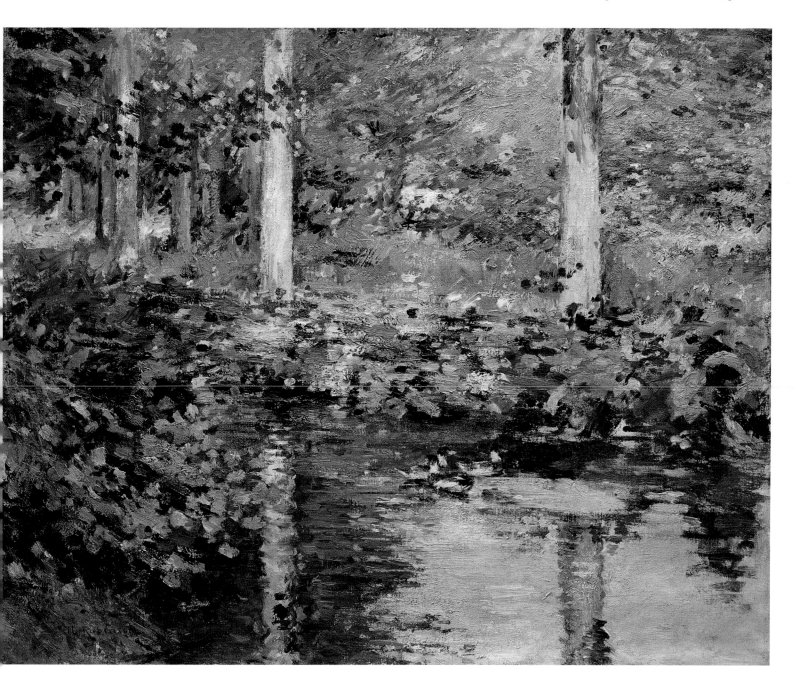

12

THE DUCK POND

c. 1891

Oil on canvas

25 ⅞ x 32 ⅛ in. (65.7 x 81.6 cm)

Inscribed lower left: *T. Robinson*

The Nelson-Atkins Museum of Art, Kansas City, Missouri, Purchase: Nelson Trust, 33-103

(Baltimore only)

Pale blues and greens predominate in this view of a small stream, possibly the Ru. Tall trees line the opposite bank with passages of sunlight illuminating the surrounding grasses and foliage. Near the center of the composition, three ducks glide effortlessly on the reflective surface of the water. Barely visible are traces of a grid pattern used by the artist to transfer the image of the birds from his preliminary photographic study to the canvas (Fig. 1). Robinson incorporated the group of ducks into two other compositions including *By the Brook* (cat. no. 30).

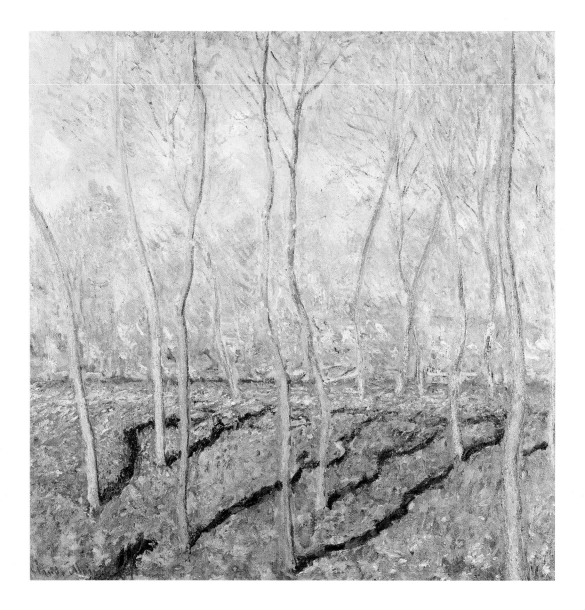

Figure 1
Claude Monet, *View of Bennecourt*, 1887, Oil on canvas, Columbus Museum of Art, Ohio: Gift of Howard D. and Babette L. Sirak, the Donors to the Campaign for Enduring Excellence, and the Derby Fund, 1991. 001.042

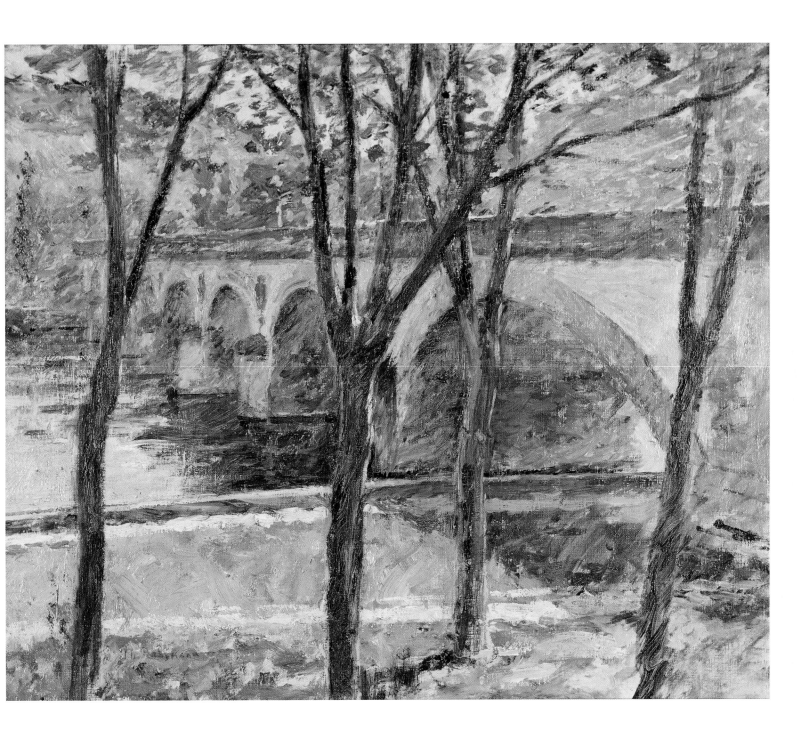

13 BRIDGE NEAR GIVERNY
c. 1892
Oil on canvas
19 x 22 in. (48.3 x 55.9 cm)
Inscribed lower left: *Th. Robinson*
Hackley Picture Fund Purchase,
Muskegon Museum of Art, Mich.

Shortly after his arrival in the village for what would be his final extended sojourn, the artist mentioned in his diary that he was working near the arched bridge across the Seine that connected Giverny with the town of Vernon on the opposite bank. This composition, marked by the strong diagonal thrust of the bridge and in particular the arrangement of tree trunks in the immediate foreground, is unusual for Robinson. It is possible that he may have been aware of Monet's similar placement of trees in a number of compositions from the 1880s, among them his *View of Bennecourt* from 1887 (Fig. 1). *Bridge Near Giverny* is one of a number of canvases left by the artist at the Hôtel Baudy following his departure from Giverny in December 1892, suggesting that he may have intended to return to the village.

14 THE RED HOUSE
c. 1892
Oil on canvas
18 ⁵/₁₆ x 22 ³/₁₆ in. (45.7 x 55.9 cm)
Inscribed lower left: *Th. Robinson*
Yale University Art Gallery, New Haven,
Conn., Gift of Arthur G. Altschul, B.A.,
1943, 1976.124.1
(Baltimore only)

In this loosely brushed canvas, Robinson
returned once more to depict the
distinctive rose-colored *mairie* (town
hall) at Giverny, a structure visible in
two other compositions, *From the Hill,
Giverny* and *The Wedding March* (cat.
nos. 6 and 34). The nearby buildings,
surrounding foliage, and the village
beyond are treated in summary fashion,
the warm-toned ground throughout
unifying these various elements. The
view would appear to be taken from
the western boundaries of the town,
possibly late in the day, the sun
illuminating the façade of the *mairie*
while cool tones toward the horizon
suggest the approach of evening.

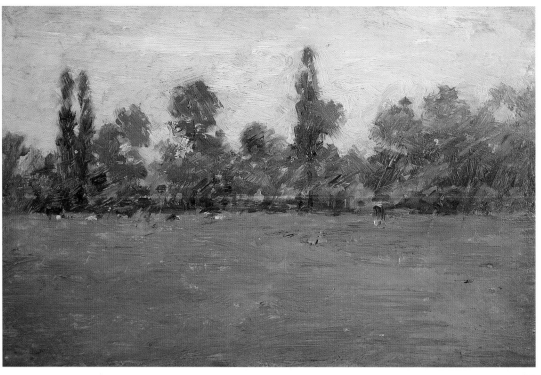

15

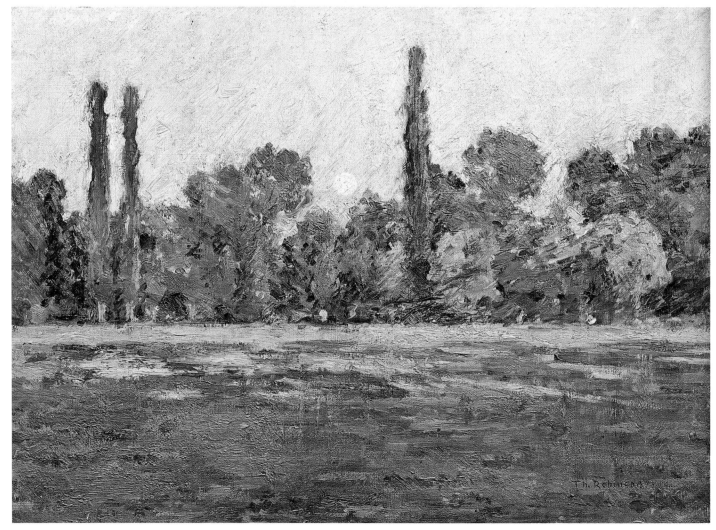

16

15 MOONRISE – STUDY
c. 1892
Oil on panel
7 x 10 ⅝ in. (17.8 x 26.9 cm)
Kennedy Galleries, Inc., New York

16 MOONRISE
1892
Oil on canvas
15 ⅞ x 22 ⅛ in. (40.3 x 56.2 cm)
Inscribed lower right: *Th. Robinson*
The Collection of The Newark Museum,
N.J., Purchase, 1965, Felix Fuld
Bequest Fund

In a diary notation for June 9, 1892, Robinson indicated that he had begun "a charming motif in the meadows—willows and three small poplars." It is possible that the small, vigorously painted panel here is the work to which he refers. In the same entry he continues, "Mem. do this a few days *less* than one month from now, and catch the rising moon—it ought to be pretty." He entitled the larger second version *Moonrise*, and subsequent diary notations record favorable responses to the work from studio visitors, including Monet, who admired the silhouette of the thin poplars against the pale sky (Diary, September 15, 1892). Monet, in fact, had painted a series of views of poppy fields similar in composition in 1890 that were surely known to Robinson.

Nocturnal scenes such as this as well as *House with Scaffolding* (cat. no. 17) and *Moonlight, Giverny* (cat. no. 55) are rare in the artist's oeuvre. That the mood conveyed in this painting would be perceived as melancholy surprised the artist. In an undated letter to a young admirer, artist Jacques Busbee, who apparently expressed such a sentiment upon seeing the work in New York, he explained, "And the 'moon-rise' that you like so much never occurred to me as having any sadness in it. At all events, I never (consciously) have any feeling but great pleasure and lightness in painting out-doors."[1]

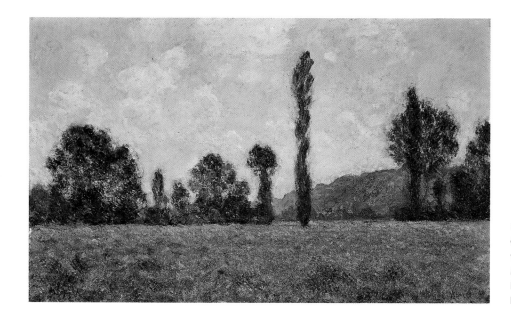

Figure 1
Claude Monet, *Field of Poppies*, 1890, Oil on canvas, Smith College Museum of Art, Northampton, Massachusetts, Gift of the Honorable and Mrs. Irwin Untermeyer in honor of their daughter, Joan L. Untermeyer (class of 1940), 1940

17 **HOUSE WITH SCAFFOLDING**

1892

Oil on canvas

18 $^7/_8$ x 22 $^1/_4$ in. (47.8 x 56.4 cm)

North Carolina Museum of Art, Raleigh,

Gift of Mrs. Jacques Busbee

Robinson chose a relatively close-up view of a house in Giverny covered with scaffolding to explore the distinctive characteristics of moonlight and shadow on the elevation of the building and its surroundings. His interest in this particular challenge was reinforced by Monet's praise for the work still in progress, which he noted in his diary on September 16, 1892. Later in the autumn, the artist wrote at some length about the painting: "House with scaffolding—night. The extremities of shadows running up to the hedge very dark and grading lighter towards the middle of the street. Lights on hedge (boughs, etc.) soft and indistinct, light on road much lower than on house. Sky neutral—light on chimneys very little lighted than sky and contours against sky particularly vague—especially dark ones. Much mystery and only in *middle* of shadow, masses, detail is seen."
(Diary, October 4, 1892).

Jacques Busbee, the young painter from North Carolina whom Robinson befriended following his return from France late in 1892, would purchase this canvas at the artist's 1898 Estate Sale held at the American Art Association in New York.

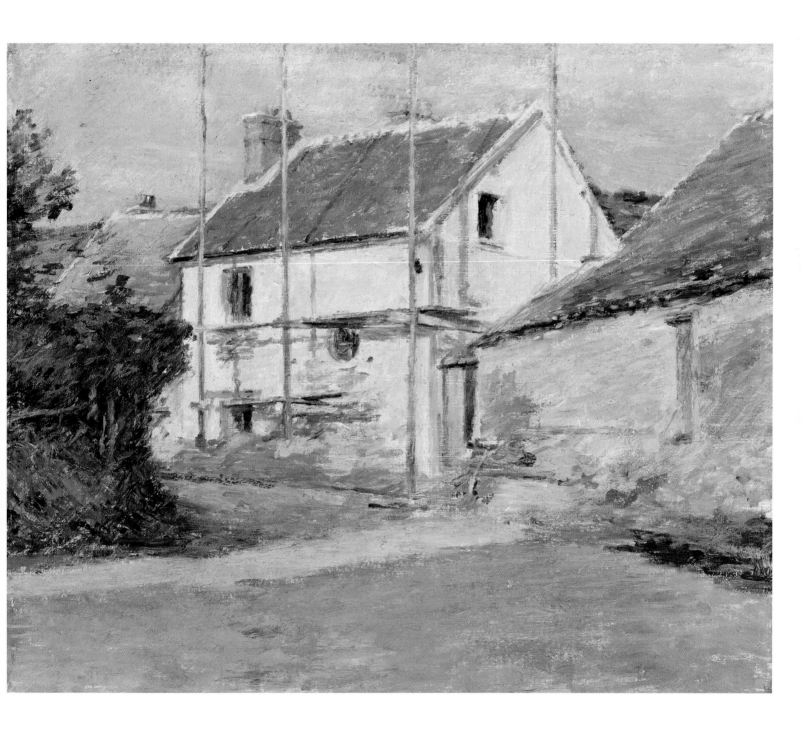

From the onset of his career, much of Robinson's art was firmly grounded in figural representation. Rigorous academic training both in America and in France, as well as early employment with muralists John La Farge and Prentice Treadwell, fostered both an interest in such subject matter and the technical proficiency with which to advance his personal Impressionist style. His own rural beginnings in New England and the mid-west may have ultimately prompted him to reject the decorative and sentimental in his figural compositions in favor of the realism implicit in Impressionism that focused on ordinary aspects of contemporary life.

The agrarian community at Giverny provided such subject matter in abundance. Not compelled to record peasants laboring in the surrounding fields, he chose instead to depict the somewhat rustic life within the village itself, portraying his subjects in familiar settings as they engaged in such mundane tasks as laundering clothes in a local stream, filling watering cans at a well, or simply tending cows in a nearby meadow.

Robinson's figural images painted at Giverny appear to fall into two categories. In the first, certain paintings such as *The Young Violinist*, c. 1889 (cat. no. 21) and most notably *The Wedding March*. 1892 (cat. no. 34), capture the spontaneity of a particular moment: a young girl, absorbed in tuning her violin, walks forward, one foot raised as she prepares to take another step; similarly, members of the wedding party stride purposefully along a roadway, the bride clutching her billowing veil as she keeps pace with her partner.

In contrast, figures in other compositions, whether standing in the midst of a clearing in the woods or pausing on a little bridge crossing a stream, seem somewhat static as if posed over a period of time. This is particularly apparent in certain paintings based on photographs taken by the artist which he employed as preliminary studies, for instance the group of canvases that depict a young woman in the process of filling her watering cans at a round well in the village (cat. nos. 23, 24, 25). However, the use of such prototypes did not always preclude the element of "instantaneity" from a work. In *Gathering Plums*, 1891 (cat. no. 31), a woman thrusts her hands into the leafy branches of a fruit tree. The flurry of movement captured by the artist with his camera is, in turn, transferred to the canvas.

During his years at Giverny, Robinson was clearly drawn to the challenge of interpreting the landscape in an Impressionist manner. His admiration for Monet's ongoing investigations, his own continual search for fresh "motifs" in the countryside, and, most of all, his increasingly vibrant palette and expressive brushwork affirm his commitment to record his perceptions of nature in this innovative style. He arrived in the village, however, as a painter of figures and ultimately would remain so, in his most successful works brilliantly combining the two genres, each enhancing the other.

Theodore Robinson, *Gathering Plums*
(cat. no. 31, detail)

Friends and
Acquaintances
as Models

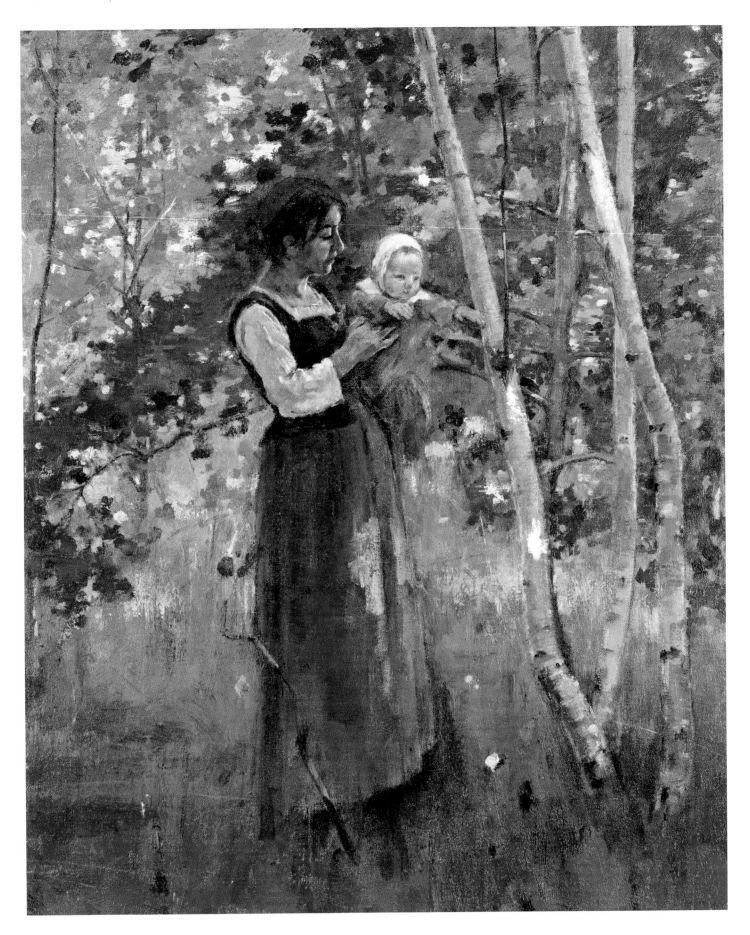

18 **MOTHER AND CHILD**
c. 1887
Oil on canvas
21 ⁷/₈ x 18 in. (55.6 x 45.7 cm)
The Baltimore Museum of Art, The Cone
Collection, formed by Dr. Claribel Cone
and Miss Etta Cone of Baltimore,
Maryland, BMA 1950.357

In a clearing in the woods, a young
woman holds an infant who stretches its
small arms forward as if reaching for
some unknown entity beyond the scope
of the composition. Through the leaves
at the upper left, there is the suggestion
of blue sky. A range of subdued
tonalities describes the mottled effect of
light falling on the foliage. Such
glimpses of ordinary life among the
peasantry in the countryside were
desirable subjects for the artist and are
reminiscent of the work of Barbizon
painter Jean-François Millet, whom
Robinson greatly admired.

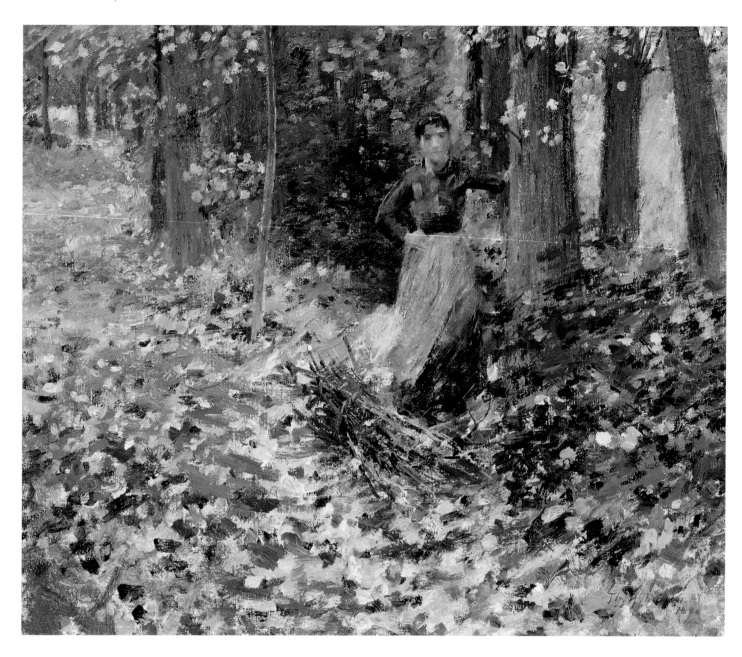

19 AUTUMN SUNLIGHT
1888
Oil on canvas
18 x 22 in. (45.7 x 55.9 cm)
Inscribed lower right: *Th. Robinson/1888*
Florence Griswold Museum, Old Lyme,
Conn.; Gift of the Hartford Steam Boiler
Inspection and Insurance Company

In a diary entry written shortly before he died, Robinson referred to this painting as "Autumn—Josephine by tree-fagots . . ." (February 6, 1896). Josephine Trognon, a Giverny native, served as the model for a number of the artist's compositions. Here, she pauses at the edge of a wood, one hand resting on a nearby tree, her apron blowing in the wind. At her feet are bundles of twigs or fagots that she has gathered for firewood. The natural setting in which the figure stands gives context to her activity and she, in turn, provides both focus and scale in the composition. Broadly painted and employing a full range of animated brush strokes, *Autumn Sunlight* recalls a comment later made by the artist upon seeing a painting by Jean-François Millet: "I am impressed with the necessity of synthesis, an ignoring of petty details, and seeing things *du grand coté*. And this is not incompatible with *modernisté* and the true *plein air* feeling as we understand it. But we will never compete with the old men if we run after detail and paint blades of grass" (Diary, November 21, 1894).

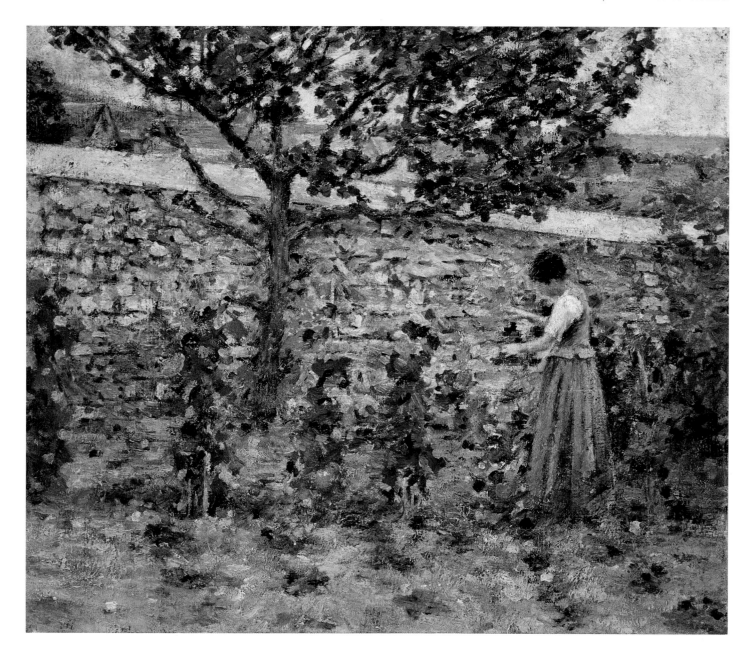

20 IN THE GARDEN

c. 1889

Oil on canvas

18 x 22 in. (45.7 x 55.9 cm)

Collection of the Westmoreland Museum
of American Art, Greensburg, Pa., Gift of
the William A. Coulter Fund, 1958.36

Here, Robinson's model tends her plants within a sloping walled garden. Beyond the
stone enclosure, buildings are visible on the hillside. The setting is similar to that in
The Layette, 1892 (cat. no. 43) and identified by him in a diary notation as Gill's
Garden (October 30, 1892). Artist Mariquita Gill of Boston (1865–1915), together
with her mother, took a house at Giverny late in the summer of 1892. The garden
had been known to Robinson who employed it as the backdrop for a number of
paintings prior to their rental of the property.[2] The subdued, even light and
adherence to local color are typical of the artist's production from the late 1880s.

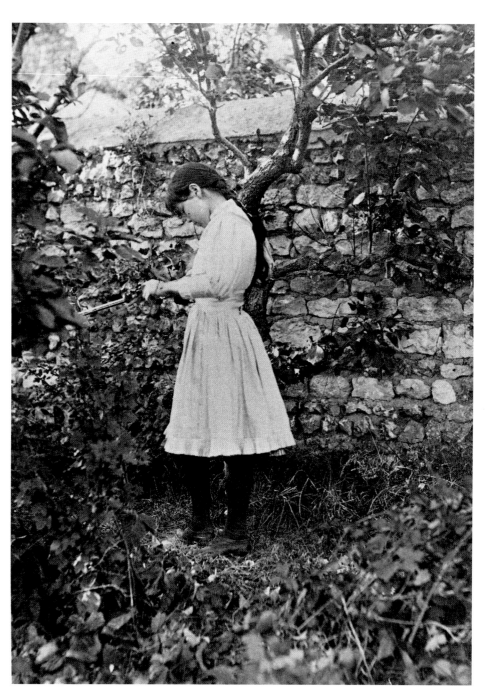

Figure 1
Theodore Robinson, *Margaret Perry and her Violin*, 1889, Photograph,
Private Collection

21 THE YOUNG VIOLINIST (MARGARET PERRY)

c. 1889
Oil on canvas
32 ¹/₁₆ x 26 ¹/₁₆ in. (81.5 x 66.2 cm)
The Baltimore Museum of Art, The Cone
Collection, formed by Dr. Claribel Cone
and Miss Etta Cone of Baltimore,
Maryland, BMA 1950.290

Among the extant photographs taken by
Robinson of Boston artist Lilla Cabot
Perry (1848–1933) and her family
during their initial visit to Giverny in
1889 is an image in profile of her eldest
daughter, Margaret, holding her violin
(Fig. 1). The location is thought to be
the garden of their first residence at
Giverny. It is possible that this painting
may be based on another photographic
study taken at the same time, given the
similarities in the general demeanor and
dress of the young girl. Here, violin in
hand, she walks forward through a
wooded setting. An assortment of
colors, applied with a wide variety of
animated brushstrokes, record the
surrounding foliage and impart a
distinct vibrancy to the composition.
The artist has taken particular care to
note the patterns of sunlight falling
through the leaves onto the pale fabric
of the dress. Such treatment of light is
similar to that observed in Monet's
Springtime (p. 66).

Many years later, Margaret Perry
would recall "Grandpa Robinson," as
he was known by some in Giverny, as a
painter whose art reflected his gentle
disposition.[3]

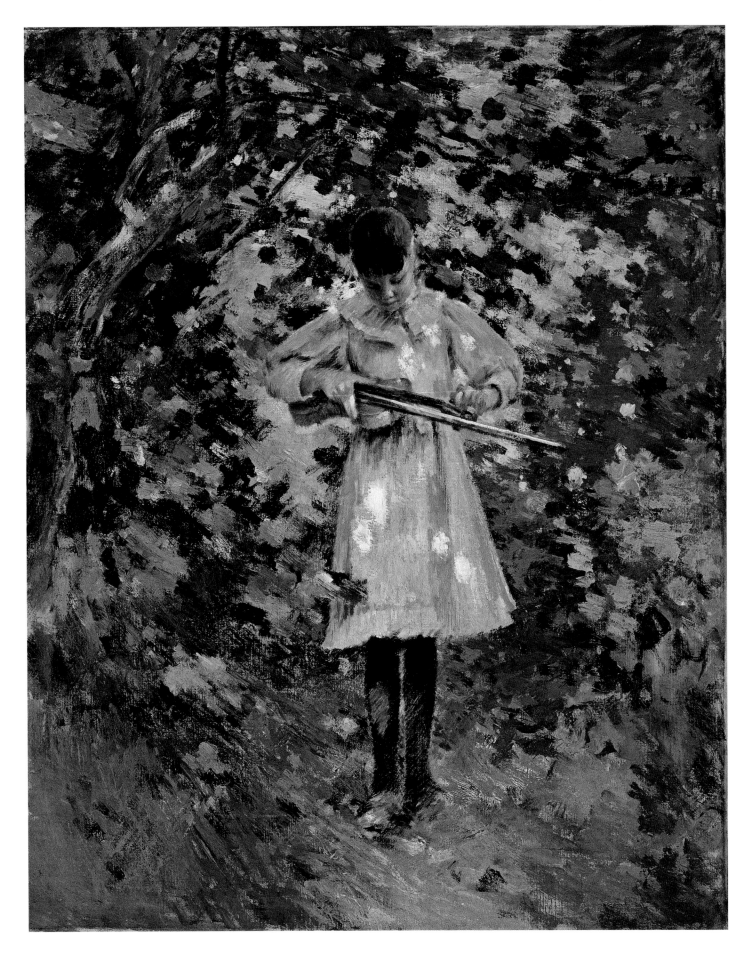

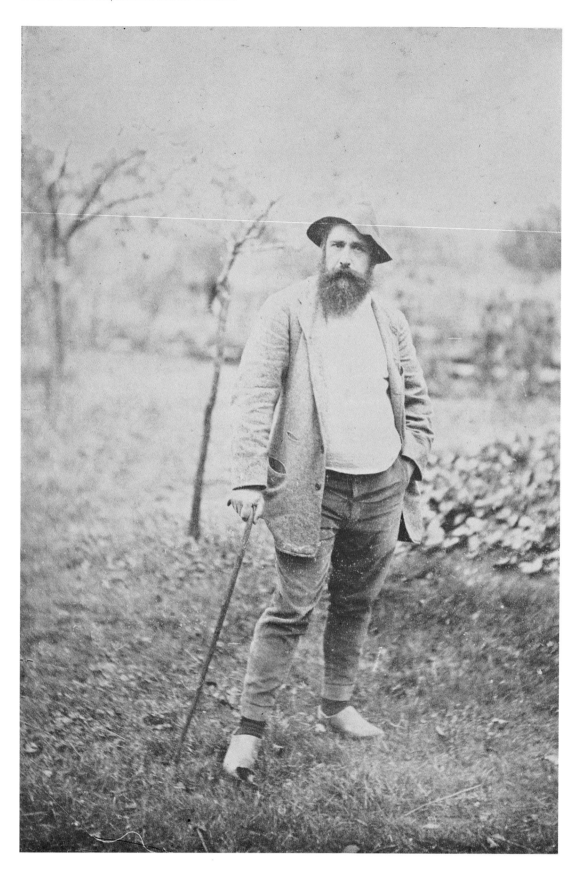

Figure 1
Theodore Robinson, *Portrait of Monet*, c. 1888–90, Cyanotype, Terra Foundation for the
Arts, Gift of Mr. Ira Spanierman, C1985.1.6

22 PORTRAIT OF CLAUDE MONET

1890
Charcoal on paper
21 $^5/_8$ x 12 $^3/_4$ in. (54.9 x 32.4 cm)
Inscribed lower right:
TH. ROBINSON/1890
Ann M. and Thomas W. Barwick

Both this drawing and the photograph
on which it is based portray Monet as a
serious if not fretful man of about fifty
years of age. A somewhat portly
individual, his broad face is partially
concealed by the beard he began to
grow while still in his twenties.
Although in this charcoal drawing
Robinson has eliminated virtually all
reference to the setting, Monet's casual
attire, sabots, and walking stick identify
him as a man in touch with nature.

Robinson included the portrait as an
illustration in his laudatory article on
Monet that appeared in *Century
Magazine* in September 1892 (see
Appendix, Reprint). Upon seeing the
published image, the French artist
deemed it "not bad" (Diary, September
14, 1892).

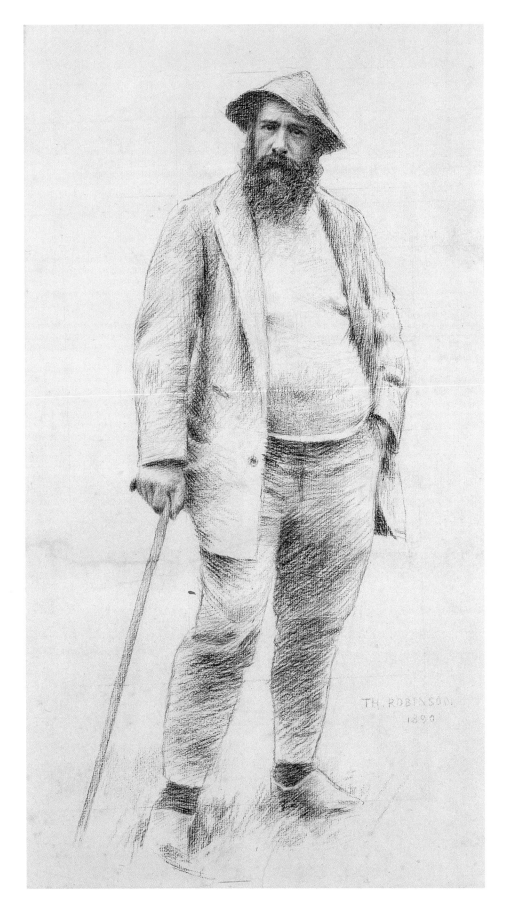

23 AT THE FOUNTAIN

c. 1890

Oil on canvas

32 x 26 in. (81.3 x 66 cm)

Courtesy of the Canajoharie Library and
Art Gallery, N.Y.

According to the Hôtel Baudy Guest Register, Robinson arrived at Giverny on May 19, 1890 for his fourth visit to the village. It was probably shortly thereafter that he took a series of photographs of Josephine Trognon, who modelled frequently for him, as she filled watering cans at a circular well. There was such a cistern located not far from the hotel. In the course of the summer, he began a number of paintings based on these photographic studies. Of the group, the two most fully resolved compositions *At the Fountain*, c. 1890 (cat. no. 23), and *Watering Pots*, 1890 (cat. no. 24) are vigorous manifestations of his mature Impressionist style. Josephine, posed in bright sunlight, engages the viewer with her direct gaze. The artist has afforded particular attention to the element of light, emphasizing strong foreground shadows while delicately shading the figure. In both canvases, such items as the cistern and the watering cans are solidly drawn, their forms in contrast to the to the vibrant, mottled setting. While no specific photographic studies for these two compositions are known, it is probable that their origins lie in such prototypes.

The smaller, more freely painted version of *At the Fountain* (cat. no. 25) is one of three other works that complete the group as it is presently known.

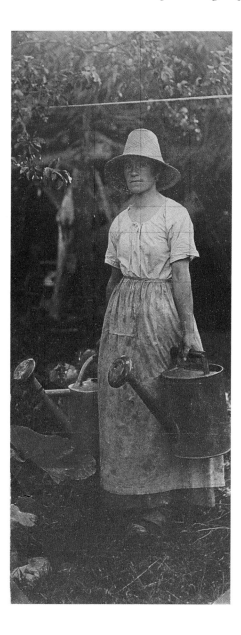

Figure 1

Theodore Robinson, *Watering Pots*, c. 1890, Cyanotype, Terra Foundation for the Arts, Gift of Mr. Ira Spanierman, C1985.1.3

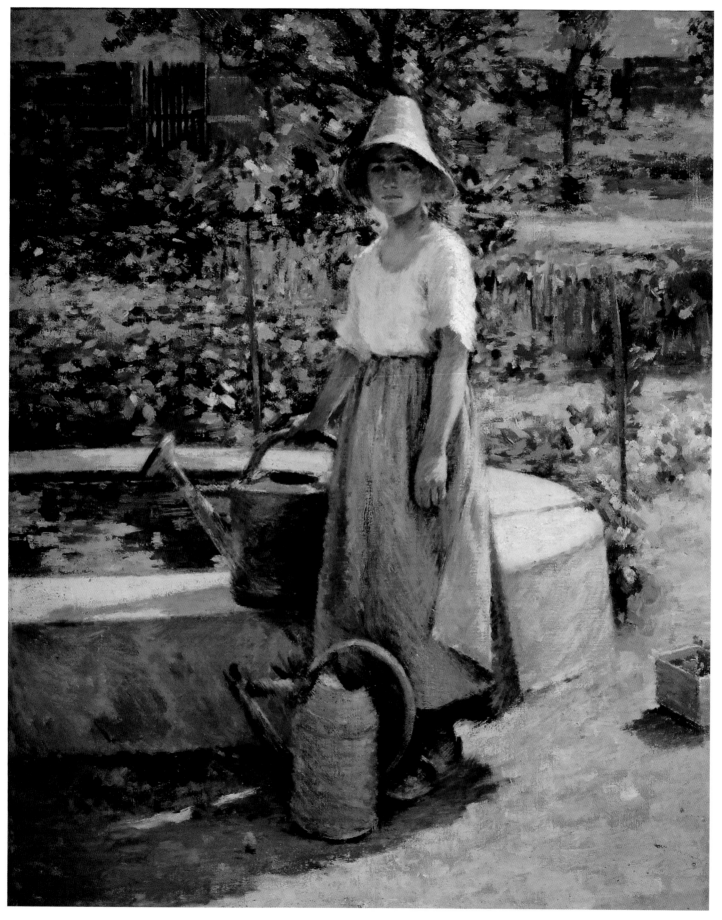

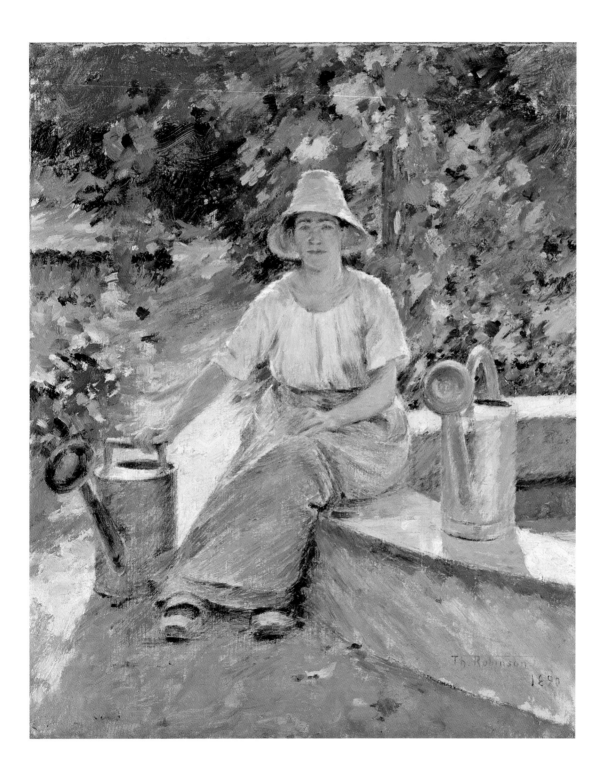

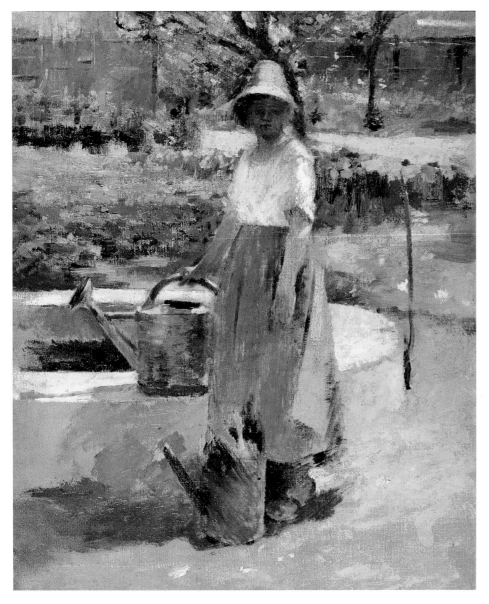

24 WATERING POTS
1890
Oil on canvas
22 x 18 ⅛ in. (55.9 x 46 cm)
Inscribed lower right: *Th.Robinson/1890*
Brooklyn Museum of Art Collection Fund,
New York, 21.47

25 AT THE FOUNTAIN
c. 1890
Oil on canvas
18 x 15 in. (45.7 x 38.1 cm)
Inscribed lower left: *Th. Robinson*
Bernard & S. Dean Levy, Inc., New York

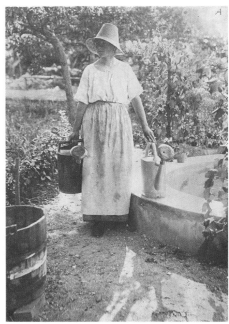

Figure 2
Theodore Robinson, *At the Fountain*, c. 1890,
Cyanotype, Terra Foundation for the Arts,
Gift of Ira Spanierman, C1985.1.5

26 GOSSIPS

1891

Oil on canvas

18 ¹⁄₄ x 23 in. (46.4 x 58.4 cm)

Inscribed lower left: *TH. ROBINSON/1891*

Private Collection, Courtesy of Pyms Gallery, London

The site depicted here is the small bridge located in the village not far from Monet's house and gardens. It served as the setting for three additional compositions by Robinson, *The Watering Place* (cat. no. 27), *Pére Trognon and his Daughter at the Bridge* (see cat. no. 27, Fig. 1), and *La Débâcle* (cat. no. 44). Although the painting closely follows the artist's photographic study, slight variations are apparent between the two images. Most notably, the little girl seated near the bridge in the photograph has been eliminated in the painting, and a somewhat younger child sits against the tree on the opposite bank observing the women as they wash their laundry and gossip. Also altered in the painted version is the position of the door in the stone wall which is partially open, permitting a glimpse into an inner yard. Neither the photograph nor the painting display any evidence of the grid used by the artist when transferring a composition from a preliminary study onto canvas.

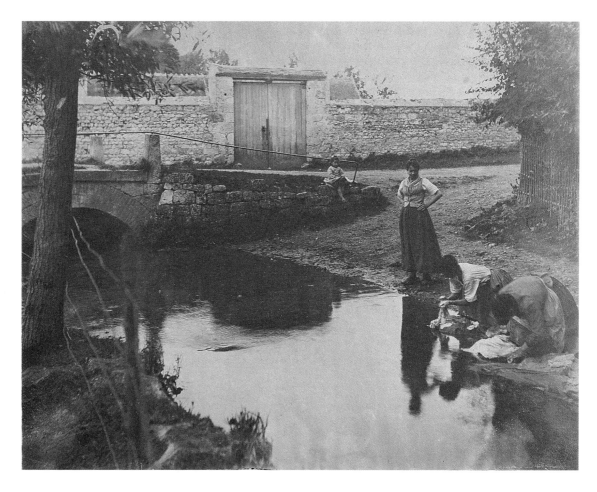

Figure 1

Theodore Robinson, *Women by the Water*, c. 1891, Cyanotype, Terra Foundation for the Arts, Gift of Mr. Ira Spanierman, C1985.1.8

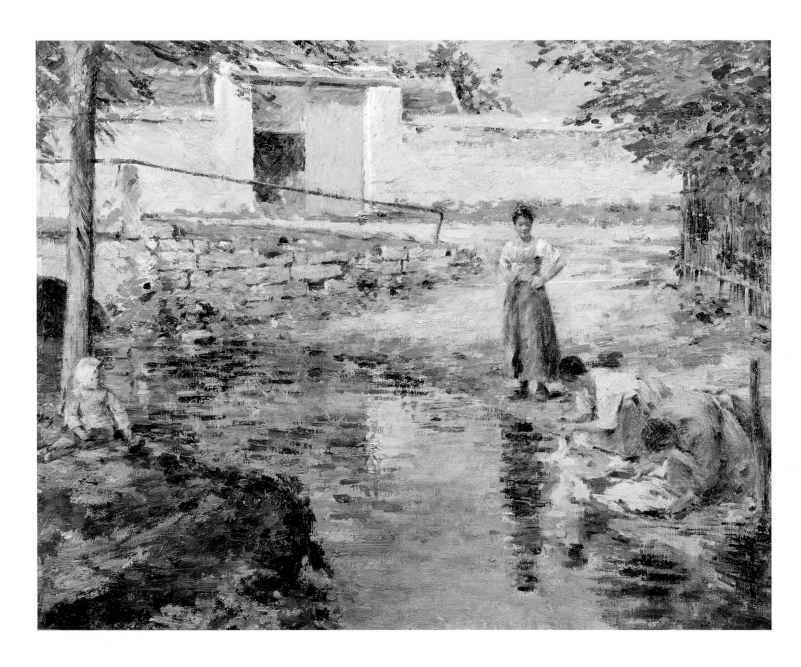

27 THE WATERING PLACE

1891

Oil on canvas

21 ⁷⁄₈ x 18 in. (55.6 x 45.7 cm)

Inscribed lower right: *Th. Robinson/1891*

The Baltimore Museum of Art, The Cone Collection, formed by Dr. Claribel Cone and Miss Etta Cone of Baltimore, Maryland, BMA 1950.358

In diary entries for May 23 and July 6, 1893, Robinson identified the man seated on the horse as Père Trognon, presumably the father of Josephine, his frequent model at Giverny. A more expansive version of the composition includes the figure of Josephine standing on the bridge watching her father as he waters his horse (Fig. 1). Here, the artist has employed great delicacy in rendering his color harmonies. Muted pink tones predominate and are carried throughout both the background and the glass-like surface of the water where they blend with the blue reflection of the sky into soft mauves.

In a review of the exhibition of Robinson's work held at the Macbeth Gallery in New York in 1895, the painting was singled out by a critic: "'The Watering Place' is perhaps the best example of pure and vigorous color. A white horse, ridden by an old man, is descending a short bank into a stream below a stone bridge. Long reflections are cast forward in the water and the landscape behind is in broad sunlight."[4] Faint traces of a transfer grid are visible, suggesting that this carefully organized composition was based on a preliminary study.

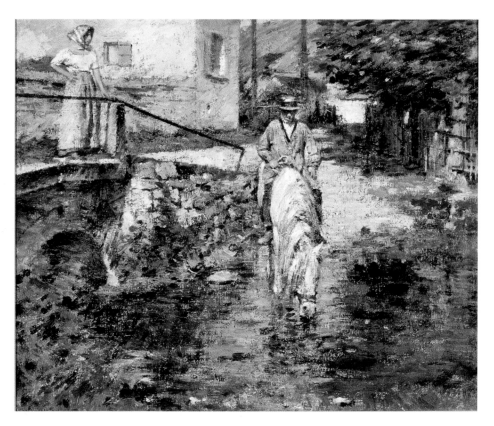

Figure 1

Theodore Robinson, *Père Trognon and His Daughter at the Bridge*, 1891, Oil on canvas, Terra Foundation for the Arts, Daniel J. Terra Collection, 1988.29

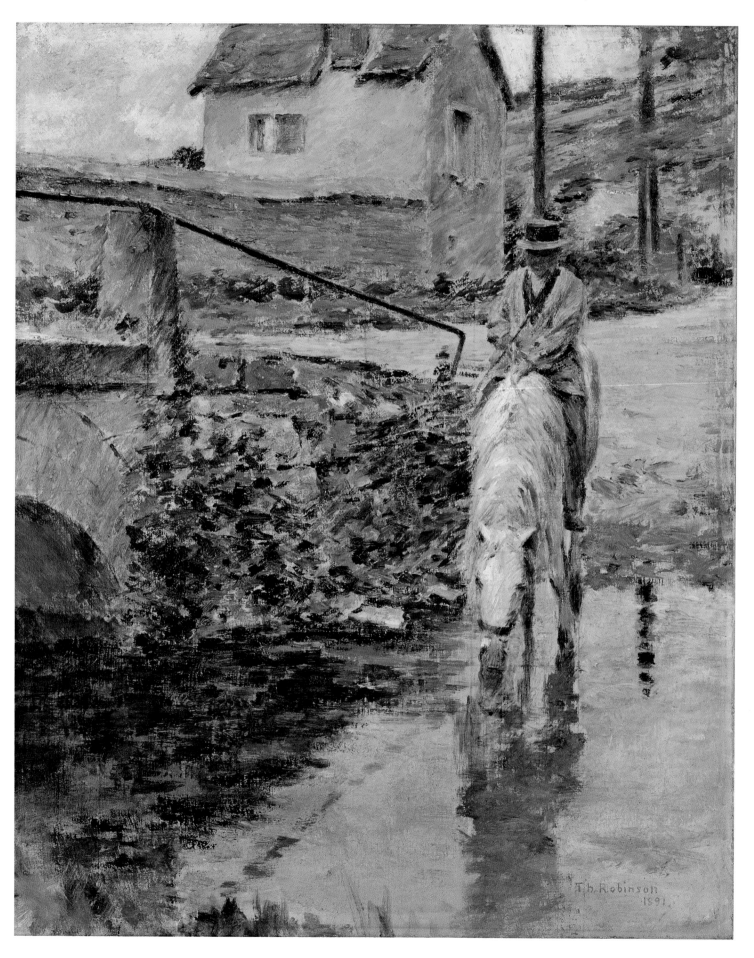

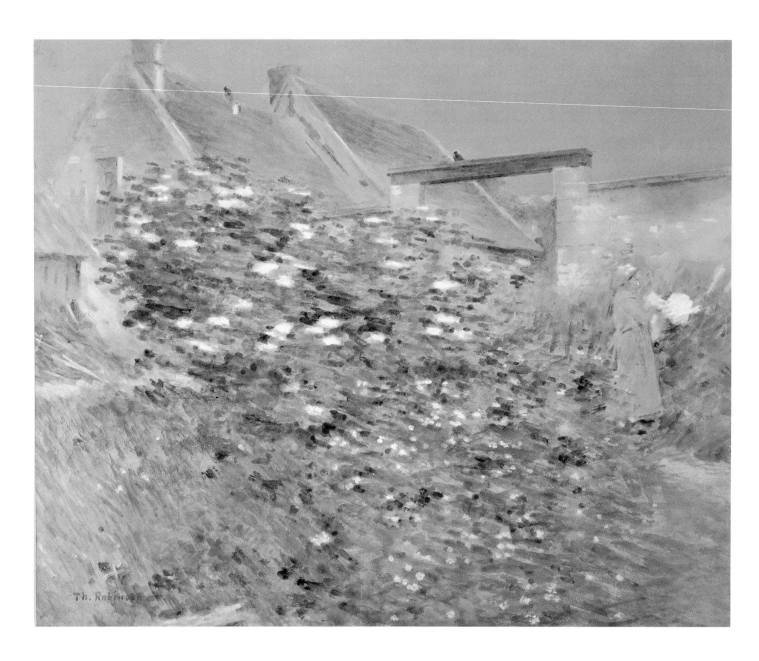

**28 NORMANDY FARM, A
CHARACTERISTIC BIT, GIVERNY**
c. 1891
Watercolor on paper
14 x 16 ½ in. (35.6 x 41.9 cm)
Courtesy of the Canajoharie Library and
Art Gallery, N.Y.

A lush, flowering shrub in the immediate foreground dominates this view of an enclosed garden at Giverny which is based on a photograph by the artist. Minor differences are apparent between the prototype and the watercolor, most notably the high gate that appears closed in the photograph is open here providing a glimpse of the village beyond the wall. Furthermore, Robinson has cropped the photographic image particularly on the left and bottom margins focusing on the foliage and architecture. A larger oil version (Private Collection) repeats the composition. Both works were acquired by New York collector, Samuel T. Shaw (1861–1945), at Robinson's Estate Sale held in New York in 1898.

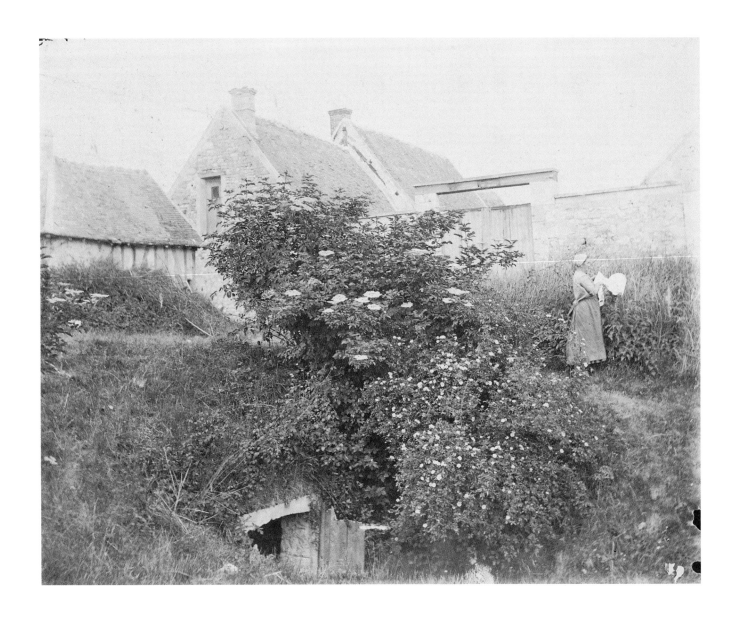

Figure 1
Theodore Robinson, *House and Garden with Figure*, undated, Albumen print, Terra Foundation for the Arts, Gift of Mr. Ira Spanierman, C1985.1.15

Figure 1
Theodore Robinson, *Two in a Boat*,
c. 1891, Albumen print, Terra
Foundation for the Arts, Gift of Mr.
Ira Spanierman, C1985.1.1

Figure 2
Claude Monet, *Jeunes filles en barque*, Oil on
canvas, 1887, P.1959-148, Matsukata Collection,
The National Museum of Western Art, Tokyo

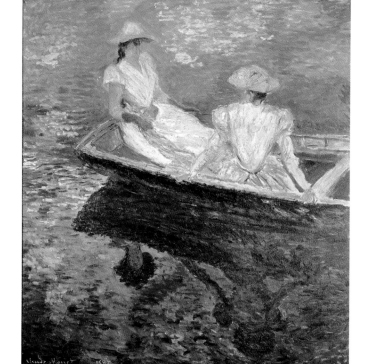

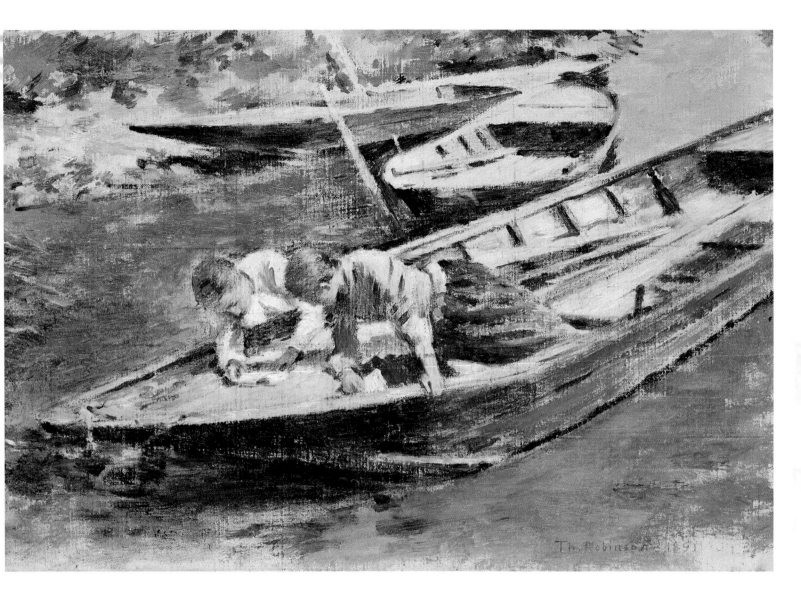

29 TWO IN A BOAT

1891

Oil on canvas

9 ³/₄ x 14 in. (24.8 x 35.6 cm)

Inscribed lower right: *Th. Robinson—1891*

The Phillips Collection, Washington, D.C.

With the exception of the elimination of an empty boat on the left visible in his photograph, Robinson has made a faithful transcription of the image to canvas through the use of a grid which is clearly visible in both the photographic study and in the painting (Fig. 1). Pigments are thinly applied, revealing a warm, pink-toned ground observed in a number of the artist's representations that serves to unify the composition. The location is probably the Epte River, and the theme of young women in a flat-bottomed skiff may have been suggested by a group of works showing similar subjects painted by Monet in 1887. As in these compositions, the view here is taken from above. Robinson is known to have owned a preparatory drawing for Monet's *La barque bleu*, 1887 (W.1153; location unknown), which depicts two of the French artist's stepdaughters, Marthe and Blanche Hoschedé, seated in a small boat on the river (Fig. 2). The general demeanor of the models here suggests that they may have been among the Americans who flocked to the summer art colony at Giverny in the1890s.

A slightly larger watercolor version of this work displays a similar grid pattern and is inscribed with the date 1892 (*Two in a Boat*, 1892, Watercolor, Private Collection).

30 **BY THE BROOK**
c. 1891
Oil on canvas
18 ¹/₄ x 23 ³/₈ in. (46.4 x 58.4 cm)
Inscribed lower right: *Th. Robinson*
Courtesy of the Montclair Art Museum,
Montclair, New Jersey. Gift of William
T. Evans, 1915.39

In a diary entry for January 23, 1893, the artist speaks of the realism he had hoped to achieve in this composition that portrays Giverny villager Josephine Trognon having just crossed a small footbridge: "Looking at my things I see the necessity absolute of conviction. Some things . . . like the 'little bridge' (with Josephine, fork on shoulder) by their conviction and the persistence with which I see I tried to get a reality, are interesting and will wear better than more brilliant ones done too easily and too cleverly."

Somewhat more loosely painted than many of his Giverny pictures, this work is also higher in key. Passages of bright yellow near the figure and in the background beyond the trees suggest sunlight illuminating the landscape. In the freedom with which he has described the view, and in carefully balancing color and brushstroke throughout the broadly painted surface of the canvas, Robinson achieves the "synthesis" he admired in Jean-François Millet's art as expressed in his diary entry for November 21, 1894 (see cat. no. 19). The arrangement of ducks at the right, based on a photograph by the artist, appears in two other paintings—a second version of this composition—dated 1891, titled *The Little Bridge* (Private Collection) and *The Duck Pond*, c. 1891 (cat. no. 12).

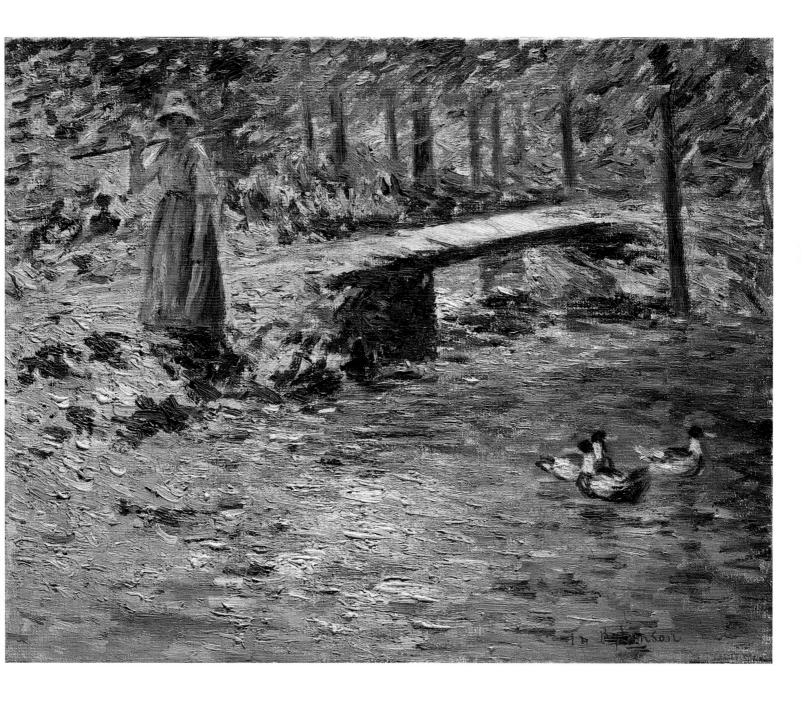

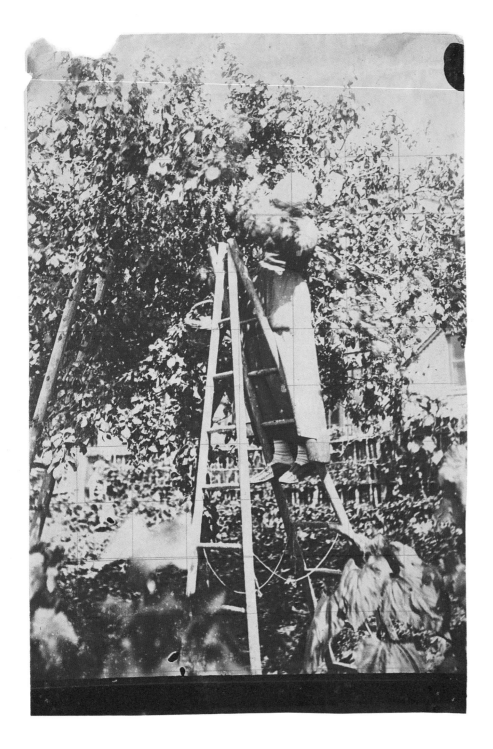

Figure 1
Theodore Robinson, *Woman Picking Fruit*, c. 1891, Cyanotype, Terra Foundation for the Arts, Gift of Mr. Ira Spanierman, C1985.1.20

31 GATHERING PLUMS
1891
Oil on canvas
22 ½ x 18 in. (57.2 x 45.7 cm)
Inscribed lower right: *Th. Robinson/1891*
Georgia Museum of Art, University of Georgia. Eva Underhill Holbrook Memorial Collection of American Art, Gift of Alfred H. Holbrook, GMOA 1945.76

Although Robinson relied on a preliminary photographic study for this painting, he made certain changes in the composition, most notably the addition of the female figure in the background between the two ladders and the position of the head of the woman on the ladder whose profile is now revealed. He also cropped the top of the photograph, reducing the expanse of sky but suggesting it in passages of blue visible through the leaves of the trees.

While the artist often made such modifications when using a photographic study, he remains curiously faithful to certain imperfections in the prototype; here, he transfers the blur caused by the movement of the woman's hands as she harvests the fruit and, to a somewhat lesser degree, replicates the distortion apparent in the foliage in the immediate foreground. *Gathering Plums* is among Robinson's most vibrant Impressionist works, employing a broad palette that captures the effects of sunlight and shadow on a variety of surfaces while remaining essentially faithful to actual colors in nature.

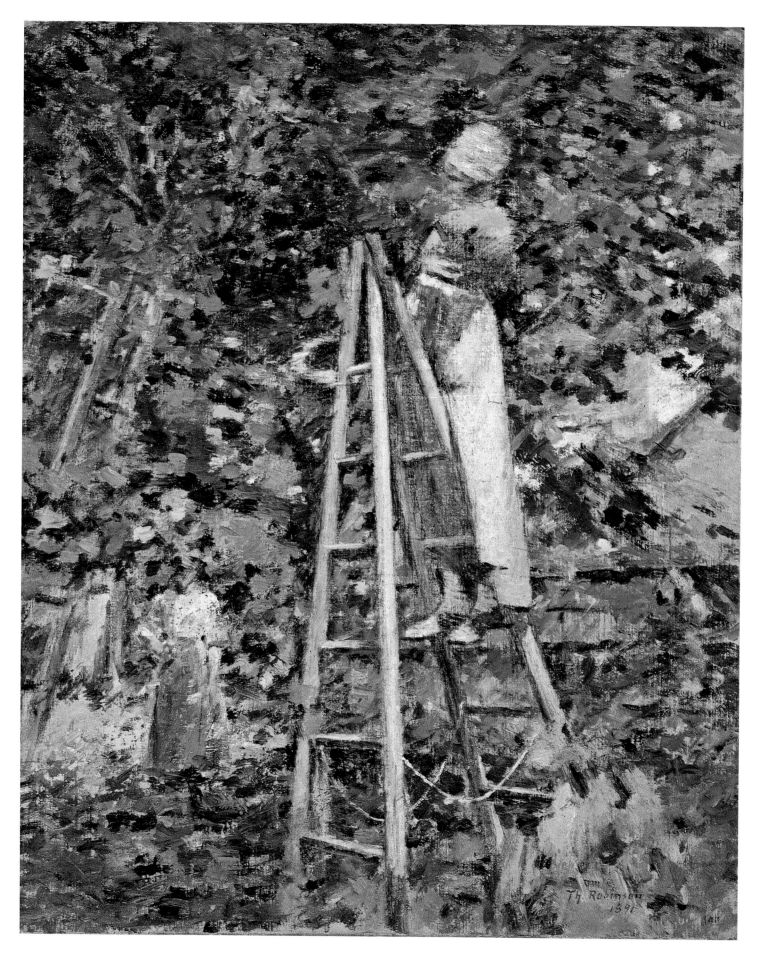

Figure 1
Theodore Robinson, "A Normandy Pastoral," *Scribner's Magazine*, June 1897.

32 WOMAN SEWING, GIVERNY
c. 1891
Oil on canvas
26 ⅝ x 32 in. (66 x 81.3 cm)
Inscribed lower left: *Th. Robinson*
The Roland P. Murdock Collection,
Wichita Art Museum, Wichita, Kans.,
M57.45

Throughout his Giverny period, Robinson was drawn to the subject of a young peasant woman sewing out-of-doors. In this work, more expansive than others employing the theme, he has placed his model in a sunlit meadow near a thicket of willow trees. Deep shadows suggest the time of day is late afternoon, the blue cast to the foliage in the background further alluding to the approach of evening. The canvas repeats a smaller version of the composition which is signed and dated 1891 (Theodore Robinson, *Woman Sewing, Giverny*, Oil on canvas, Private Collection).

In December 1895, the artist returned to the image, altering it somewhat for use as an illustration to accompany his rather sentimental poem "A Normandy Pastoral" which was published posthumously in *Scribner's Magazine* (June 1897).

33 **WATCHING THE COWS**
1892
Oil on canvas
16 x 26 in. (40.6 x 66 cm)
Inscribed lower left: *Th. Robinson 1892*
Collection of The Butler Institute of
American Art, Youngstown, OH,
961-0-132M

The theme of a woman doing
handiwork out-of-doors is further
explored in this composition in
which a young mother, absorbed in
her sewing, sits in a lush, sun-dappled
pasture. Nearby, an elaborately attired
child looks intently at the viewer, and
behind, two tethered cows graze. The
inclusion of more than one figure is
unusual for the artist who generally
focused on a single model. A diary
entry for November 29, 1892 notes a
studio visit by Monet who responded
positively to the picture. Shortly after
his return to New York, however,
while acknowledging that the painting
had been "done in a good spirit of
endeavor," Robinson chastised himself
for not bringing it to full resolution
while still at Giverny: "how foolishly I
let time pass and did not get more time
on both figures and cows . . ." (Diary,
January 23, 1893).

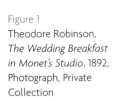

Figure 1
Theodore Robinson,
*The Wedding Breakfast
in Monet's Studio*, 1892,
Photograph, Private
Collection

Figure 1
Theodore Robinson,
*The Wedding Breakfast
in Monet's Studio*, 1892,
Photograph, Private
Collection

34 THE WEDDING MARCH

1892
Oil on canvas
22 ⁵⁄₁₆ x 26 ½ in (56.2 x 66.7 cm)
Inscribed lower right: *Th. Robinson*
Terra Foundation for the Arts, Daniel
J. Terra Collection, 35.1980

Robinson describes the Giverny wedding of American painter Theodore Earl Butler and Suzanne Hoschedé, Monet's stepdaughter, in his diary (July 20, 1892) and in a letter to Lilla Cabot Perry's husband, Thomas, written three days later. First noting the marriage of Monet and Alice Hoschedé which had occurred on July 16, he continues to Perry: "There was a double ceremony—first at the *Mairie*— then at the church. Nearly all the wedding party were in full dress Most of the villagers and *all* the *pensionnaires* were there—guns were fired, two beggars held open the carriage doors and received alms."[5]

On August 5, a little more than two weeks later, he recorded that he had begun a painting to mark the occasion, using Gaston Baudy's hat as a prop. Gaston, a son of Lucien and Angélina Baudy, assisted his parents in the running of their Giverny hotel. Robinson chose to represent the procession of the bridal party from the mairie, seen on the right, towards the nearby church of Sainte Radégonde. The rose-colored town hall is also visible in *From the Hill, Giverny*, c. 1889 (cat. no. 6), and is most probably the building which appears in *The Red House*, c. 1892 (cat. no. 14). Although the artist wrote in his diary that Monet entered the church with Suzanne, followed by the groom and Alice, the identities of the figures in the procession, with the exception of the bride, are unclear.

This painting is particularly notable for the complexity of its composition, which is built on the careful placement of diagonal elements. The slope of the hill in the background, the thrust of the wall on the right, and the articulation of the bend in the roadway all serve to draw attention to the members of the wedding making their way to the church.

Following the ceremony, a celebration was held in Monet's studio, an event that Robinson documented in a photograph and described: "A break-fast at the atelier—lasting most of the afternoon [Fig. 1]. Frequent showers, champagne and gaiety. . . Dinner and evening at the Monets— bride and groom left at 7.30 for the Paris train" (Diary, July 20, 1892).

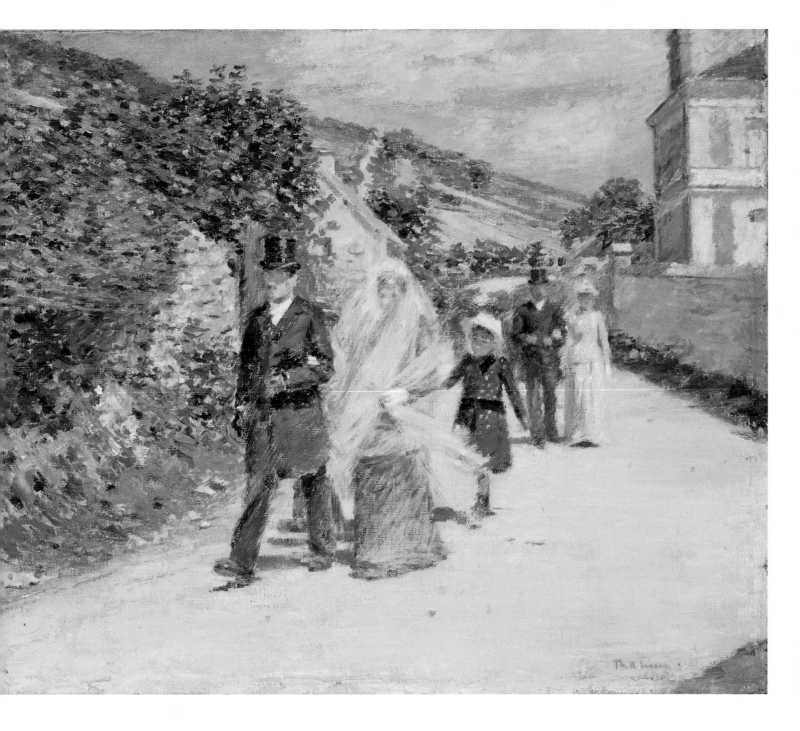

Shortly before departing from New York for what would be his final visit to France, Robinson noted that artist friend J. Alden Weir had come to his studio in the morning and "'wanted to talk to me'—the dear boy had heard that I was going back to France to get married" (Diary, May 9, 1892). Both Weir and Will Low were certainly the artist's closest confidantes, and in a deeply personal letter to Low, written from Barbizon several years earlier, he had recounted a decision made reluctantly together with a young woman known only as Marie, that they should not enter into marriage.[6] Nonetheless, their close association continued until his death in 1896 with numerous diary entries referring to her only by the initial "M."

The couple was often at Giverny, and Robinson would see Marie in Paris where she presumably lived and may have earned her livelihood as an artist's model. This is suggested by a somewhat droll anecdote concerning Edgar Degas told to Robinson by Marie and subsequently related in his diary: "M. gave some amusing details of the man—his ideas, prejudices, etc. Old Durand-Ruel [the Paris dealer] carried off a picture when she was there, to make sure he [Degas] would not work on it more—or worse, scrape it out" (Diary, May 29, 1892).

The relationship also fostered a certain measure of gossip within the community of Americans at Giverny. This is revealed in a letter to Boston painter Philip Leslie Hale (1865–1931), a Hôtel Baudy lodger on two occasions, from a lady-friend in residence in 1890: "By the way, dear, it looks very strange but Mr. Robinson has a model down here who has her little daughter—I believe she says niece, with her. Everyone says that—well, it seems difficult to say, but that the little girl is the daughter of Mr. Robinson . . . if true I can easily see why Mr. Robinson's life has been so utterly unhappy—surely an affair to be deplored—the child looks very like him—I've only seen them together once—because while she is here, they all dine with Mme. Baudy . . ."[7] In subsequent correspondence dated a few days later, the writer would distance herself from this somewhat defamatory inference.[8]

If little documentation is to be found regarding Marie, she is most certainly familiar through the numerous works in which she appears as the subject, the earliest from 1885 (cat. no. 35), and the last painted at Giverny in 1892 (cat. no. 44).

She is the young woman at the piano in an elegant Paris salon (cat. no. 37) and seated on a hillside engrossed in her reading (cat. no. 39). Unlike other figural representations in which a model's features are rather generalized, Robinson's representations of Marie are refined and carefully drawn, giving her a distinctly recognizable persona. Curiously, in all of these images, she is shown in profile, with one exception from 1886, an arresting work entitled *Reverie*; here, violin in hand, she gazes pensively at the viewer (Fig. 1).

Robinson may have employed preliminary photographic studies for a number of his paintings of Marie. It is possible that only one such image survives in the photograph that he relied upon as he worked on his large canvas *The Layette*, during the summer of 1892 (cat. no. 43). The hairstyle, general outline of her profile with its protruding upper lip, and her somewhat somber demeanor are all common to his portrayals of this unknown young woman who played such a vital role both in his life and in his art.

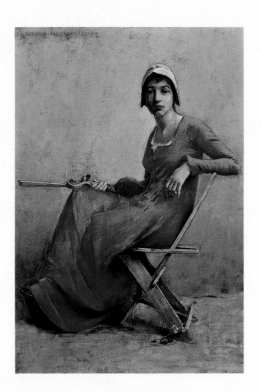

Figure 1
Theodore Robinson, *Reverie*, 1886, Oil on canvas,
Private collection, Courtesy of Berry-Hill
Galleries, Inc.

Right: Theodore Robinson, *The Layette*,
(cat. no. 43, detail)

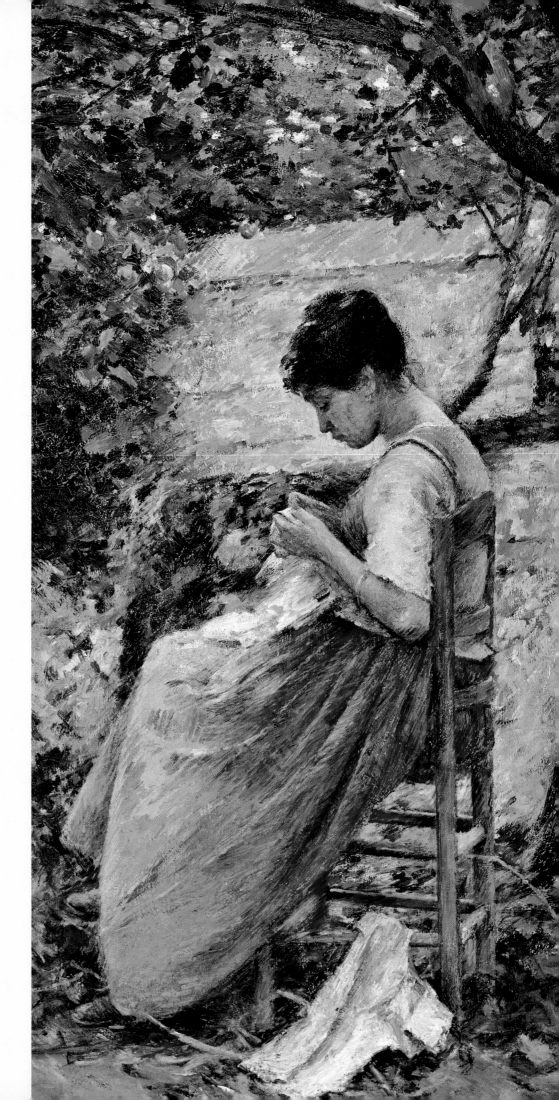

His
Favorite
Model

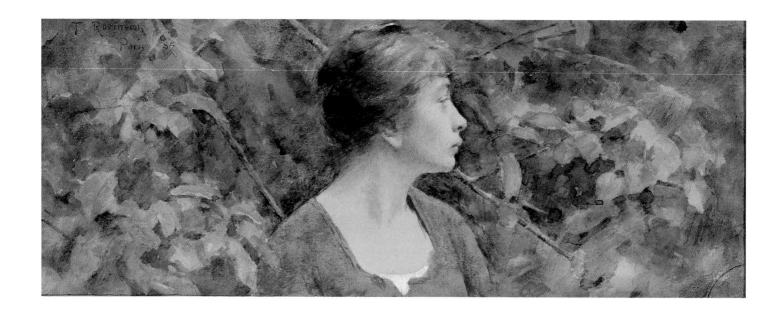

35 LADY IN RED
1885
Watercolor on paper
5 x 12 ³/₄ in. (12.7 x 32.4 cm)
Inscribed upper left: *T. Robinson/Paris '85*
Robert A. Mann

This watercolor is the earliest image presently known of Marie. It appears that Robinson met her some time after his arrival in France in the spring of 1884 for his second extended visit. She is shown in profile against a mottled background of leaves and delicate branches; her red costume is familiar from several of the artist's early representations of her and was undoubtedly a studio prop. A certain monumentality reflected in the figure recalls the aesthetic realism of muralists La Farge and Treadwell, for whom Robinson worked in the early 1880s prior to embarking on his second trip abroad in 1884. An undated oil version repeats the composition with slight variations in the hair style and in the neckline of the dress (Theodore Robinson, *Head of a Girl, Giverny*, c. 1885, Oil on canvas, Collection Mr. and Mrs. Meredith J. Long).

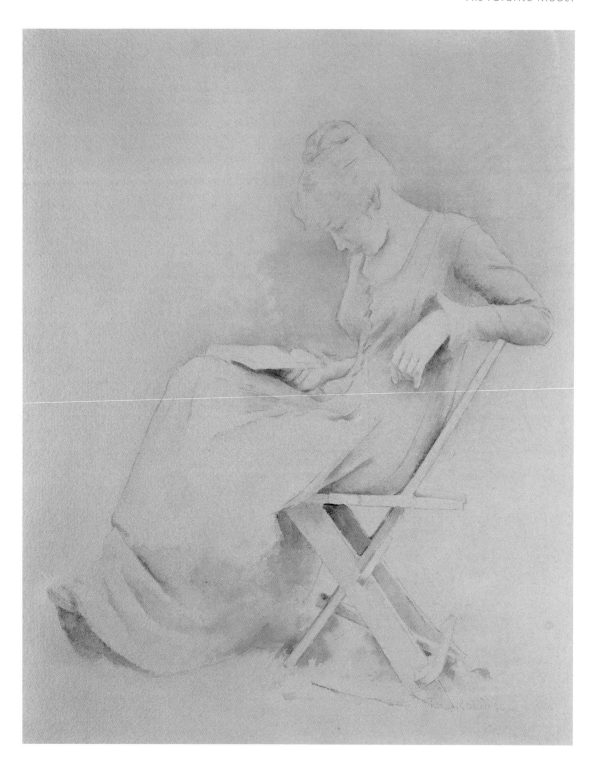

36 READING (STUDY IN MONOCHROME)
1887
Pencil and wash on paper
12 ³⁄₈ x 10 in. (31.4 x 25.4 cm)
Inscribed lower right: *Th. Robinson 1887/Paris*
Susan and Herbert Adler

Robinson invariably portrayed Marie engaged in genteel pursuits such as reading, needlework, or music. Here, she gazes down at a book resting in her lap, her right hand barely grasping the small volume. The artist's superb drawing ability is clearly manifested in the exquisite rendering of the young woman. The wooden chair on which Marie sits as well as her gown are familiar from two other representations, a somewhat larger watercolor version of this composition also inscribed *Paris/1887* (*Young Woman Reading*, 1887, Watercolor, Collection: Mr. and Mrs. Raymond J. Horowitz) and *Reverie*, painted the previous year (see Fig. 1, page 142).

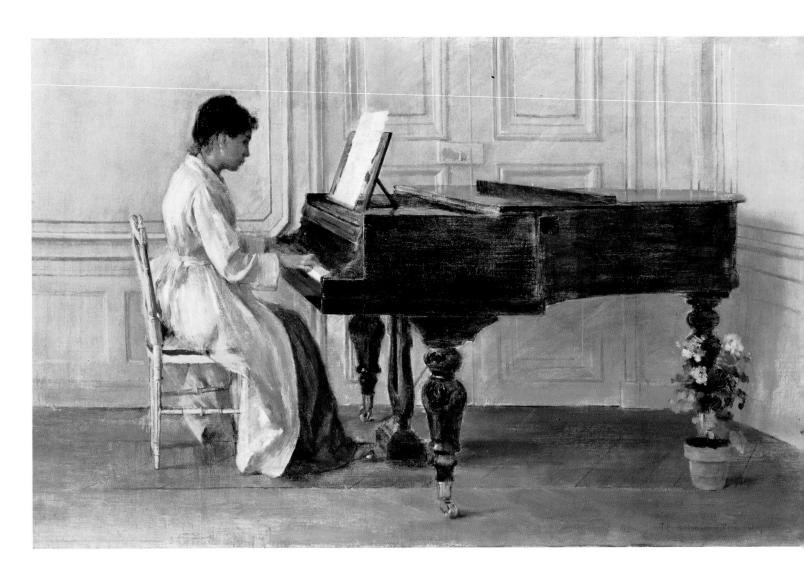

37 **AT THE PIANO**
1887
Oil on canvas
16 ¹/₂ x 25 ¹/₄ in. (41.28 x 64.14 cm)
Inscribed lower right: *Th. Robinson, Paris, 1887*
Smithsonian American Art Museum, Washington, D.C. Gift of John Gellatly, 1929.6.90

Robinson explained the apparent popularity of this work in a diary entry for September 10, 1893: "It is probably the sincerity with which it was done—I remember it seemed to me a sad failure at the time, and at Archie's rue Dumont d'Urville just before leaving for the country." This notation also suggests that the painting was completed in the spring of 1887, prior to the artist's departure for his first extended visit to Giverny and further reveals the elegant setting as the Paris residence of John Armstrong Chanler (1862–1935). Known as Archie, Chanler, a wealthy acquaintance and descendant of John Jacob Astor, was concerned with the plight of American artists living abroad and may have provided financial assistance to Robinson from time to time.

The portrayal of Marie here is reminiscent of James Abbott McNeill Whistler's well-known composition, *At the Piano*, 1858–59, which the artist may have seen when it was exhibited at the Pennsylvania Academy of the Fine Arts in Philadelphia in 1881 or at the Society of American Artists in New York in 1882. In contrast to Whistler's painting, with its dark passages and shallow, cluttered space, Robinson's interior, bathed in a delicate light, is airy and unencumbered.

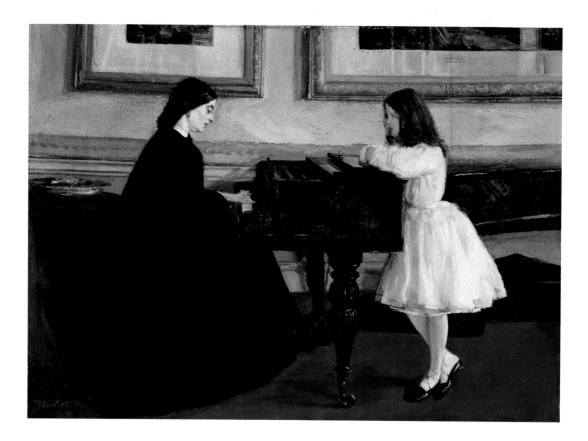

Figure 1
James Abbott McNeill Whistler (American 1834–1903), *At the Piano*, 1858–59, Oil on canvas, Bequest of Louise Taft Temple, The Taft Museum of Art, Cincinnati, Ohio, 1962.7

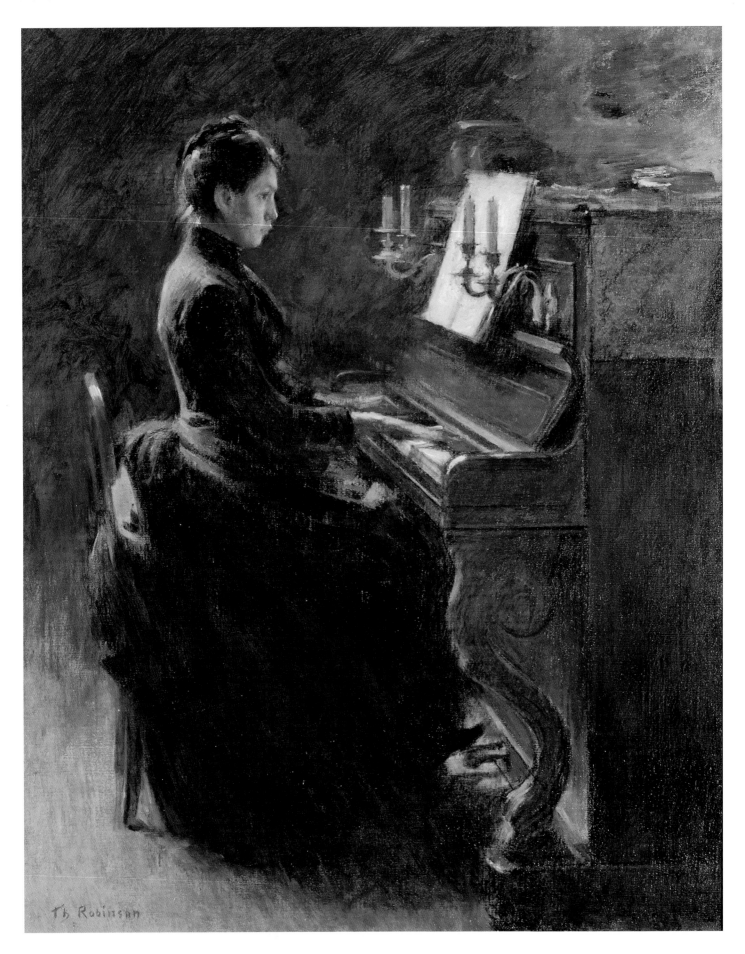

38 GIRL AT PIANO

c. 1887
Oil on canvas
21 ³/₄ x 18 ¹/₁₆ in. (55.3 x 45.9 cm)
Inscribed lower left: *Th. Robinson*
Courtesy of the Pennsylvania Academy of the Fine Arts, Philadelphia
Henry D. Gilpin Fund, 1898.7

Robinson's portrayals of Marie seated at a piano imply that she was indeed familiar with music and with this particular instrument. Here, dressed somewhat formally in black, her hands at the keyboard, she studies intently the sheet of notes before her. All references to the setting have been eliminated in order to focus on the figure engaged in her playing, the vignette further enhanced by the dramatic lighting. The piano, with its distinctive scroll legs and candle brackets, is similar to one observed in a photograph of the dining room at the Hôtel Baudy, suggesting this as the location where the work was painted (Fig. 1). Also identifiable in the photograph on the wall above the piano are two of the artist's compositions, a view of the Seine valley from 1892 (see cat. nos. 57, 58, 59) and a smaller variation of *The Layette* (cat. no. 43).

Figure 1

A. Lavergne, Vernon, Vintage postcard, *GIVERNY – Hôtel Baudy Dining Room*, before 1909, Courtesy Musée d'Art Américain, Giverny, Terra Foundation for the Arts

GIVERNY. - Salle à Manger de l'Hôtel BAUDY
Phot. A Lavergne, Vernon

39 VAL D'ARCONVILLE
c. 1888
Oil on canvas
18 ⅛ x 22 in. (46 x 55.9 cm)
Inscribed lower right: TH. ROBINSON
The Art Institute of Chicago, The Friends
of American Art Collection, 41.11

Robinson has positioned Marie seated on a flower-filled hillside overlooking a site he identified as the valley of Arconville across the Seine River opposite Giverny. In the distance on the right are puffs of white smoke possibly discharging from the train which ran from Vernon to nearby Gisors. Typically, a broad range of brush strokes defines the landscape as it recedes toward the high horizon. Although recognizable from her profile, pose, and general demeanor, the identity of the young woman here as Marie in confirmed in a diary notation for June 11, 1893: "Mrs. B. told me of the inspiration she got from a picture of mine (Carey's, with Marie on the hill-side)." Arthur Astor Carey (1857–1923), the first owner of the painting, is mentioned frequently in the artist's Diary.

A cousin of wealthy acquaintance John Armstrong Chanler, he was among the group of Americans who took a house at Giverny during the summer of 1887 together with Robinson and Canadian artist William Blair Bruce.

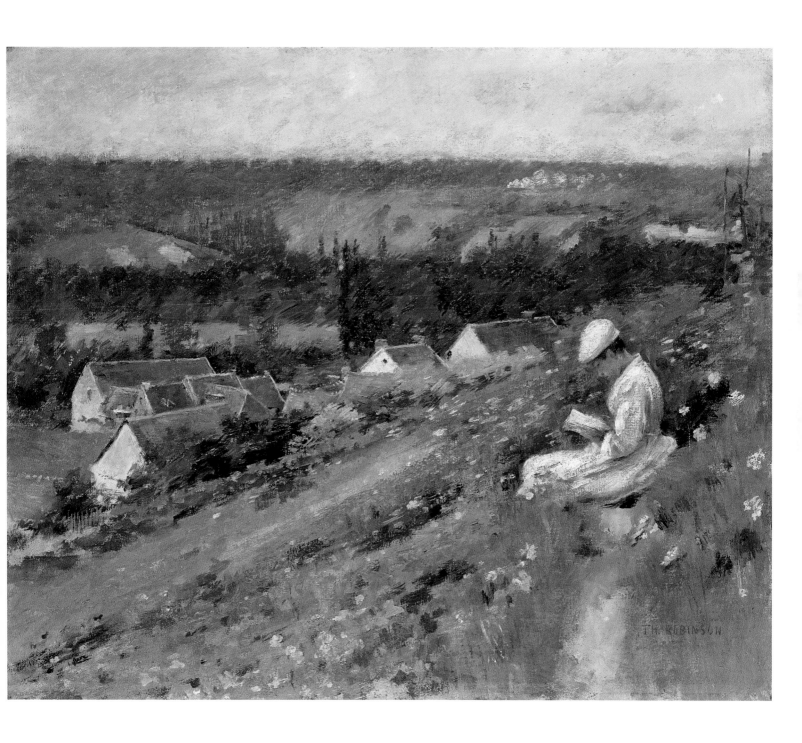

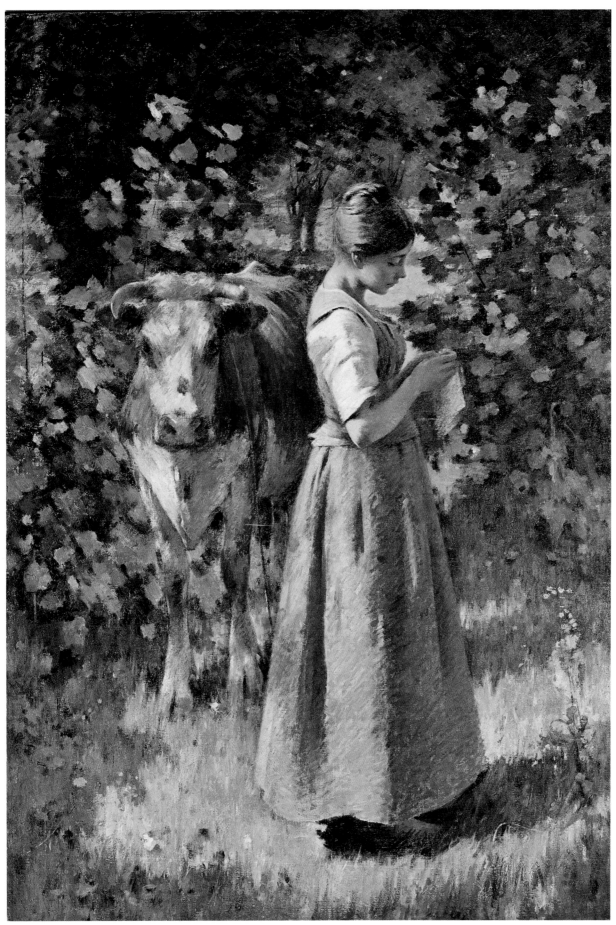

40

40 LA VACHÈRE

1888
Oil on canvas
86 ³/₈ x 59 ⁵/₈ in. (219.4 x 151.5 cm)
Inscribed lower left: *TH. ROBINSON—1888*
The Baltimore Museum of Art, Given in
Memory of Joseph Katz by his Children,
BMA 1966.46

Both the generous size of the canvas
and the popular pastoral theme of a
young peasant girl watching cows imply
that Robinson intended to submit this
painting to the Salon, where it was
indeed accepted for exhibition in 1889.
Although the artist did not identify the
subject as Marie, the features and
general bearing suggest that she was the
model who posed for the painting.

The figures of both the young woman
and the cow are surrounded by foliage
that shimmers in reflected light. Large
touches of pigment in proportion to the
ample scale of the composition define
the verdant setting. An opening in the
background frames Marie's delicate
profile and gives depth to the
representation. While the frontal pose
of the cow is somewhat disarming,
she seems curiously oblivious to the
animal's presence which challenges
her dominance in the image.

Of the several works related to this
painting, only an oil sketch of the cow's
head (cat. no. 41) and a half-length
representation of the figure (*La Vachère,
Study*, c. 1888, Oil on canvas, Private
Collection) would appear to be
preliminary studies. Other smaller
variants, including *In the Grove* (cat. no.
42), may have been painted later as
implied by diary notations from
October 1892, shortly before the artist's
final departure from Giverny, in which
he indicates that he is working on "my
Vachère" (see Diary, October 11, 18,
24, 1892).[9]

41
LA VACHÈRE - STUDY FOR HEAD OF COW

c. 1888
Oil on canvas
13 ¹/₈ x 6 ³/₄ in. (30.8 x 17.2 cm)
Kennedy Galleries, Inc., New York

42
IN THE GROVE

c. 1888
Oil on canvas
31 ³/₄ x 25 ³/₄ in. (80.7 x 65.4 cm)
The Baltimore Museum of Art, The Cone
Collection, formed by Dr. Claribel Cone
and Miss Etta Cone of Baltimore,
Maryland, BMA 1950.291

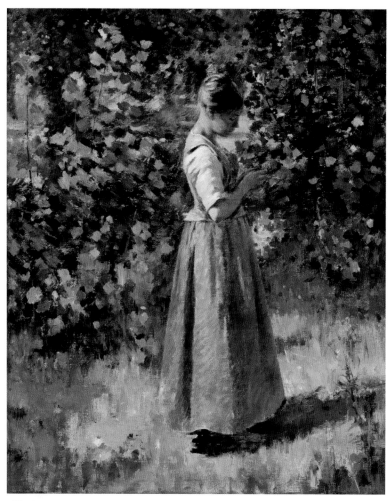

42

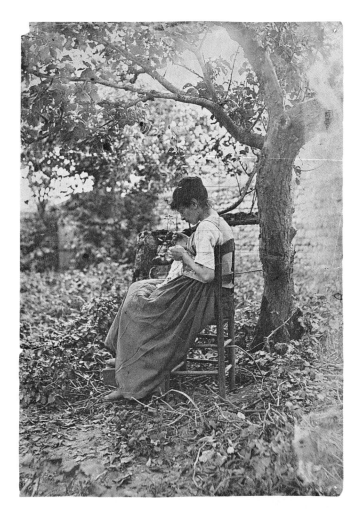

Figure 1
Theodore Robinson, *The Layette*, c. 1892, Cyanotype, Terra Foundation for the Arts, Gift of Mr. Ira Spanierman, C1985.1.2

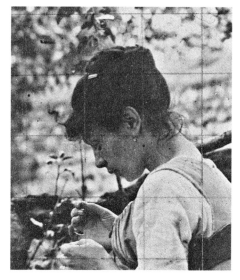

Detail of Figure 1

43 THE LAYETTE
1892
Oil on canvas
58 ⅛ x 36 ¼ in. (147.7 x 92.1 cm)
Inscribed lower right: *Th. Robinson*
In the Collection of The Corcoran Gallery of Art, Washington, D.C., Museum Purchase, and Gift of William A. Clark

During the summer of 1892, Robinson explored the theme of a young woman sewing as she sits in a walled garden. Several paintings resulted which were based on a series of photographs that exhibit variations in small details of costume, pose, and setting. The model must surely be Marie, and it is possible that the photographic study for the composition provides the only actual likeness of the artist's elusive female friend.

Robinson's initial reference to this, the largest version of *The Layette*, appears in a diary notation for October 30, 1892 in which he mentions that he is at work on the "large Layette" with Yvonne (a local resident) in Gill's garden, the Giverny setting he used for a number of paintings (see cat. no. 20). As was his practice on occasion, he evolved the composition relying both on the photograph and on a model whom he posed in a similar manner. Somewhat less expansive than the study, the painting also differs in the addition of an infant's garment draped across the chair rail in the foreground.

The Layette was among the works exhibited by the artist at the World's Columbian Exposition in Chicago in 1893. A diary entry, for February 22, 1896, however, indicates that he was still making changes to the canvas which remained in his studio until his death less than two months later. It would be purchased at his Estate Sale in 1898 by collector, George A. Hearn, who had acquired a painting from the *Valley of the Seine* series in 1893 (cat. no. 57).

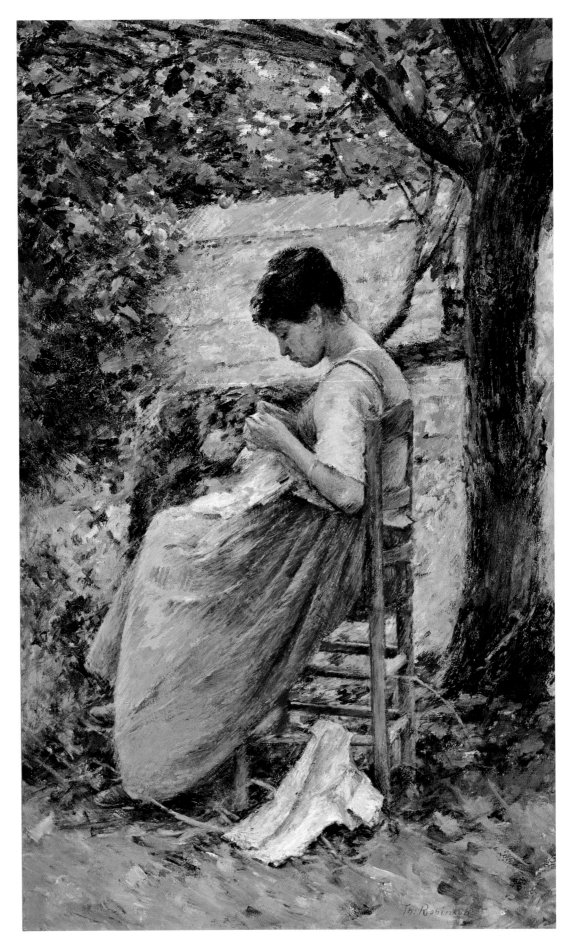

Figure 1
A. Lavergne, Vintage postcard, *GIVERNY – Ancien Moulin sur l'Epte*, before 1904,
Courtesy Musée d'Art Américain, Giverny, Terra Foundation for the Arts

44 LA DÉBÂCLE

1892
Oil on canvas
18 x 22 in. (45.7 x 55.9 cm)
Inscribed lower left: *1892/Th. Robinson*
The Ruth Chandler Williamson Gallery,
Scripps College, Claremont, Calif.
Gift of General and Mrs. Edward Clinton
Young, 1946

In his diary, Robinson refers to this work both as "Marie at the little bridge" and
La Débâcle, confirming the identity of the now familiar figure. This would appear
to be the final likeness that he painted of her. The latter title, which he ultimately
assigned to the canvas, refers to Emile Zola's novel, published in 1892, that deals
with the tragedy of the Franco-Prussian war of 1870–71. The artist was deeply
moved by the saga that he read in the course of the summer; presumably, it is the
volume Marie holds in her lap. Seated by the arched stone bridge, a locale seen in a
number of other compositions, Marie glances up as if to reflect for a moment on
her reading. The pink and blue tones of her stylish dress shimmer in the soft light;
typically, colors in the landscape are naturalistic, the pigment applied in an
assortment of expressive strokes and touches.

Robinson wrote in his diary on September 15, 1892 that Monet, on a visit to his
studio, found *La Débâcle* "amusing." A subsequent entry dated shortly after his
return to New York notes praise for the canvas from Chicago collector, Potter
Palmer, who deemed it "brilliant" (Diary, January 23, 1893).

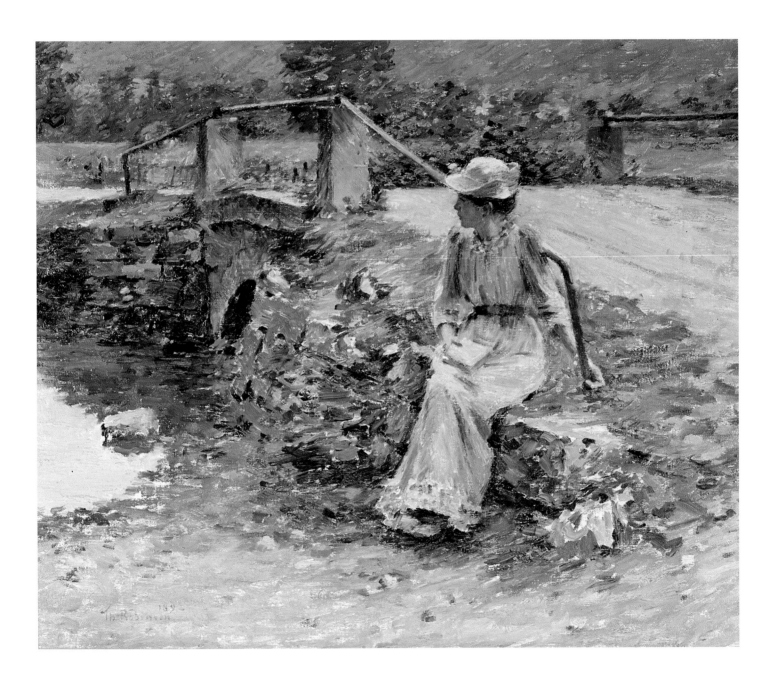

Throughout his Giverny years, Robinson produced multiple versions of mainly figural compositions, as in the groups of works relating to *La Vachère*, from 1888 (cat. no. 40) and *The Layette*, painted in 1892 (cat. no. 43). In both instances, these variations include reductions, some with generally minor compositional changes, as well as bust and half-length representations of the figures, all probably painted in the studio. As such, they are more reworkings than fresh inventions evolved from the original concept.

In the course of his second extended visit in 1888, Robinson painted two nearly identical canvases that present a specific view of the village seemingly taken at different times of the year (cat. nos. 45, 46). Repetitive imagery of this kind must surely have its origins in the precedent set by Claude Monet who, from the mid-1860s, had turned to paired compositions in order to capture the effects of seasonal or atmospheric changes on a particular subject or view. Robinson would continue to paint such related sets in subsequent years. In 1891, he depicted in two canvases a single grainstack seen from across a meadow marked by deepening shadows as evening approaches (cat. nos. 47, 48). Like Monet, he had considered this agrarian subject in more expansive settings, for instance, in *Giverny* (cat. no. 1) and *A Farmhouse in Giverny* (cat no. 9). Here, the stack of grain is the focus of the composition, as it is in the works that form Monet's monumental series of 1890–91.

Robinson's last pair of canvases was completed late in 1892, just prior to his final departure from Giverny. In these, he paints willows in a flower-filled meadow near the Seine River. Referred to in his diary as *Champs de Mauves—temp gris* (cat. no. 51) and *Champs de Mauves—soleil* (cat. no. 52); one depicts the landscape in sunlight and the other represents the view under a cloudy sky.

While pursuing the concept of multiple images, he also explored the related idea of sequences of works that present the same subject from differing vantage points. Monet had painted such groups in the 1870s and early 1880s, for example, his views of the bridge across the Seine River at Argenteuil and those of the customs house at Varengeville near Dieppe on the Normandy coast. Robinson chose as his motif an old mill at Giverny which he portrayed in sunlight (cat no. 53), on an overcast day (cat. no. 54), and in the darkness of a moonlit night (cat. no. 55). He also recorded the structure from a somewhat different aspect, barely discernible, enveloped in an array of foliage against a brilliant blue sky. (cat. no. 56).

The artist came closest to replicating Monet's series in three panoramic landscapes, identical in size, that represent the valley of the Seine from high in the surrounding hills. Looking southwest, they show the arched bridge crossing the river and the town of Vernon in the distance. Although it was his intention to paint only two canvases, one "in morning sunlight" and the other with clouds casting shadows on the terrain, Robinson soon began a third version of the composition that records the expanse on a grey, sunless day. The artist worked on these paintings from early June through the end of November, revisiting his "point of view" when conditions were favorable for capturing the desired effects.

In the summer of 1895, three years after returning to America, he began a similar series of landscapes of the West River Valley at Townsend, Vermont, where he had gone to conduct a painting class and hopefully discover an agreeable locale in his own country in which to pursue his Impressionist investigations. That he had thoroughly embraced Claude Monet's innovative vision and methods is apparent in these canvases that acknowledge transient moments in nature with finely tuned color harmonies and descriptive brushwork. He would impart the fundamental tenets of Impressionism to his homeland both through the exhibition of his Giverny works and through his teaching as observed by a journalist who visited the artist as he conducted an outdoor class at Evelyn College for Young Women in Princeton, New Jersey. When asked where the students might be found, he responded: "There are some down here by the big tree and I think there are some in the apple orchard, and some in the cabbage patch, and perhaps one or two by the canal." Approaching a young woman at her easel, Robinson commented on her efforts: "Your color is a little gray, it doesn't give me the effect of sunlight." She answered, "The light has changed a good deal since I began on it" to which he replied, "It often does. Perhaps it would be good to take another canvas."[10]

Theodore Robinson, *Valley of the Seine*
(cat. no. 58, detail)

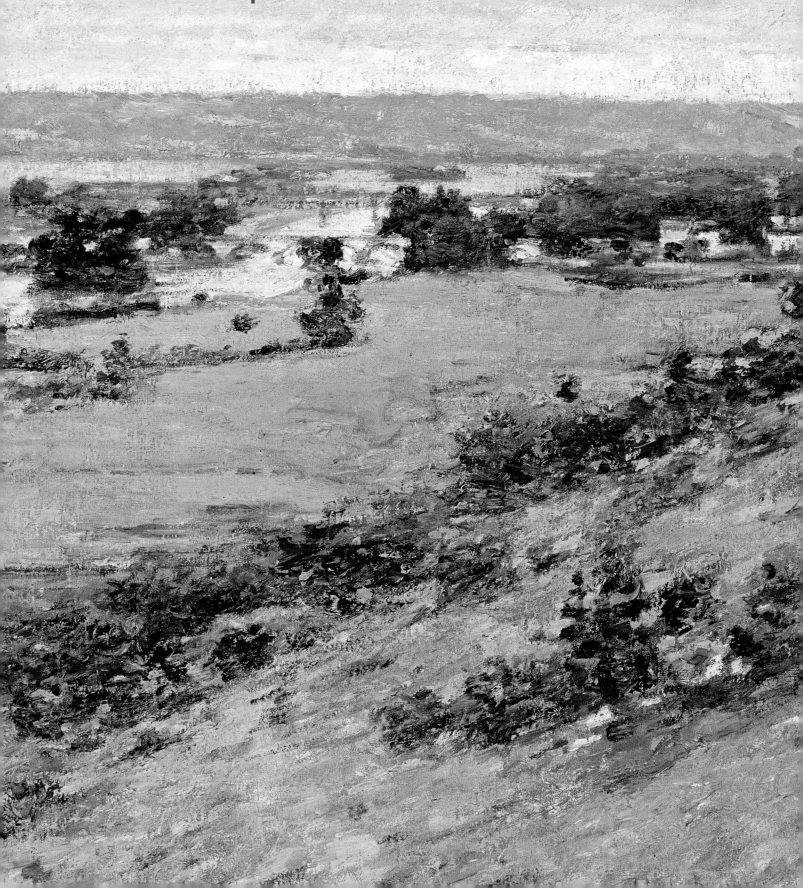

Pairs, Sequences, and Series

45 **IN THE ORCHARD**
c. 1889
Oil on canvas
18 x 22 in. (45.7 x 55.9cm)
Addison Gallery of American Art, Phillips
Academy, Andover, Massachusetts,
Candace C. Stimson Bequest, 1944.24

46 **SAINT MARTIN'S SUMMER, GIVERNY**
1888
Oil on canvas
18 x 22 in. (45.7 x 55.9 cm)
Inscribed lower left: *Th. Robinson/1888*
Collection Spanierman Gallery, LLC,
New York

Variations in the colors of these two landscapes depicting a cluster of fruit trees on a slope above Giverny suggest that each describes a different moment in the day or more likely, time of year. Somewhat less vibrant in overall tone, *In the Orchard* (cat. no. 45) may represent a springtime view with touches of light pigment indicating flowering blossoms. The richer, more varied hues apparent in *St. Martin's Summer, Giverny* (cat. no. 46) together with the relatively barren limbs of the trees in the right foreground, imply that the season is autumn. The title given to the latter work by the artist when it was exhibited at the Society of American Artists in New York in 1889 refers to a period of mild, warm weather occurring around the feast day of Saint Martin which is celebrated on November 11.

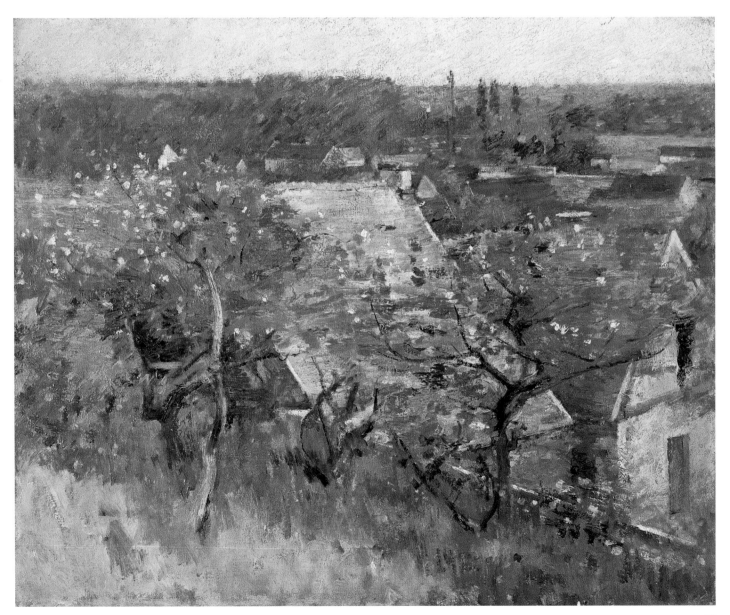

45

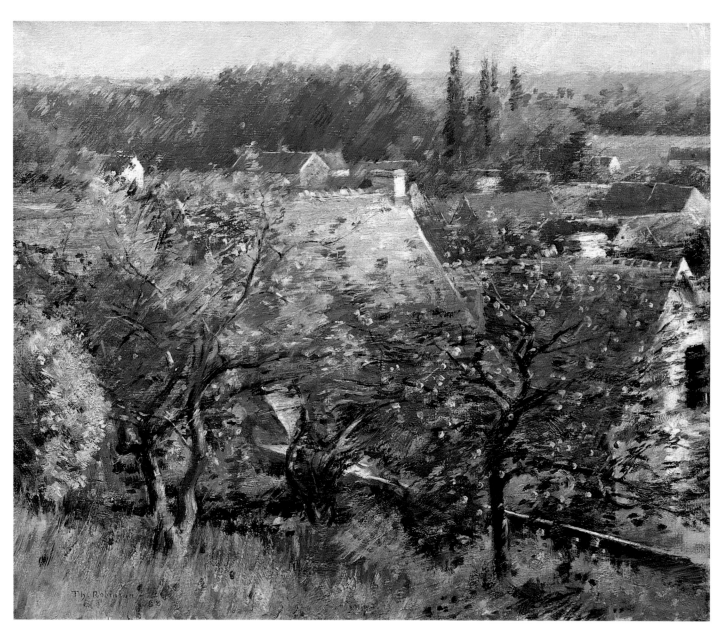

46

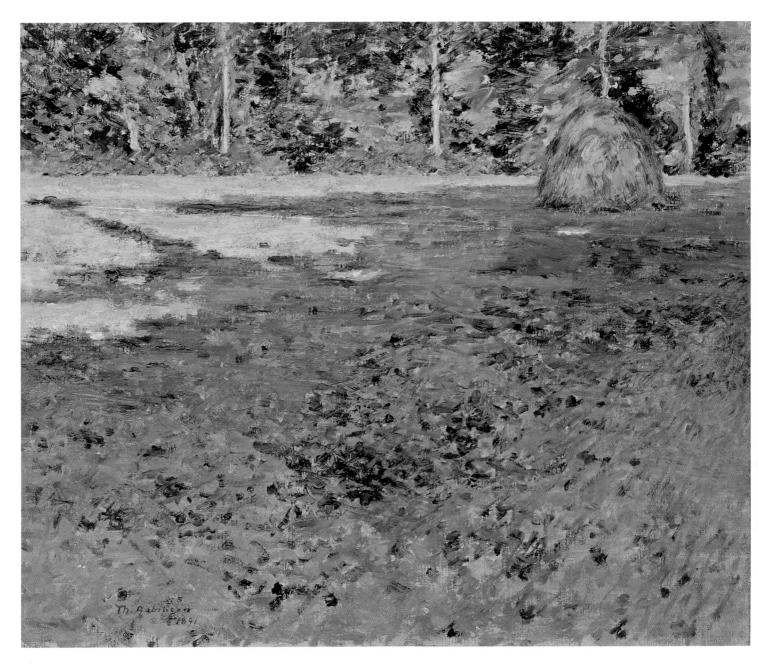

47 AFTERNOON SHADOWS

1891

Oil on canvas

18 ½ x 22 in. (47 x 55.9 cm)

Inscribed lower left: *Th. Robinson/1891*

Museum of Art, Rhode Island School of
Design, Providence. Gift of Mrs. Gustav
Radeke

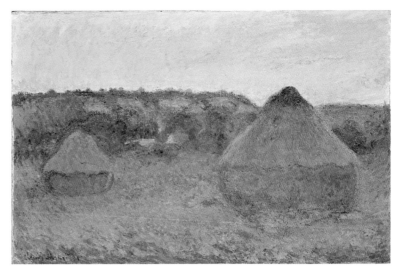

Figure 1

Claude Monet, *Stacks of Wheat (End of Day, Autumn)*, 1890–91,
Oil on canvas, Mr. and Mrs. Lewis Larned Coburn Memorial
Collection, The Art Institute of Chicago, 1933.444

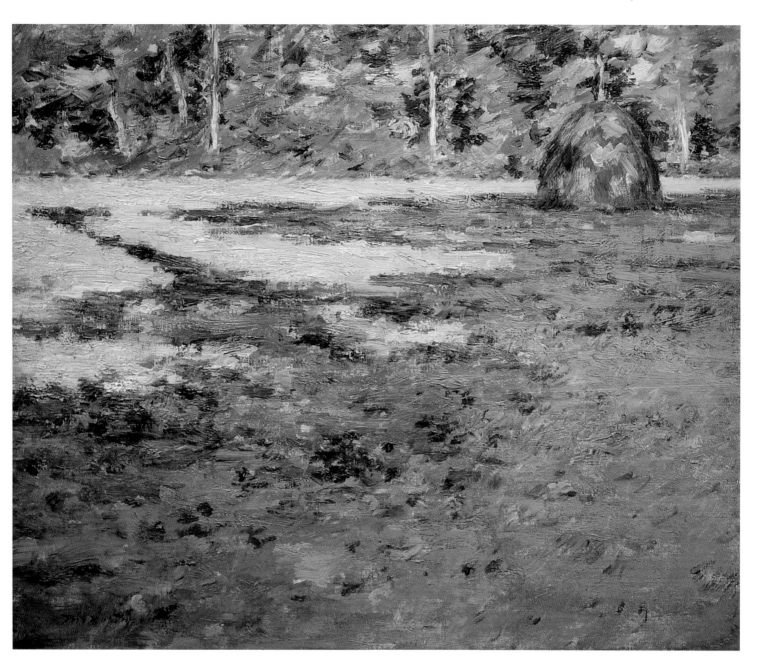

48 AFTERNOON SHADOWS
c. 1891
Oil on canvas
18 ⅛ x 22 in. (46 x 55.9 cm)
Inscribed lower left: *Th. Robinson 189[1?]*
Kennedy Galleries, Inc., New York

In a diary entry for December 8, 1893, Robinson referred to this composition as *Afternoon Shadows*, noting that collector Frank Lusk Babbott of Brooklyn (1854–1933) found it "a bit arbitrary and artificial" although he expressed admiration for "the beauty of the shadows." Monet's haystack series of 1890–91 may have inspired Robinson to turn to a similar theme (Fig. 1). However, this pair of paintings is more closely related to the French artist's treatment of the subject in the mid-1880s in which similar stacks of grain are seen in a meadow bordered by a line of trees. Unlike Monet's compositions, which include a substantial expanse of sky above the foliage, Robinson's reveal only a suggestion of blue through the lush vegetation in the background. In both works, deepening shadows in the foreground recede towards the sunlit boundary of the field. In one, vivid greens and yellows describe the scene close to mid day, while the other, with slightly altered patterns of shadow and grayed tonalities, suggests a later hour.

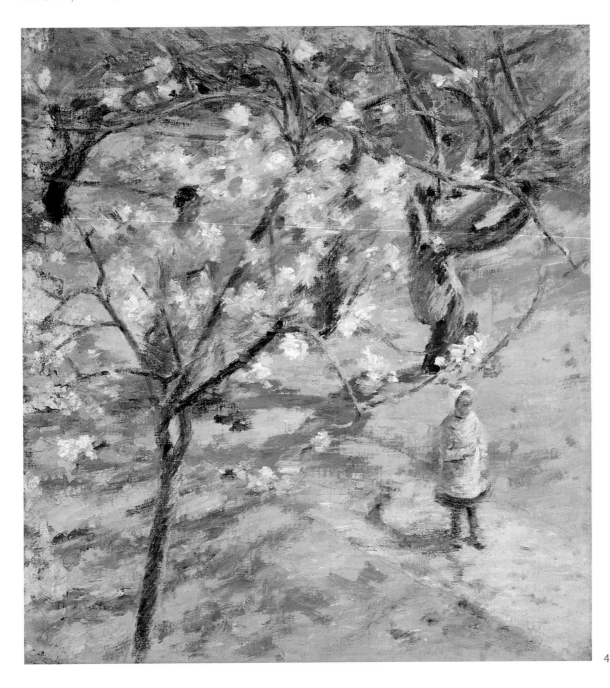

49

49 BLOSSOMS AT GIVERNY
c. 1891
Oil on canvas
21 ¹/₆ x 20 ⁵/₁₆ in. (54.9 x 51.1 cm)
Terra Foundation for the Arts, Daniel
J. Terra Collection, 1992.130

50 IN THE ORCHARD
c. 1891
Oil on canvas
20 ¹/₈ x 16 ³/₈ in. (51.1 x 41.6 cm)
Inscribed lower left: *Th. Robinson*
Princeton University Art Museum.
Gift of Frank Jewett Mather, Jr.

Although varying slightly in size, each of these canvases presents a nearly identical view looking from above through blossoming trees at a young woman and child as they proceed along a path. The bright palette and shadow patterns in both compositions record the effects of sunlight passing through the tree limbs. In a departure from other paired works that focus on atmospheric variations, the artist documents here sequential moments in time as the figures stroll down the walkway in one image (cat. no. 49) and pause to converse in the other (cat. no. 50). The dark-haired woman with her watering can may be Giverny resident Josephine Trognon, who posed for the *Watering Pots* series (cat. nos. 23, 24, 25).

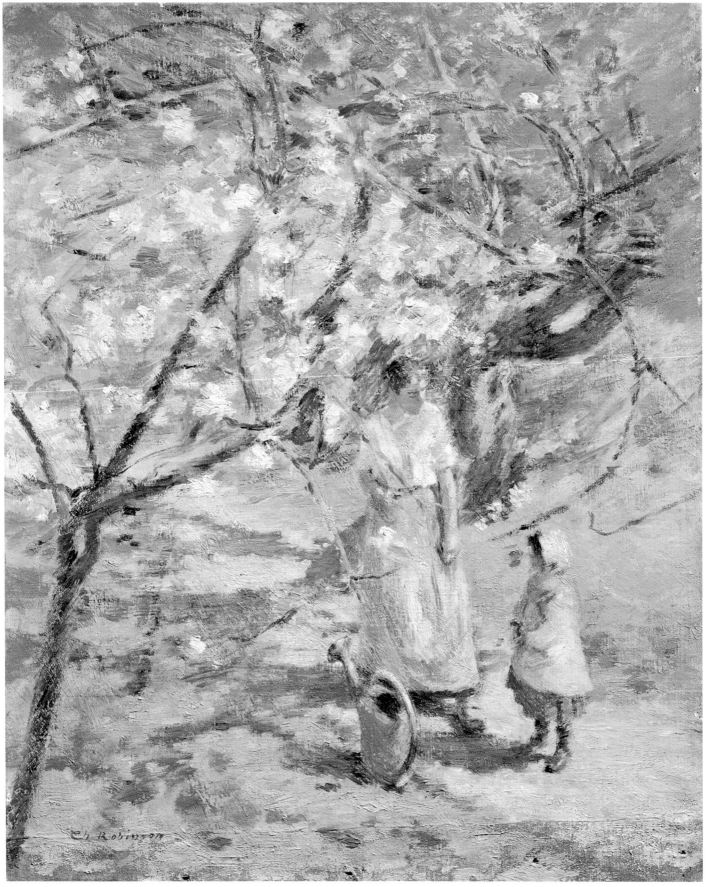

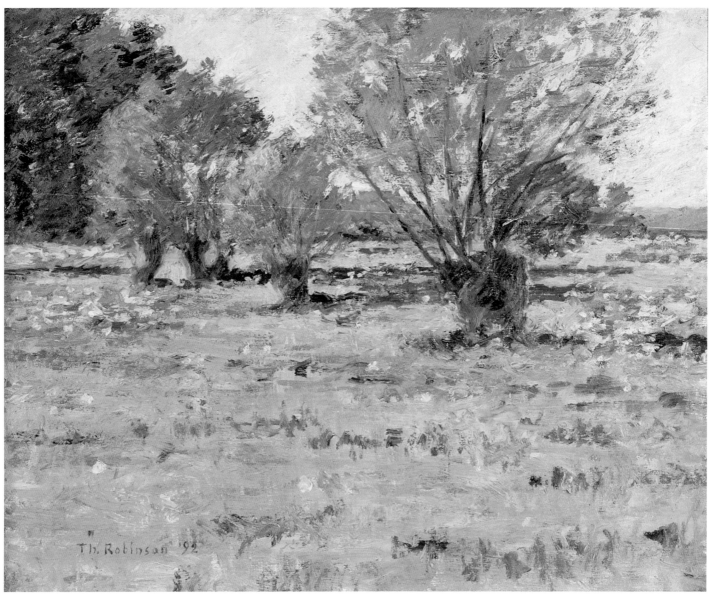

51

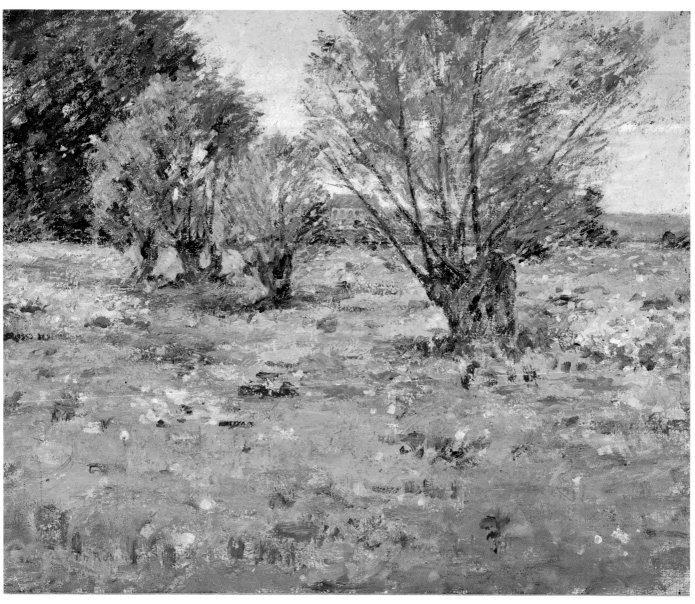

52

51
WILLOWS AND WILDFLOWERS
1892
Oil on canvas
17 ¹/₂ x 21 ³/₄ in. (44.4 x 55.3 cm)
Inscribed lower left: *Th. Robinson '92*
Lois and Arthur Stainman

52
WILLOWS AND WILDFLOWERS
1892
Oil on canvas
18 ¹/₈ x 22 in. (46 x 55.9 cm)
Inscribed lower left: *Th. Robinson 1892*
Mr. and Mrs. Meredith J. Long

Several diary notations from October 1892 reveal that Robinson was at work on two compositions, one depicting a landscape in bright sunlight with willows casting deep shadows on the terrain, and the other representing the identical view but under a subdued, uniform light. The locale is the flat river plain, dotted with mauve or mallow blossoms, looking towards Vernon, the form of the Notre-Dame church barely visible in the distance. Entries through the first ten days of the month mention weather conditions as cold and windy, allowing considerable progress on *Champs de Mauves—temps gris* (cat. no. 52). On October 11, the artist wrote with considerable enthusiasm that the day was sunny, permitting him to work on both versions. A week later, however, the inevitable seasonal changes had transformed the site: "Went for the last time to my *Champs de Mauves* and worked a few minutes. They were cutting the grass—it looked odd to see hay-making on such a dark, cold autumn day" (Diary, October 19, 1892).

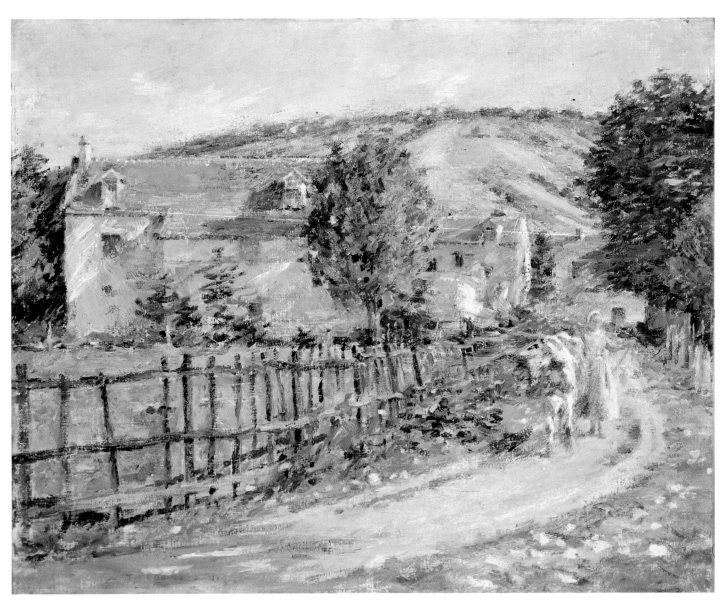

53

Figure 1
Theodore Robinson, *Girl Walking Cow*, c. 1892,
Photograph, Private Collection

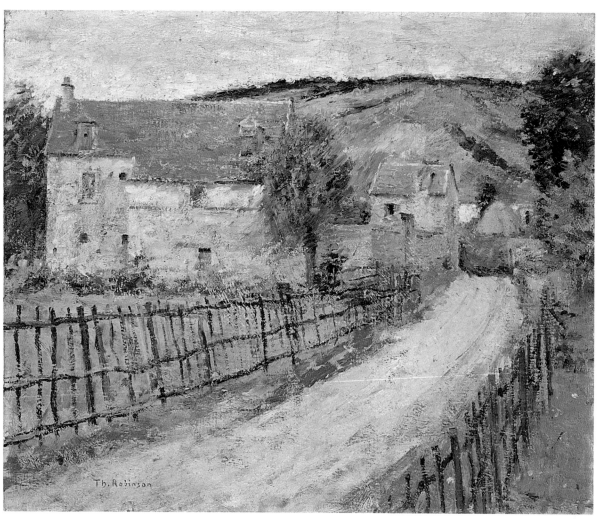

54

53 ROAD BY THE MILL

1892
Oil on canvas
20 x 25 in (50.8 x 63.5 cm)
Inscribed lower left: *TH. ROBINSON.–1892*
Cincinnati Art Museum, Ohio. Gift of
Alfred T. and Eugenia I. Goshorn, 1924.70

54 THE OLD MILL (VIEUX MOULIN)

1892
Oil on canvas
18 x 21 ⅞ in. (45.7 x 55.6 cm)
Inscribed lower left: *Th. Robinson*
The Metropolitan Museum of Art.
Gift of Mrs. Robert W. Chambers, 1910, 10.2

Of the canvases that comprise the group of images of a Giverny mill,
Le Moulin de Chennevières, shown under differing conditions of light
and atmosphere, only one bears the date of 1892 (cat. no. 53). It is probable,
however, that all were painted in the course of the same year, the artist's last in the
village. Two closely related compositions present the view in daylight. In the single
dated work, which is illuminated by brilliant sunshine, a young girl guides a cow
along a curved roadway. An extant photograph provided the prototype for this
vignette (Fig. 1). In the other canvas, the landscape, the distinctive building, and the
curved path bordered by fences are the focus, all enveloped in the gray light of an
overcast day (cat. no. 54). Robinson explored the locale further in three moonlit
representations that are marked by deep shadows, blurred outlines, and overall dark
tonalities broken by passages of reflected moonlight (cat. no. 55).[11]

Although virtually obscured by foliage, the mill also appears to be the structure
depicted in *Willows*, albeit from a different vantage point. (cat. no. 56).[12]

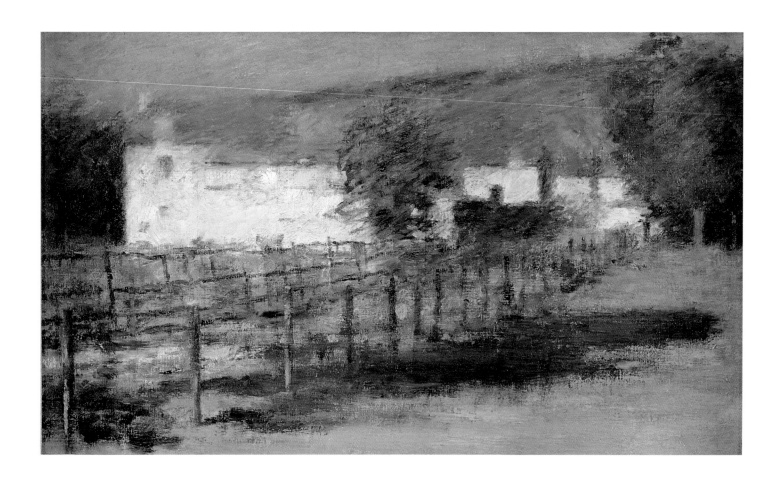

55 MOONLIGHT, GIVERNY
c. 1892
Oil on canvas
15 ⅝ x 25 ¾ in. (39.9 x 65.4 cm)
The Parrish Art Museum, Southampton,
N.Y., Littlejohn Collection, 1960.1.3

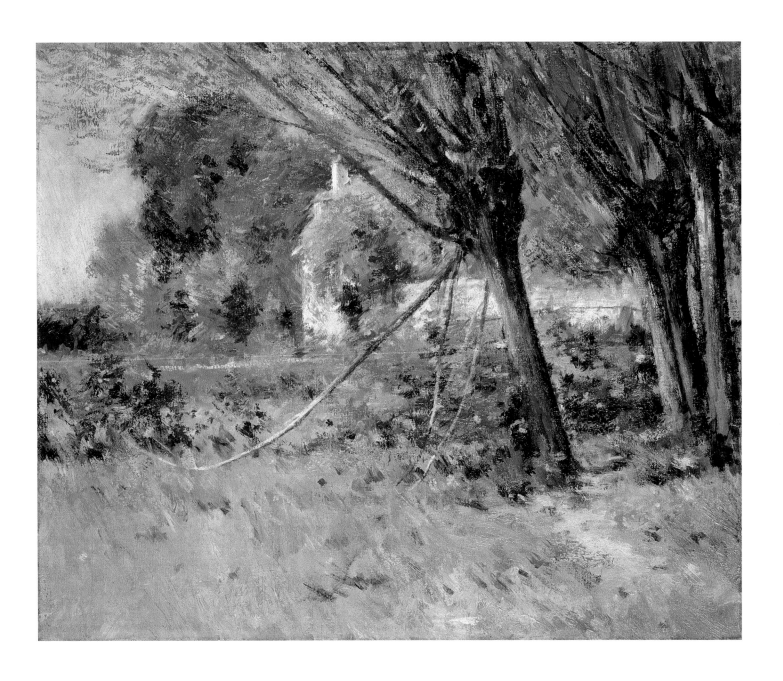

56 WILLOWS
c. 1891
Oil on canvas
18 1/8 x 21 7/8 in. (46 x 55.6 cm)
Brooklyn Museum of Art, Gift of
George D. Pratt, 14.550

57 VALLEY OF THE SEINE FROM GIVERNY HEIGHTS
1892
Oil on canvas
25 ⁷/₈ x 32 ⅛ in. (65.7 x 81.6 cm)
In the Collection of The Corcoran Gallery of Art, Washington, D.C., Museum purchase, Gallery Fund

On pages 174 and 175

58 VALLEY OF THE SEINE
1892
Oil on canvas
25 ³/₄ x 32 ⁷/₈ in. (65.4 x 83.4 cm)
Inscribed lower right, in blue:
TH ROBINSON/1892
Addison Gallery of American Art, Phillips Academy, Andover, Massachusetts, Museum Purchase, 1934.3

59 VALLEY OF THE SEINE
c. 1892
Oil on canvas
26 x 32 in. (66 x 81.3 cm)
Inscribed lower right: *Th. Robinson*
Maier Museum of Art, Randolph-Macon Woman's College, Lynchburg, Virginia

In the spring of 1892, shortly after arriving in Giverny, Robinson ventured once again into the hills above the town and began three expansive Seine valley landscapes looking towards Vernon. He considered this series his most significant artistic effort and it is documented in more than thirty diary entries dated from June 1892 through mid-November 1895. While roughly half of the notations trace his almost daily progress on the views, those written following his return to America describe the enthusiastic response of friends, fellow artists, and collectors to these innovative Impressionist compositions.

He started two canvases on June 4, one showing the vista in full sunlight (cat. no. 57), and the other capturing the shadows cast by passing clouds on the terrain (cat. no. 58). Five days later, he began a third painting of the valley as it appears on an overcast day (cat. no. 59). In the course of the summer, he would write to his friend, J. Alden Weir, of the challenges presented by the first two versions in particular: ". . . For six weeks, I worked mornings on two landscapes—sort of panoramic affairs—the valley and Vernon seen from the hill-side. They are not great successes, I fear. I tried to paint floating cloud shadows—I am interested just now in skies—which I have always shirked too much; there is an inexhaustible field for beautiful variety and color."[13]

Only one of the three paintings is both signed and dated. It is the version representing the view in partial sunlight and was exhibited by the artist at the Society of American Artists in April 1893. A month later, George A. Hearn of New York purchased the landscape and in January 1894 invited Robinson to see his collection. The artist noted with some pride: "In the dining room is my Valley of the Seine between two Boudins. Mr. H. hoped that I would not object to its position and cracked a bottle of wine (champagne) which we drank" (Diary, January 21, 1894).

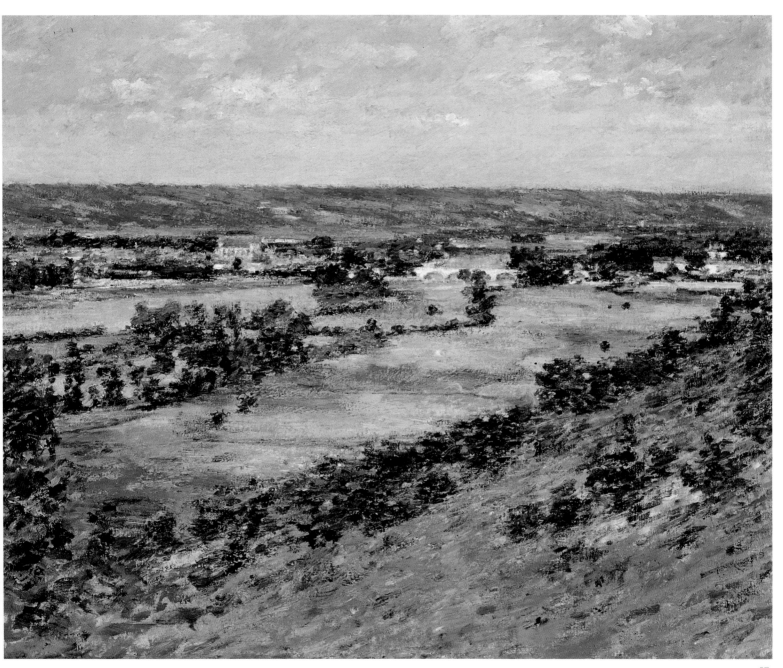

57

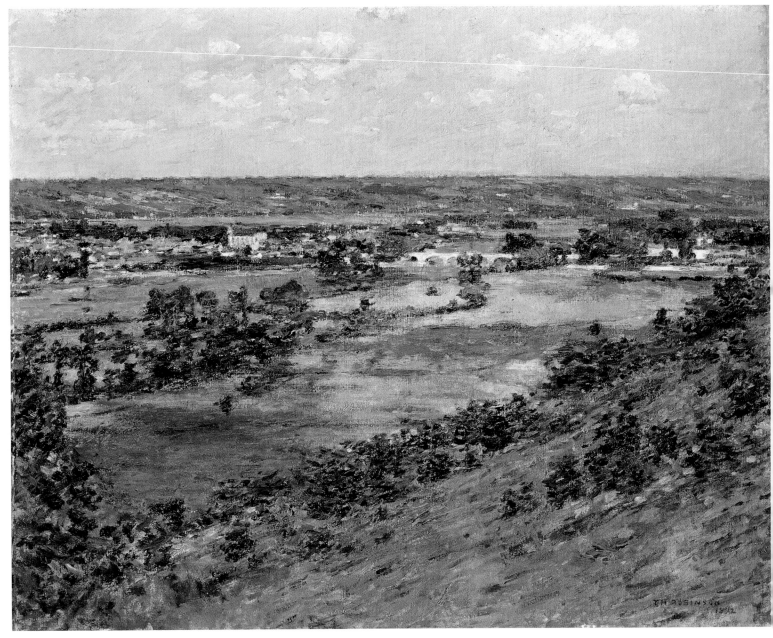

58

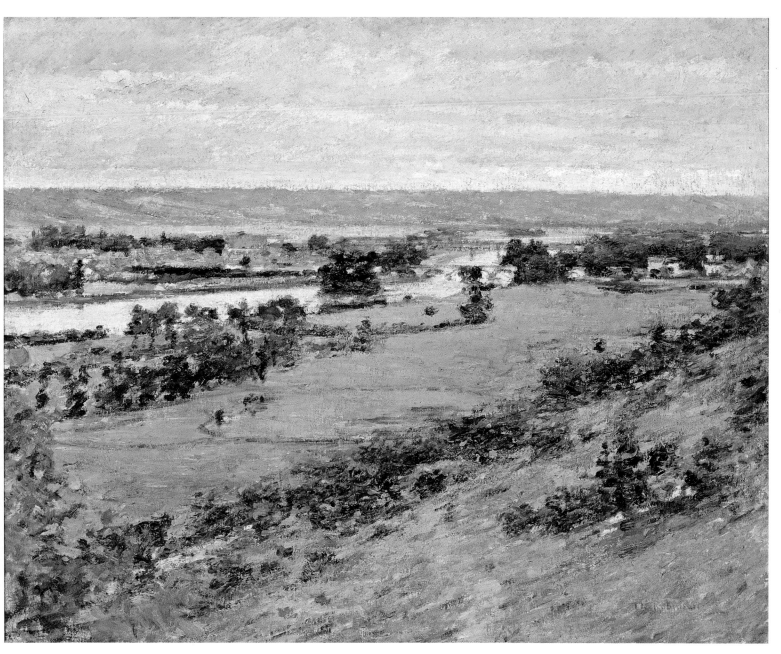

59

NOTES TO THE CATALOGUE

1 Theodore Robinson to Jacques Busbee, undated letter. Robinson's letters to Busbee from the years, 1893 to 1895, Transcript, Archives of the North Carolina Museum of Art, Raleigh.

2 See: William H. Gerdts, *Monet's Giverny, An Impressionist Colony*, (New York, London, Paris: Abbeville Press Publishers, 1993): 87.

3 Margaret Perry to Perry Rathbone, 6(?) October 1951, Archives, Museum of Fine Arts, Boston.

4 [Anonymous review], *Brooklyn Standard Union*, 1895, John I. H. Baur Papers, unprocessed, Archives of American Art, Smithsonian Institution, Washington, DC

5 Theodore Robinson to Thomas S. Perry, 23 July 1892, Thomas Sergeant Perry Papers, Special Collections, Miller Library, Colby College, Waterville, Maine.

6 Theodore Robinson to Will H. Low, 4 November 1886, John I. H. Baur Papers, unprocessed, Archives of American Art, Smithsonian Institution, Washington, D.C.

7 Katharine Kinsella to Philip Leslie Hale, 23 September 1890, Philip Leslie Hale Papers, Archives of American Art, Smithsonian Institution, Washington, D.C.

8 Katharine Kinsells to Philip Leslie Hale, 27 September 1890, Philip Leslie Hale Papers.

9 In addition to those works cited, there is a nearly identical undated version of the painting in the Smithsonian American Art Museum, Washington, D.C. and a watercolor replicating Marie's head and shoulders which is inscribed TH.ROBINSON—89 (Collection: Brooklyn Museum of Art, New York). A sketchbook drawing of a cow's head dated July 29, 1888 is also related (With Richard Love Galleries, Inc., Chicago, IL).

10 Marguerite Tracy, "A Foreground Figure," *The Quarterly Illustrator II* 8 (1894): 411–12.

11 The artist painted a second version in oil (Private Collection) and a watercolor, both of the mill in moonlight. The watercolour is dated 1892 and bears the trace of a transfer grid (Collection: Mr. and Mrs. Raymond J. Horowitz, New York).

12 For a discussion of Robinson's paintings of the mill, see: Robert J. Killie, *A New Look at Theodore Robinson's Giverny Mill Views*, Typescript, January 1987 and Gerdts, *Monet's Giverny*, 91–94.

13 Theodore Robinson to J. Alden Weir, 14 August 1892, Weir Family Papers, Department of Archives and Manuscripts, Harold B. Lee Library, Brigham Young University, Provo, Utah.

Theodore Robinson,
The Brook (cat. no. 11, detail)

Appendix

Chronology of the Artist's Life

1852

June 3: Theodore Pierson Robinson born at Irasburg, Vermont; third of six children of Elijah Robinson and Ellen (Brown) Robinson.

1856

Autumn: family settles in Evansville, Wisconsin; father leaves ministry and opens clothing store.

1860

Attends Evansville Seminary where he is awarded several prizes in penmanship; sketches family members and friends.

1869/70

With encouragement of his mother, enrolls at Chicago Academy of Design.

Stricken with severe attack of asthma, goes to Denver, Colorado to recuperate; returns to Evansville where he draws crayon portraits from photographs.

1873

April: returns to Chicago to resume art studies.

1874

In New York: enrolls in National Academy of Design; studies under Professor Lemuel Everett Wilmarth.

1875

Travels to France via Liverpool and London.

In Paris: registers for examinations at the Ecole des Beaux-Arts; joins atelier of history and portrait painter, Karl Lehmann.

1876

Enters atelier of Emile-Auguste Carolus-Duran, 81 Boulevard Montparnasse; other American students include John Singer Sargent, Will H. Low, J. Carroll Beckwith and Melville Dewey.

Summer: visits Rouen, Jumièges, Caen, Bayeux, Falaise as well as Grèz-sur-Loing. Studies at Ecole des Beaux-Arts with Jean-Léon Gérôme.

1877

Exhibits first painting at the Paris Salon: *Une Jeune Fille*, 1877.

Summers at Grèz with Robert Louis Stevenson, Will Low, Lowell Birge Harrison, and others.

1878

Continues studies at the Ecole.

April: with Kenyon Cox visits Alexandre Cabanel's Paris studio.

September through mid-December, in Italy; visits Turin, Milan, Verona, and Bologna as well as Venice where he possibly meets James Abbott McNeill Whistler.

1879

In Paris and Grèz.

Returns to New York and briefly takes a studio at 188 Broadway.

1880

Rejoins family in Evansville, Wisconsin.

1881

Returns to New York to teach at Mrs. Sylvanus Reed's Boarding and Day School for Young Ladies; also teaches a private class. Takes a studio at 1267 Broadway.

In May, elected to Society of American Artists and begins to work for John La Farge on various mural decorations.

Summer: travels through New York and Vermont.

Works for Prentice Treadwell on architectural decorations in Boston, Massachusetts.

1882

In New York at 52 East 23rd Street; also in Boston.

Summers on Nantucket and paints local island life.

December: in Albany, New York working for Prentice Treadwell.

1883

In New York at 52 East 23rd Street; works for Prentice Treadwell on decorations for the Metropolitan Opera House at 39th Street and Broadway.

Also in Boston, and Newport, Rhode Island.

1884

In New York and Boston.

Early May: visits Evansville, Wisconsin.

Spring: travels to France.

Summer and part of autumn at Barbizon.

1885

In Paris and Barbizon.

Possibly briefly at Giverny in the company of landscape painter, Ferdinand Deconchy, who introduces him to Claude Monet.

1886

In Paris, Barbizon, and Boissise-la-Bertrand on the Seine River near Melun.

LATE 1886 OR EARLY 1887

December: returns to US for short visit.

1887

In Paris, Barbizon, Dieppe, and Giverny.

January and April: in Barbizon with Canadian artist, William Blair Bruce.

June 24: at Giverny.

June 25: at Dieppe.

September 18, 1887 through January 4, 1888 at Giverny (Hôtel Baudy Guest Register).

1888

In Paris at 3 rue Dumont d'Urville with wealthy acquaintance, John Armstrong Chanler

At Giverny. (Note: No listing for Robinson appears in the Hôtel Baudy Register in the spring and summer of 1888).

Summer: American artist, John Leslie Breck inscribes painting, *Yellow Irises*, to Robinson at Giverny.

December: returns to New York and stays briefly at 80 East Washington Square.

Jardin éditeur, Vernon, Vintage postcard,
GIVERNY (Eure) – Rue de l'Eglise, undated,
Courtesy Musée d'Art Américain, Giverny, Terra
Foundation for the Arts

1889

In New York at 123 5th Avenue.

May 4: sails to France.

At Giverny: May 12 – December 12 (Hôtel Baudy Guest Register).

1890

Early in the year, returns to New York; takes studio first at 42 West 15th Street; then 11 East 14th Street which he keeps until his death.

May: awarded Webb Prize at the Society of American Artists for his *Winter Landscape*, 1889 (cat. no. 8).

At Giverny: May 19 – November 3 (Hôtel Baudy Guest Register)

Also in Paris: chez: M. Raynal, 14 rue du Seine (1890 Salon cat.).

December: begins extended sojourn to Italy, and southern France.

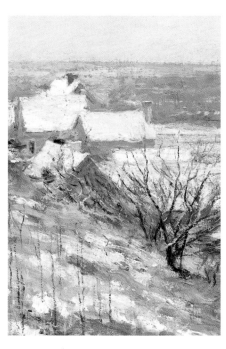

Winter Landscape (cat. no. 8, detail).

1891

January – March: at Frascati and Rome.

Late March: at Antibes.

April 6 – November 20: at Giverny (Hôtel Baudy Guest Register).

Early December: returns to New York.

1892

January – May: in New York.

March 22: writes to Monet and offers to bring him American plants for his gardens.

Awarded Shaw Fund Prize at Society of American Artists for *In the Sun*, 1891 (see Appendix, Correspondence, p. 190).

March 29 – April 7: in Boston for joint exhibition of works with Theodore Wendel at Williams & Everett Gallery; also visits private collections of Quincy Adams Shaw and Mrs. Montgomery Sears as well as St. Botolph Club exhibition of Monets organized by collector Desmond Fitzgerald.

April 7: to New York.

April 8–11: in Greenwich, Connecticut to visit friend, John Henry Twachtman.

April 20: writes Thomas S. Perry in Boston thanking him for return of paintings from exhibition at Williams & Everett Gallery; works on a view of Madison Square.

May 7: sells Giverny painting *Gossips*, 1891 (cat. no. 26) to Mrs. Nathaniel Thayer of Boston.

May 9: receives close friend, J. Alden Weir, who is concerned about rumors of his possible marriage in France.

May 13: departs New York for France.

May 22: arrives at Rouen and travels on to Vernon and Giverny.

May 23: calls on Monet and speaks of his admiration for *Rouen Cathedral* paintings.

May 25: at Giverny; writes to Weir; describes Rouen and Monet's *Cathedrals;* notes pleasure in friendship with Monet.

May 29: works at Vernon near the bridge crossing the Seine River.

June 1: receives Ferdinand Deconchy who is living at nearby Gasny; they discuss Emile-Auguste Carolus-Duran and Jean-François Raffaëlli.

June 3: celebrates 40th birthday; visits Monet who bemoans his own lack of verve in his work.

June 4: begins series of three paintings entitled, "vue de Vernon"(cat. nos. 57, 58, 59).

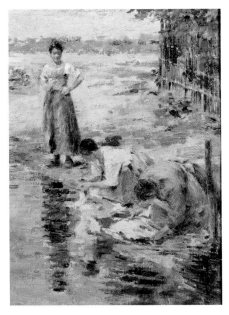

Gossips (cat. no. 26, detail).

June 9: at work on "vue de Vernon" series; begins a meadow view with three tall poplars in the evening (cat. no. 16).

June 10: dines at Monet's house with Deconchy and American painter, Theodore Butler, who will marry Monet's step-daughter, Suzanne Hoschedé in July.

June 12: works on "vue de Vernon" series.

June 14: continues efforts on "vue de Vernon" paintings; visits Deconchy at Gasny; they discuss Camille Pissarro.

June 18: to Paris; sees Berthe Morisot exhibition at Boussod, Valadon et Cie.

June 19: Paris; visits Salon Champs de Mars and dines with Will Low and wife.

June 20: Paris; visits American painter, John H. Johnston, where he sees Whistler who has taken a Paris studio.

June 21: at Giverny; visits Monet and discusses mutual liking of Giverny countryside; admires early Monet view of Vétheuil in studio.

June 24: works on "vue de Vernon" series.

June 25: tours environs of Giverny with Deconchy.

June 29: continues to work on his "vue"; begins a canvas that includes the local church of Sainte Radégonde.

July 3: mentions that Hôtel Baudy is crowded; dines at Monet's with Theodore Butler; speaks of his admiration for Monet's portrait of Camille Monet on her deathbed which is on wall in Monet's "chamber."

July 4: visits Vernon across Seine River.

July 6: learns of impending marriage of Monet and Alice Hoschedé.

July 9: takes photographs of Monet family and of Suzanne Hoschedé.

July 12: expresses discouragement with his "vue de Vernon" series.

July 13: travels to Mantes with close friend and model, Marie; Will Low and wife visit Giverny.

July 16: wedding of Monet and Alice Hoschedé; dines with Deconchy at Monet's; also present are Gustave Caillebotte and Paul Helleu.

July 18: receives Deconchy who has brought his canvases for Monet to review.

July 19: addresses announcements of Monet's marriage to Americans, James Sutton of New York, Boston collector Desmond Fitzgerald, and the Perry family.

July 20: describes wedding of Theodore Butler and Suzanne Hoschedé.

July 21: visits villages of Gasny and Blaru.

July 23: in a letter to Thomas S. Perry, describes the weddings of Monet and Alice

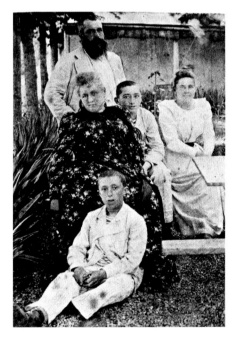

Detail from *The Monet Family*, 1892

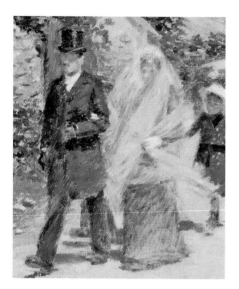

Detail from *Wedding March* (cat. no. 34).

House with Scaffolding, (cat. no. 17, detail).

Hoschedé, and Suzanne Hoschedé and Theodore Butler; works on his "vue de Vernon."

July 25: walks to Vernon and sees interesting "motifs" to paint but feels that he must look further than Giverny environs for subjects.

July 27: begins a painting which he titles "Audrey" using a photograph of Marie.

August 3: finishes Emile Zola's novel of the Franco-Prussian War, *La Débâcle,* (1892).

August 5: begins *Wedding March* (cat. no. 34).

August 9: Boston artist, Philip Leslie Hale, brings banker Henry G. Marquand to see his paintings.

August 10: visits Monet; discusses art and painting; Marquand buys small version of *Layette* (cat. no. 43) for his Boston partner, "Mr. Blake."

August 14: writes to Weir; mentions visitors to Giverny and speaks of his own progress on various compositions.

September 5: receives Deconchy and they both visit Monet; dines with Monet and urges him to travel.

September 6: receives a copy of his article on Monet written for *Century Magazine* from Thomas S. Perry in Boston (see Appendix, Reprint).

September 14: calls on Monet who thanks him for the article.

September 15: receives Monet who comments on his canvases.

September 16: works on *House with Scaffolding* (cat. no. 17) urged on by Monet's favorable comments about the painting.

September 19: visits Vernon; moves into Hôtel Baudy.

October 3: calls on Monet; notes that greenhouses are finished; Monet informs him that Mary Cassatt liked his *Century Magazine* article.

October 4: works on painting "grey champs de Mauves" (cat. no. 52).

October 5: speaks of liking Monet's paintings that are spontaneous rather than those that are too studied like his square "whirl" series of 1891 (possibly the *Poplar* series).

October 10: continues efforts on "grey champ de Mauves."

October 11: at work on both *La Vachère* (cat. no. 40) and a pair of "champs de Mauves" paintings.

October 18: works on *La Vachère*; visits Giverny locale from which he painted his "vue de Vernon" series.

October 19: works for the last time on his pair of "champs de Mauves" canvases.

October 25: dines with Theodore and Suzanne Butler, and Monet's stepson, Jacques.

October 30: at work in nearby Gill's garden on the large version of *Layette* with model, Yvonne; notes departure of various Americans from the village.

October 31: in Paris to lunch with Will Low.

November 1: works on his "large" *Layette* and visits Monet to see greenhouses.

November 6: photographs Josephine Trognon and her family; begins a small canvas of the little mill from the river plain.

November 9: begins a painting he describes as "Miss Brady in a cloak."

November 10: continues efforts on "Miss Brady."

November 14: works on "mill in sunlight." (cat. no. 53)

November 20: makes further progress on "mill in sunlight" but regrets staying at Giverny so late into the year.

November 21: to Paris.

November 27: in Paris; lunches with Marie and says farewell.

November 28 or 29: returns to Giverny, photographs "little mill" and prepares to depart.

November 30: receives Monet and family; they review his paintings; visits with Theodore and Suzanne Butler.

December 2: departs Giverny for New York via Le Havre where he dines with Jacques Hoschedé before embarking.

December 12: in New York; sees Society of American Artists exhibition.

December 24: to Greenwich, Connecticut for holiday with Twachtman and his family.

December 26: in New York; William Merritt Chase visits his studio.

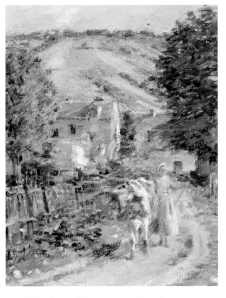

Road by the Mill, (cat. no. 53, detail).

1893

January – May: in New York at his studio, 11 East 14th Street.

March 6 – April 1: in Chicago to tour site of the World's Columbian Exposition; also travels to Cobham, Virginia with friend, John Armstrong Chanler.

April 23: to Greenwich to see Twachtman.

May 17 – 18: in Greenwich with painter Henry Fitch Taylor.

May 20: journeys to Morristown, New Jersey with Taylor.

May 15 – July 10: at Greenwich and paints a small number of works.

July 10 – October 30: at Napanoch, New York near the Delaware and Hudson Canal;

teaches summer class under auspices of the Brooklyn Institute of Arts and Sciences.

October 30: – end of December: in New York (possibly makes a visit to Vermont).

1894

January – May 16: in New York at 11 East 14th Street.

May 11: to Branchville, Connecticut to visit Weir family.

May 16: to Greenwich.

June 6 – July 10: works at Cos Cob, Connecticut with Henry Fitch Taylor.

July 10 – August 22: at Princeton, New Jersey; teaches summer class for the Brooklyn Art School at Evelyn College.

August 22 – September 3: returns to Cos Cob to paint.

Mid-September – November 14: paints at Brielle, New Jersey.

October 25: at Brielle; writes to Monet and speaks about painting at the New Jersey shore; expresses fondness for Giverny; hopes to return to France in the spring (see Appendix, Correspondence, TR to Claude Monet, 25 March 1894).

November 14: returns to New York

1895

In New York at 11 East 14th Street.

January: teaches Robert Vonnoh's class at the Pennsylvania Academy of the Fine Arts in Philadelphia.

February 2 – 16: first solo exhibition of thirty-three paintings is organized by the Macbeth Gallery in New York.

February – March: troubled by increasingly poor health due to chronic asthma.

April 8: travels to Vermont and settles at Townshend from May 16 through November 21; teaches summer class and paints landscape views and rural life in the village much as he had done at Giverny. Throughout summer and autumn, expresses in correspondence with friends, his pleasure in painting in Vermont.

November 21: to New York

December 5: writes to young artist friend, Jacques Busbee, and speaks of happiness derived from being in the Vermont countryside; expresses satisfaction in painting American vs. European scenery.

1896

January – April: in New York at 11 East 14th Street.

February 6: writes to Monet; talks of returning to Vermont which he describes; mentions desire to visit France (see Appendix: Correspondence, TR to Claude Monet, 6 February 1896)

April 2: Theodore Robinson suffers an acute asthma attack and dies at the home of cousin Agnes Cheney, 258 West 55th Street. His body is returned to Evansville, Wisconsin for burial.

Diary of Theodore Robinson
References to Claude Monet, 1892–1896

1892

April 4 –
At the St Botolph some fine Monets (21),[1] the "Hills of Vétheuil delightful—slightly painted but true and *vibrant*.[2]

May 23 –
Called on Monet—most cordially received. He was at Rouen in the winter and did a number of Cathedral things. "j'ai cherché comme toujours. j'ai voulu faire de l'architecture sans faire les traits, les lignes." They are noble canvases, well filled up, and conveying a fine idea of grandeur and solidity—one grey day is colossal. The sunshine ones are handsome, but as he says, makes one think of the south, Venice or Sicily . . .

June 3 –
Called on Monet. He said that he regretted he could not work in the same spirit as once, speaking of the sea sketch Sargent[3] liked so much. At that time anything that pleased him, no matter how transitory, he painted, regardless of the inability to go further than one painting. Now it is only a long continued effort that satisfies him, and it must be an important motif, that is sufficiently <u>entraînant</u>.

He agreed with me that it was a pity one could not always paint freely, all sorts of things, without thinking too much of their importance. He said that it took courage—in speaking of Mirbeau[4] to talk about Carolus[5] as many think but no one has yet done, in cold print. In speaking about the possibility of an <u>affair</u>, said Mirbeau had had several. Sargent is very doubtful about the success of his Boston decoration,[6] and wanted Monet's advice . . . Said, in regard to the chase after light painting—the painters, following each other like sheep, that one sighed for a black picture. "<u>La fait défaut</u>." It is painfully true, both in subject and painting, never was there less independence or real integrity—honesty with a few exceptions, Whistler, Rafaelli, Lebourg, Ary, Renan, Puvis.[7]

June 10 –
Dined at the Monets—Deconchy, Butler, & the family, 11 in all. Mme. H. rather handsome—her grey hair. We dined in the garden, very well—a large dish of <u>écrevisses</u> made a good deal of merriment. In talking of his changing, Monet said he once liked Daubigny—now, not at all. The contrary with Ingres—who he said was a realist—could not bear Delacroix.

Very amusing after dinner the promenade in the garden to see the flowers—one a night-blooming kind. We all had Chinese lanterns—the <u>gamines</u>, two or three apiece.

June 19 –
Salon ch. de Mars. The Street—in autumn sunlight by Raffaëlli has a good deal of Monet's <u>desideratum</u>, mystery, and the little figures so spiritually done—the whole in fact curiously full of detail, yet the effect is broad and fine—a fluidity and freeness of <u>faire</u>.

June 21 –
Called on Monet who has the little square picture by Mme. Berthe Morizot.[8] Light greens a house and two vague figures in the background. Greenish sack and a yellow bowl in her hands—the head is delicious. Also a Renoir I liked less—he

called attention to its suppleness—(a nude). He had been on a little trip down the Seine yesterday and came back as always with an increased liking for this place, which I was glad to hear, its variety and charm. He agreed with me that it was not too picturesque—the *motifs* didn't jump at you at once, but required seeking. An early Monet, Vétheuil, pretty but not so fine as Fitzgerald's.[9] He has few of the early canvases left, there has been such a call for his work.

July 3 –
Dined with Butler at Monet's. Some good things in Monet's chamber. The canvas of Mme. M. After death—extraordinary for impression and verity.[10] A good little Pizarro, some peasant women sticking peabrush, amusing enchevêtrement of arms like a Greek frieze. A pastel—girl's head by Mme. Morisot. w.c. by Jongkind[11]—Monet thinks them better than his oils— which were generally done from them. He would go out with sketchbook, w.c. box and bottle of water and do a number in a day—sometimes 15 or 20. M. spoke of a Jap. who has started a house—the first—in Japan for the sale of European art. He liked much Monet's work—bought the bully canvas of Germaine with her arms full of flowers.[12] Dinner very pleasant on the *perron*, a good dinner. Speaking of Whistler—he is frequenting the French aristos—Mme. Greffalhi—the Duc d' Annali, etc.[13]

I saw some things by Mlle. Blanche,[14] she has improved greatly since I saw her work last—a spring landscape, sold to Potter Palmer quite charming—Monet said she ought to work away with from him—they both like to work together.

July 6 –
The Gills[15] came to see my croutes, and told me that on the 12th—Monet would marry Mme. Hoschedé. Looking at a pastel by Degas—a stout woman bathing in a chamber— Monet said he valued Degas drawing only, and said it was a common trick of his to make the frame assist and complete the picture. Thus the light in the pastel falling on the figure and clothing lying near, was low-toned and grey, which passed by help of the frame, for which he searched a good while to find the particular shade of satin which covers it. It is a very cold grey slate color, throwing by contrast light into the picture and making particularly rich a lot of red tones on the walls. The picture was sold to Monet with the stipulation (from Degas) that the frame must be kept. Monet got one of the little water-colors by Jongkind at the sale, not dear. It appears that for the collection—the only interesting valuable Jongkind water-colors are views in Holland with windmills.

July 9 –
Took 2 clichés—one of Mlle. Suzanne, the other of Monet and the family[16]—Jean had just arrived from Alsace—was

indignant at the way he had been catechized at every stop, and especially at the frontier by German gens d'armes.

July 16 –
With Deconchy dined at Monets—his marriage with Mme. H. took place in this a.m. At dinner were Caillebotte, figure sympathique, Helleu[17] who is painting at Versailles and is enthusiastic over the beauties of the place—is doing among other things the Grandes Eaux.

July 18 –
Cold—grey day—Deconchy came—showed his canvases to Monet, who told him there was real progress—

July 20 –
A great day—the marriage of Butler & Mlle. Suzanne. Everybody nearly at the church—the peasants—many almost unrecognizable—Picard[18] very fine. The wedding party in full dress—ceremony first at the *mairié*—then at the church. Monet entering first with Suzanne. Then Butler and Mme. H.—considerable feeling on the part of the parents—a breakfast at the atelier—lasting most of the afternoon. Frequent showers. Champagne and gaiety—a pretty blonde, Mme. Baldini amusing, Dyce and Courtland Butler—flirting

with and kissing her.[19] Dinner and evening at the Monets—bride and groom left at 7.30 for the Paris train Monet rather upset and apprehensive, which is perhaps natural enough—I had to reassure him.

July 21 –

[Re: legion d'honneur]
Only last winter Monet and Renoir were approached, and decided to refuse—"une pose, peut-être, à refuser," Monet said in talking about it to Deconchy.

July 29 –

A good criticism by Monet on a canvas of Deconchy's—sunlight and shadow—little spots of sunlight on ground were too much "spots of paint"—not observed closely enough—too little mystery.

August 10 –

After breakfast called on Monet—he had brot back two charming canvases—cliff & sea—light and prismatic in color. He said he had quite lost the power of doing a thing at once and letting it go at that—as he did 25 years ago—now he wants to feel that he has the time to keep at a thing for a certain space of time. They made a tour of the coast and found Etretat charming as ever.[20] He probably feels the charm (as I do) more and more of a country or place he has worked in and got to know.

September 5 –

Deconchy came this a.m. and after breakfast we called on Monet—busy super-intending his serre—Mlle. Blanche was painting in one of the alleys. In the eve, dinner with the family—Monet very fine in his ruffles and dark blue clothes—his découragement continues—I advised a journey—but he hates to leave while building is going on. He spoke of Turner with admiration—the railway one—and many of the w.c. studies from nature . . . Pizzarro visited here the other day fresh from London . . . said he envied Monet's abstention from work—4 months.

September 8 –

An amusing letter from T.S. Perry and the Sept. Century with my "Monet."[21] It is a disappointment quant aux illustrations, and they have not used one of Monet's sketches—much to my disgust. Some of the letter-press appears to me not too bad—in spots—but it is over-concise and foolish in parts—one doesn't write well without an effort and infinite pains. I like the spirit of the article—enthusiastic and written con amore—as I felt then—the enthusiasm of the young convert. Now, I am unchanged—but perhaps less exuberant in my liking.

September 14 –

Called on Monet who was most charming—thanked me for my article (Century) and was civil about the illustrations—liked best perhaps the "near Mentone,"[22] said the portrait was not bad. Jacques[23] had translated (the thing) for him, he liked the paragraph saying there was no sense of fatigue, of abatement of interest in his painting. And he spoke of stupid people saying, "you are going to finish that, you are not going to leave that comme ça." "Mais pourquoi pas?" Why not indeed, and who is the judge when to stop, if not the painter. This exhortation of others to "finish that" has weighed on me all my life. He spoke of the possibility of the "new school" not being represented at Chicago.[24] They, of course, will not send to a Beaux-Arts committee—and doubt is entertained about a separate exhibition being arranged—the only thing to do. I translated a rather foolish article by George Moore[24] from the London Speaker, damning with faint praise Monet calling him inferior to Pizzarro and Sisley—brilliant, superficial, lacking in mystery—and self-confident cock-sure, a curiously false criticism—to be taken by contrary, like a great deal of art criticism.

Monet will make a voyage later, when his green-house is finished: "of isolation and work" he does not know where.

once and letting it go at that — as he did 25 years ago. — now he wants to feel that he has time to keep at a thing for a certain space of time. They made a tour of the coast and found Etretat charming as ever. He probably feels the charm (as I do) more and more of a country or place he has worked in and got to know. Some painters at a place Aizier(?) in the Seine opposite Tancarville.

Mr. Marquand bought my little "Layette" for $300. for his partner Mr. Blake of Boston. who he says has been most kind to the Hales. The elder H's came later to look at my things — charming old people. Did a pochade in the meadow — a young cow — I must do more — It will do me good, once in a while to do a thing directly and at one sitting — getting as much as possible.

Phil. Hale did a very good little portrait of Mrs. M. on a panel. — good in character and refined in color.

Told by Scherer — The Whale and the Sole meeting, The Sole says "Ah. Whale." The Whale replies "Ah Sole!"

September 15 –

A call from the Master who saw my things—he liked best the "Vue de Vernon"—the one I tho't nearest my ideal—he said it was the best landscape he had seen of mine—he liked the grey—the other sunlight one less.[26] Some undecided tones in the "moulin" around the figure and values rather equal.[27] The "lever de lune," fore-ground "de la peinture" the poplars against the rose sky, good.[28] The "Vernon river bank" with trees—a good start, it was a pity I stopped.[29] En somme, not a bad summer if one has one good thing as he considered my "Vue." The "Marie au petit Pont" amusing.[30] The "derriens le Grand" not worked on too much, but a difficult motif of greens very slightly different in which I failed to get the exact note, the question of paint unimportant, either more or less provided the result is good. He had received a clipping from Galignani[31] with a part of my article reprinted. He spoke of meeting de Maupassant at Etretat—while painting a storm— de M. made an article on three painters he had met— Courbet, Corot, and Monet.

An enthusiastic letter from the Perrys felicitating me for the article on Monet and a suggestion that I might win a reputation as an art critic!

September 16 –

Monet called my "Noce"[32] curieux—said a good word for the Marie Trognon & bébé [33]—but en general the figure things left him cold. He liked the motif with the scaffolding, said I must finish that.[34]

September 19 –

Letter from Jaccaci[35] who likes my Monet article—full of ideas, etc. I now see that it was much too condensed, or rather the ideas were suggested rather than dwelt on enough to make them clear, except to a limited circle.

October 3 –

Called on Monet. His green-house most completed—the garden very lovely in color—the little sun-flowers especially. He had commenced a canvas the other day and scraped it out.—sunflowers and green grass. Miss Cassatt spoke of my article and portrait in the Century—which she liked A letter from a Phil. lawyer, Hart, & ch'm of Penn. Acad. Fine Arts committee,[36] finds my article unsatisfactory and would like to know M. Monet's "own views and aims," and about his palette and colors. He [Monet] understood that these things might interest a painter, but was a little puzzled that an outsider was curious in that direction. He spoke of the way certain of the public regarded the new school.

October 4 –

Monet characterized Detaille[37] and the military painters as "Peintres de boutons."
[In reference to Degas]
According to Monet, his eyes are failing, and he has a *manie* for working on things done sometime ago, often scraping and ruining them—working in a different spirit or manner.

October 5 –

In Monet's own work, I like best the things directly painted, and less, some that have been "pushed" almost to the point of worriment, as for instance one of the big, square canvases of the "whirl" series, 1891.[38]

November 1 –

P.m. called on Monet—the green-house finished and full of flowers in pots. He said that Degas will have an exhibition soon at Durand-Ruel's. He told Monet, on meeting him at his peupliers (exhibition) that his rêve est de faire le paysage. Paysage de fantaisie—the nude woman with her chevelure and forms.

November 6 –

Two items in *Petit Journal*. M. Jules Breton gives up his commission—panel–landscape in *Hotel-de-Ville* and it is given to P. Lagarde 10 *voix*, against 4 to Claude Monet.[39]

November 21 –
To Paris—to Durand-Ruel. Degas show on—it is very
curious . . . A charming Monet at Gimpil's Bd Montmartre—
a winter thing and a pastel.

November 30 –
Call from Monet & family after breakfast. He did not care for
many, said I ought to have success with the "Vue de Vernon,"
he liked the "cows and baby" (M. I will try cows—perhaps
next summer, seriously.).[40] The snow thing I saw at Gimpil's
was a pochade. It was delightful. Foreground in shadow, and
in the distance, snow-covered roofs, sunlight falling on them
here and there—lively rose sky. It was at Argenteuil, done at a
sitting. A pleasant visit, and all drank to my safe journey.

December 1 –
Deconchy arrived early and we went to Monets to breakfast.
Met Mirbeau, a roux tall, stoops a little and damns most every
thing and everybody, in most interesting fashion . . . He and
Monet were fine discussing very earnestly and often
disagreeing tho' sympathique in many lines. And Monet's
appreciation was often to me, much finer, more direct and
simple, the other man having a literary way of looking at
questions of art. In talking of Carrierè's art . . . according to
Monet, pleases literary men and should painters less, who
think, and rightly—too, first of their material with which they
appeal first to what? Not the heart or mind, but the eyes. I
remember M. said of C. once that he was a great
draughtsman "il dessine bien."[41]

A charming send off and cordial good wishes by the
family, Deconchy and Monet for my return.

December 2 –
To Harve and p.m. dined with Jacques Hoschedé. He said
Monet's present loaf was the longest he had made—now six
months and more—the longest before was 3.

NEW YORK

December 13 –
Worked putting things to order and writing . . . My "Vue de
Vernon" really seems to me quite charming in the frame.
Monet said I ought to have a success with it. It remains to
be seen.

December 14 –
P.M. at the Sherwood. The Blashfields, Beckwiths and Miss
Hallowell . . . Four of the Cathedral Monets were bought by
Potter Palmer last spring—making his total collection 40.
Miss H. says he is very fond of them in an ignorant sort of
way—has a no. in his dressing-room.[42]

December 15 –
Weir read one of my letters (about Monet's Cathedrals) to his
pupils at the League last spring—he said it was received with
much enthusiasm.[43]

December 30 –
At the Dunhams. 10 p.m. to meet the pianist—Paderewski . . .
La Farge gave me a most complimentary word, linking my
name with Monet's and condemning Weir—which left me
assez froid.[44]

December 31 –
Call from Miss Hallowell and Miss Fay who gushed
considerably—how much they liked my things, etc. Miss H.
seemed to like my "Valley of the Seine"—she gave me a card
to Spencer[45] and wanted my opinion on his Monets. Sargent
spoke of them once as being very swell.

long – full of blunders and more o less idiotic lauda-
tion – sent to Miss Bickington by her aunt.
　　Caught in the rain again this a.m. on the
cité – will stop working there soon.
　　18 Cold – grey day – Deconchy came – shwd
his canvases to Monet, who told him there was a
real progress – commenced with model in garden
– too cold for comfort.
　　19 Heard of Stewardson's sad death – by
drowning, at Newport. Addressed several of the
marriage "Faire-parts" to parties in America –
Sutton, Perry – Fitzgerald, etc. Cold and beastly
have a model. young girl but too cold for comfort.
　　5 p.m. a tea by Mrs. Metegard – some
30 people – 14 females and the Lord forbid I
get caught again soon at such a gathering.
At table d'hôte dinner – 26 people.
　　20 A great day – the marriage of Butler &
Mlle. Suzanne. Everybody nearly at the church – the
peasants – many almost unrecognizable – Picard very
fine. The wedding party in full dress – ceremony first
at the mairie – then at the church. Monet entering
first with Suzanne. Then Butler and Mme. H. –
considerable feeling on the part of the parents – a

1893

January 23 –

Potter Palmer called, said he came on Miss Hallowell's say—
he was agreeably simple in his ways and words. Said he
disposed of a few of his Monets he liked least—he wanted "to
buy pictures he wouldn't lose on " as the Monets and would
have something of mine later, would come with Mrs. Palmer
in Feb. of March . . . I liked the way he spoke of Monet—
whose personality and artistic conscientiousness seem to have
impressed him.

February 4 –

P.M. to Mr. Spencer's with Weir and Twachtman. Some fine
paintings by Monet, Renoir & Degas, a drawing by Millet
and a little Boudin.[46] The Monet I liked particularly was
this—a hill by the river—luminous yellow sky—two or three
little islands—foreground reeds—the whole full of color and
charming—an uncommon fine example.

February 11 –

Call from an admirer, a young art student, Busbie.[47] In
reminds me of my coming to N.Y. and calling on Homer—
only this boy has a confidence and ideas, far ahead of mine at
the time. He adores Monet, doesn't like Renoir at all, and in
general talks well, perhaps too well.

February 15 –

Rather pleasant evening at the Dunhams—Paderewski there
and a lot of pretty women, painters, etc. Parsons,[48] just now
getting ready an exhibit of his Jap. things—he spoke of
Monet—also of his own work in a slightly mercenary tone.

February 20 –

This interests me, the liking for landscapes (both in nature
and art) in America. It is very genuine and wide-spread, and it
is a good way to begin—something good will come of it if it
is directed and taught, as the canvases of Monet and others
are doing, or at least beginning to do.

February 23 –

The Loan Ex Good Monets have an extraordinary
"fullness" together with no lack of simplicity, breadth and
restraint. A notable example is the beautiful "Vétheuil"
autumn, with beautiful sky & water. The only way is careful,
slow, looking-hard-at-nature sort of working, a thought
between each touch—for fine, involved color and the mystery
nature is so full of.[49]

February 24 –

At Ortgies[50] a collection to be sold—a good Monet, on the
road near Falaise, sunlight striking inside of hill—some pretty
Cazins[51] and good Jongkinds. The Cazins suffer seen next to a
canvas like a Monet that, with other qualities, hits the note
juste frankly & squarely.

February 28 –

Lathrop[52] had called in the morning, just back from Boston—
had met a Mr. Sayles, who owned the Cureé of Courbet[53] and
some Monets and wants something of mine. Dined with him
in his flat, 29 Wash. Sq. and had a most agreeable tete à tete,
he asked a lot of questions about Monet and the modern
men—and told some things about Sargent.

March 1 –

At a sale last night a rather pretty Cazin, two stacks, just
before sunset, sold for $2500, and a fine Monet for $500!

April 21 –

Mr. Henry Sayles, of Boston called and was very
appreciative—he is a charming old gentleman with a frank
sensible way of talking—He is quite delightfully "young" and
progressive—admires Monet very much.

May 10 –

To the A.A.A. The Monets are overwhelming and—as often—
give me the blues, envious blues. They are so vibrant and full
of things, yet at a little distance, broad tranquil masses are all
one sees. They are not spotty or unquiet. There are three I
like particularly, Rouen, some boats and a lovely sky, 1872.

A lovely marine, rocks, stormy watercliffs seen thro a fish-net. Then a little river-bank, two crooked willows and hills beyond, autumn leafage, vivid greens in the foreground. Charming composition and color-scheme.[54]

May 23 –

. . . a letter from Mr. Babbott[55] who called, and wants a picture, is very appreciative, likes Monet.

July 6 –

I lose much time on the stepping-stones, but perhaps can get through when I get back, do the children a little more. The landscape is almost as good as I can make it tho' I could work longer. It has gone altogether pretty well, since the start, which seems to me vitally important, as Monet insists.[56]

August 6 –

[Referring to a friend taking one of Robinson's canvases to put along side him as he worked on his own—for inspiration re: tone/key.] The last time I did a similar thing was to copy, or rather make a pochade of Monet's "Bordighera" as a souvenir of tone, and found it was exceedingly rich in color and not very high. Many Monets are however much higher in key.[57]

August 8 –

Another "class-day" very hot. An article in the "World" about the class and its teacher, with sketches, and details about the teaching of "impressionism."[58]

August 9 -

Wrote a note to the "World"—correcting the statement that I was "a pupil of Monet."

November 30 –

I imagine the best men have been influenced for the better by Japanese art, not only in arrangements, but in their extraordinary delicacy of tone and color, and I've often noticed in Monet a subtlety, nearness of two values, almost unknown to other men, that one constantly sees in nature, especially in seas and skies.

December 26 –

Letter from Monet—he will exhibit the cathedrals in the spring, he was on the eve of a departure for Brittany. Mme. M. had been ill but was better—the little Jacques Butler is a joy[59]—A charming letter with its expressions of good will and affection. It is charming, that side of Monet's character, his affection for family and friends and way of showing it.

1894

January 2 -

A beautiful Raffaëlli at Delmonico's[60]—the Boulevards in summer—sunlight. He has perhaps stolen thunder from Monet and Renoir, but his treatment of the life of the street is his own and quite wonderful.

January 11 –

To the Union League Club[61] at 10 p.m. Met Bogert.[62] He told a malicious story but funny, of Potter Palmer who he says is in his dotage. He buys a lot of Monets, and after a while returns them to Durand-Ruel, who sell them to him again at a large advance, bien entendu. But the truth of this is rather impugned, when it is known that Mrs. Palmer always has a deciding voice, as the old man told me himself.

February 5 –

The Seney Collection very uninteresting, with few exceptions—black and tiresome. A couple of little Jongkinds, two Monets, one a little house on the edge of the cliff, the other, "Three Poplars."[63]

February 17 –

My Japanese print points in a direction I must try & take: an aim for refinement and a kind of precision seen in the best old as well as modern work, the opposite of slap-dash . . . And the Japanese work ought to open one's eyes to certain things in nature, before almost invisible, and a new enjoyment, their infinite variety of compositions, their extraordinary combinations of the convention and the reality. One thing I remember Monet speaking of, the pleasure he took in the "pattern" often nature gives—leafage against sky, reflections, etc.

February 23 –

Mr. Perry . . . He goes abroad next fall for a year or so, asked me about a good man to study landscape with. I recommended Pissarro. He had his little fling at Monet— thinks I am a better painter!

April 25 –

Call from Hamlin Garland[64]- . . .
He tells a story of Monet, new to me. A young man shows him a landscape done much in his manner—too much, in fact. Monet asks—"And do you really see Nature like that, "Certainly, sir," "Impossible, my dear friend, that it the way I see it."

June 30 –

A charming letter from T.S. Perry, from Giverny, telling of Monet and others.

July 1 –
He [John Henry Twachtman] . . . showed us some canvases done at Niegara, very good—one square one 30 x 30—is particularly good. One, on the river, is pretty, but looks to me a little too much like Monet.

November 24 –
Met a pleasant old gentleman, Cyrus J. Lawrence, who likes the moderns—has a Degas, several Monets, Sisleys, a Puvis, etc.[65]

December 27 –
. . . . Introduced myself to Mr. Durand-Ruel [at his gallery] who was very amiable, spoke of my things which he liked . . . and asked me to consider him at my disposition if I wished to leave anything on view there. Altogether, he was most empressé.
Several good Monets, Sisleys . . .

December 31 –
At 11. a.m. to Mrs. Buckley's and in her hansom to Durand-Ruel's. Went all over the house—saw a lot of Monets, Sisleys, Renoirs and Pissarros, a bully Manet, a girl with pup in her lap . . .

1895

January 26 –
P.m. a fine show of Monets at Durand-Ruels.[66] One a lovely thing I had never seen—a river bank two or three towns—at rt. Some dark poplars—on the banks willows and grey trees reflected in the water—lovely luminous sky while the landscape has much mystery, and a lovely cool tone bathed in shadow. The whole painted with an extraordinary simplicity and directness, and is of a period that always pleases me, about "75" or a little later, when he painted as a rule a little less solidly than later, and one feels the pigment rather less. A fine big river view—some 5 feet long—a charming sky and water—little village on the rt. An island or two in the middle.

January 30 –
A beautiful Monet at Delmonicos, a bit of southern sea—a bay—with trees against the sky—all luminous, lively.

March 1 –
Many of Raffaëlli's pictures are done on a "board" of agreeable neutral color—on which he draws with a lead pencil, and begins with thin color. And many of Monet's earlier things show the same disposition to help him—in skies, etc., by a tone. I believe this is something to master,

when one considers the difficulties of getting quickly some effect of sky or atmosphere, even if the picture is less solid.

March 19 –
Saw the A. A. A.—an early Monet—Vue de Rouen is delightful, '73.

April 13 –
A letter from Monet, at Christiana, in Norway, where he had gone to see Jacques, and the country. He had not worked but was delighted with the country. His cathedrals are to be exhibited this spring in Paris.[67]

April 17 –
At Durand-Ruel's—Ex. of Miss Mary Cassatt—some studies of babies—a bit hard but amusing—souvenirs of Botticelli in the treatment of heads and decorative gowns, but one misses a little the note juste, the saving integrity seen in a good Monet or Degas.[68]

April 26 –
P.m. to the 2nd Eve of the A.A.A. sale. I was glad to see the Monets excited enthusiasm, tho' of course so did the Cazins, etc., Monet's "Floating Ice" bro't 4,200 dols. The lovely "Vue de Rouen" 2500.

June 10 –
A letter from T.S. Perry, telling about Monet's show in Paris, and urging me to come to Giverny for the summer. 49 pictures of Monet, 6 done in Norway last summer, and several of the Rouen cathedral, done last fall.[69]

July 13 –
Rec'd a proof—wood engraving—of Monet's "Rouen" which seems to me to be very good.

November 1 –
A letter from Jaccaci wanting me to write about Monet's "Vue de Rouen" for the Jan. Scribner.

November 7 –
Letter from Jaccaci—thanking me for the screed [?] on Monet's "Vue de Rouen" and hoping I'll like his department—"The Field of Art"—in Scribner's.

1896

January 3 –
Mr. Sutton showed me a couple of Monets—'94, one a cathedral, the other a fog—the old ch. at Vernon from across the river. He told me of Monet's row with the dealers, wanting 15,000 fr. Instead of 10. So they formed a compact,

Boussod, Durand-Ruel, and one or two more, refusing to buy any more and Monet still holds out.

Sutton talked as tho' he were out of it, has paid Monet's price for his cathedrale, and will exhibit the whole lot here in the spring. The one he has is inspiring and the reverse, as I used to find in the old days, calling on the Master. Others seem mesquin, commercial, pretty in comparison.[70]

March 4 –
Another letter from Van Dyke about the Corot article—they will use my Monet article also and the portrait.[71]

March 10 –
To the A.A.A. a number of Monet Cathedrals. They are bewildering at first, but the more one looks, the more of beauty and charm is disclosed, but the painting is so novel that it shocks even the faithful. And I have always found it hard to like the painting, ever so sincere and successful as it might be, that is crummy and like masonry, but like best the Monets of an earlier date, when he is always thinner, gets there with more ease, is more facile as he doubtless would say. But one gets to like and appreciate the latter, thought out, elaborate visions . . .

March 21 –
Saw the Cathedrales again in a better light—they are superb—the courageous way they are done, not slighting or slurring of any parts—and several are dreams of beauty. One evidently towards sunset, rose and green tones predominating, is especially beautiful. Also a view of Vernon Cathedral from across the river, a white mist, almost fog.

March 26 –
At Durand-Ruels—one or two early Monets—one Marine, large and simple—also a coast scene, looking along the cliff.

Robinson's spelling and punctuation have been preserved as they appear in his handwritten Diary.

The Diary of Theodore Robinson, 1892–96, is in the collection of the Frick Art Reference Library, New York.

NOTES TO THE DIARY

1 In the spring of 1892 (March 28–April 9), Boston's St. Botolph Club, an art and literary association founded in 1880, held an exhibition of twenty-one works by Claude Monet owned by Bostonians. It was organized by collector Desmond Fitzgerald, who lent five paintings.

2 *The Hills at Vétheuil* (1880, oil on canvas, W.591) was in Fitzgerald's collection.

3 John Singer Sargent (1856–1925) visited Monet at Giverny during the late 1880s and owned a number of his works.

4 Octave Mirbeau (1850–1917), art critic and novelist, was a friend of Monet and frequent visitor at Giverny.

5 Charles-Emile-Auguste Carolus-Duran (1837–1917) painted mainly portraits in a realist manner.

6 In 1890, Sargent received the commission to decorate the Boston Public Library designed by McKim, Mead & White with murals illustrating the history of religion. The project would occupy him until 1919.

7 James Abbott McNeill Whistler (1834–1903), Jean-François Raffaëlli (1850–1924), Albert Lebourg (1849-1928), possibly Ary Scheffer (1795–1858), Renan?, Pierre-Cécile Puvis de Chavannes (1824–1898).

8 This undoubtedly refers to Morisot's composition, *La Jatte de Lait*, 1890, (CR 255) which was included in the Berthe Morisot exhibition held at Boussod, Valadon et Cie, Paris in 1892. Claude Monet was the first owner of the work.

9 See note 2.

10 Claude Monet, *Camille sur son lit de mort*, oil on canvas, 1879, Musée d'Orsay, Paris.

11 Johan Barthold Jongkind (1819–1891). The Dutch painter's *plein-air* views were an early influence on Monet.

12 This is probably the work from 1888 entitled *Jeune Fille dans le jardin de Giverny* (W.1207) given by Monet to Tadamasa Hayashi in exchange for a series of Japanese prints.

13 Elisabeth de Caraman-Chimay, Comtesse Greffulhe (1860–1952) and her cousin, Comte Robert de Montesquiou (1855–1921) were prominent in Parisian artistic and social circles as was Henri Eugène Phillipe Louis d'Orleans, duc d'Aumale (1822–1897), bibliophile and collector, was a son of King Louis-Philippe.

14 Blanche Hoschedé (1865–1947), a stepdaughter of Monet, married his older son, Jean (1867–1914) in 1897. She started to paint at the age of fourteen, producing mainly landscapes in the environs of Giverny and Rouen.

15 Mariquita Gill (1865–1915), a member of the American art colony at Giverny, was often accompanied by family members on her visits to the village.

16 See Johnston essay in this catalogue for these images, 65.

17 Both Gustave Caillebotte (1848–1894) and Paul Helleu (1859–1927) served as witnesses at Monet's wedding to Alice Hoschedé.

18 This may refer to a resident of Giverny or possibly a little-known artist, Louis Picard (1861-1940), who had painted a portrait of Ernest Hoschedé (1838–1891) in 1890.

19 J. Stirling Dyce, a Scottish landscape and portrait painter, made occasional visits to Giverny in the early 1890s. Courtland Butler had traveled to Giverny to attend the wedding of his brother, Theodore.

20 Following their wedding in July, Monet and Alice embarked on a tour of Normandy, which included a stop at Petites-Dalles to visit the artist's brother, Léon.

21 Bostonian, Thomas Sergeant Perry and his wife, painter Lilla Cabot Perry (1848-1933), were frequent visitors to Giverny from 1889 to 1909. Robinson's enthusiastic article, "Claude Monet," appeared in the September 1892 issue of *Century Magazine*. See the Appendix for a reprint of this article.

22 Among the images used by Robinson to illustrate his article was Monet's *Menton seen from Cap Martin*, 1884, (oil on canvas, W.897). See Appendix for a reprint of this article.

23 Jacques Hoschedé (1869–1941) was a stepson of Monet.

24 World's Columbian Exposition at Chicago, 1893.

25 George Moore (1852–1933) was an Irish critic and novelist.

26 See cat. nos. 57, 59.

27 See cat. no. 53.

28 See cat. no. 16.

29 This is possibly a reference to cat. no. 13.

30 See cat. no. 44.

31 *Galignani's Messenger*, a daily paper printed in English, was published in Paris from 1814 until 1904.

32 See *The Wedding March*, cat. no. 34.

33 This is probably a reference to a painting variously titled *Marie Trognon and Baby* and *Normandy Mother and Child* from c. 1892. Robinson often employed members of the local Trognon family as models.

34 See cat. no. 17.

35 August Florian Jaccaci (1856–1930), an acquaintance of the artist, was both a mural painter and a writer. He is best known as the art editor of both *McClure's* and *Scribner's Magazines*.

36 This may refer to Charles Henry Hart (1847–1918), a lawyer and writer who was involved with the Pennsylvania Academy of the Fine Arts in Philadelphia and also chaired the Committee on a Retrospective Exhibition of American Painting at the World's Columbian Exposition, Chicago, in 1893.

37 Jean-Baptiste-Edouard Detaille (1848–1912) was the principal artist to record the Franco-Prussian War of 1870–71.

38 This may be a reference to Monet's series depicting, with sweeping curves, a stand of poplar trees on the banks of the Epte River.

39 Jules Breton (1827–1906), who had been commissioned to paint murals in the Paris City Hall, was replaced by Pierre Legarde (1853–1910). Although Monet had also been proposed for the decorations, he was not selected.

40 See cat no. 33.

41 Eugène Carrière (1849–1906), a painter and lithographer, interpreted maternity and family life in a symbolist manner. He also produced a number of portraits of contemporary writers.

42 Robinson's companions were muralist and illustrator, Edwin Blashfield (1848–1936) and his wife Evangeline, as well as painter James Carroll Beckwith (1852–1917), an artist friend of many years who visited Giverny during the summer of 1891. Also present was Sara Hallowell, advisor to Chicago art patrons, Bertha Palmer and her husband, Potter.

43 Theodore Robinson to Julian Alden Weir, 25 May 1892, Weir Family Papers, Department of Archives and Manuscripts, Harold B. Lee Library, Brigham Young University, Provo, Utah. In both this letter written from Giverny and read by Weir to his class at the Art Students League in New York, and in his diary entry for 23 May 1892, Robinson speaks glowingly of Monet's Rouen Cathedral views first seen by him on his return to France in May 1892.

44 James Dunham of New York and his family led a cultured life which included associations with artists and musicians among them renowned Polish pianist, Ignacy Paderewski (1860–1941). In 1892, John Singer Sargent painted a portrait of Miss Helen Dunham (Private Collection), one of the Dunham daughters. Also present on the occasion of Robinson's visit was painter John La Farge.

45 In the late 1880s, Albert Spencer of New York, who had initially acquired earlier nineteenth century French painting including works by Barbizon artists, focused his collecting interests on the Impressionists and Claude Monet in particular, acquiring more than ten works by him.

46 Jean-François Millet (1814–75) and Eugène Boudin (1824–98).

47 Jacques Busbee (1870–1947). See Johnston's essay in this catalogue, 70–71.

48 This is possibly a reference to Alfred Parsons (1847–1920), an English landscapist who lived in America for many years and exhibited at the National Academy of Design in 1890.

49 The Loan Exhibition to which Robinson refers took place in February at the Fine Arts Society in New York and included four Monets. The work he especially admired was *The Small Arm of the Seine at Vétheuil*, 1880, (W.601).

50 Ortgies & Co., was a New York auction house located at 845-847 Broadway.

51 While not part of the Impressionist movement, Jean-Charles Cazin (1841-1901) demonstrated an awareness of the effects of light and atmosphere in his landscapes.

52 Landscape painter, William L. Lathrop (1859–1938).

53 Henry Sayles of Boston (d. 1918) was a collector of mainly French nineteenth-century paintings including works by Barbizon and Impressionist artists. One of his more important acquisitions was Gustave Courbet's *The Quarry*, 1856–57 (Collection: Museum of Fine Arts, Boston). He also acquired a selection of works by American artists of the period.

54 This exhibition at the American Art Galleries, New York, included works by Monet and Claude-Albert Besnard (1849–1934). Three of the Monets to which Robinson refers are *View of Rouen*, 1872 (W.217), *Fishing Nets at Pourville*, 1882 (W.769), and *Willows in Springtime*, 1886 (W.981).

55 Frank Lusk Babbott (1854–1933) was a collector with broad interests including Renaissance and Impressionist art. He was a major donor to the Brooklyn Museum.

56 Robinson's composition, which he titled *Stepping Stones*, was painted during the spring and early summer of 1893 at Greenwich, Connecticut. It portrays the two young daughters of his close friend, John Henry Twachtman, crossing a brook in a light-filled, verdant setting near their home.

57 During the winter of 1884, Monet spent several weeks on the Italian Riviera where he painted a series of landscapes at Bordighera. Robinson's composition, probably from the early 1890s (Private Collection) was based on Monet's *Vue de Bordighera*, 1884 (W.853) which was owned by New York collector, James F. Sutton by 1892. Robinson's admiration for the composition is reflected in his inclusion of the image as an illustration in his 1892 *Century Magazine* article on Monet. See Appendix in this catalogue for a reprint of this article.

58 During the summer of 1893, Robinson taught a painting class at Napanoch, New York under the auspices of the Brooklyn Institute of Arts and Sciences.

59 This may be a reference to James Butler, son of American painter, Theodore Butler and his wife, Suzanne Hoschedé, who was born in 1893.

60 L. Crist Delmonico, a dealer located at 166 Fifth Avenue in New York, handled mainly contemporary French painting.

61 Much like the St. Botolph Club in Boston, New York's Union League Club arranged regular loan exhibitions, which were open to the general public. Similar loans shows took place at the Century, Lotos, and Grolier Clubs. In February 1891, the Union League Club held an exhibition of Claude Monet's work.

62 George H. Bogert (1864–1944), a landscape painter, studied in Paris in the 1880s and later at the Art Students League in New York. His works were acquired by several prominent American collectors including George H. Hearn.

63 George I. Seney (1826–93) acquired mainly Barbizon paintings, which were sold at the American Art Association in 1885 to alleviate financial pressures. He would subsequently resume his collecting.

64 Writer and critic Hamlin Garland (1860–1940) is remembered for his novels and short stories that describe the hardships of rural life in the mid west. He was an early advocate of Impressionism in America and frequently discussed his views on modern art and the craft of writing with

Robinson. In 1899, he would author an article on Robinson in *Brush and Pencil* (September 1899).

65 New York industrialist, Cyrus J. Lawrence (1832–1908), had lived in France in the early 1870s and acquired a taste for contemporary French art. In addition to those painters named by Robinson, his collection included works by Boudin, Pissarro, and Antoine-Louis Bayre.

66 This exhibition, which included forty-eight paintings by Monet, took place from 12 January through 27, 1895.

67 See Appendix, Correspondence, Claude Monet to Theodore Robinson, 26 March 1895, Artist's File, Library, Whitney Museum of American Art, New York.

68 The Mary Cassatt exhibition, held during April, included twenty-six paintings, nine pastels, one gouache, and eighteen prints.

69 The Monet exhibition at Durand-Ruel, Paris, was on view May 10 through 31, 1895.

70 James F. Sutton of New York (d. 1915), a specialist in Chinese ceramics, was one of the founding members of the American Art Association and became a major collector of Monet's work. The firm was to become the premier auction house of its time. The exhibition of fourteen of Monet's Rouen cathedral paintings took place at the American Art Galleries in March 1896.

71 The articles to which Robinson refers, one on Camille Corot and the other, a reprint of his 1892 piece on Monet (see Appendix, Reprint), were published in John C. van Dyke, ed., *Modern French Masters: A Series of Biographical and Critical Reviews by American Artists* (New York: The Century Company, 1896).

Correspondence:
Theodore Robinson and Claude Monet

TR to Monet: Frascati, 6 January 1891

Source: Getty Research Library, The Getty Research Institute, Los Angeles (860757)

Monet to TR: Giverny, 26 February 1891

Source: Photocopy of original letter, Frances Mulhall Achilles Library, Archives; Whitney Museum of American Art, New York

TR to Monet: New York, 22 March 1892

Source: Getty Research Library, The Getty Research Institute, Los Angeles (860757)

TR to Monet: New York, 17 August 1893

Source: Getty Research Library, The Getty Research Institute, Los Angeles (860757)

TR to Monet: Brielle, NJ, 25 October 1894

Source: Getty Research Library, The Getty Research Institute, Los Angeles (860757)

Monet to TR: Norway, 26 March 1895

Source: Photocopy of original letter, Frances Mulhall Achilles Library, Archives; Whitney Museum of American Art, New York

TR to Monet: New York, 6 February 1896

Source: Getty Research Library, The Getty Research Institute, Los Angeles (860757)

Theodore Robinson to Claude Monet
Frascati (near Rome)
6 January 1891

Dear Mr. Monet,

I spent the month of December on the island of Capri near Naples—there was a little too much rain and wind. It is a region where there is much sun, perhaps like the Midi of France. There are many interesting things—the cliffs, very high, and many olive trees particularly on the coast. In the areas which are somewhat sheltered from the wind, lemons and oranges grow. The women are beautiful—and the children adorable, I have never seen so much kindness, and the men are much more distinguished than the Italians in general. One sees those who are very dark almost Moorish. One supposes they are of Saracenic origin. Several women of the region have married foreign painters—the last instance is of a friend (American) and a Belle of Capri, a very beautiful woman. You may have seen the pretty thing done by Sargent on Capri ten years or so ago of a profile of a young girl with a purity rare enough. It is she—Donna Rosina that has married my friend, and I am currently with them. We live very simply, in the Italian fashion, much macaroni, the wine of the region (Frascati), for example, is excellent, and not very expensive, 10 "sous" for a litre.

I have seen many things in Rome, among the most surprising were the Michelangelos—in the Sistine Chapel which I feel are better that I thought they would be. There are also Rococo fountains and monuments, often amusing and the old gardens of the nobility, the Borghese etc. At Frascati there are even some, they are beautiful, and make one think of Gustave Doré. The Campagna is one of the most beautiful things I have seen in Italy—a plain, immense, almost deserted except for some flocks of sheep and Roman ruins scattered about—the light of the moon, a railroad arriving from Naples. Seen from Frascati it is like the sea—one sees Rome in the distance. In the foreground, the olive trees still green, planted symmetrically. Until now, I did not have much enthusiasm for Italy. I believe that it is necessary to know a country in order to love it—at the least to live there for a while. I still feel it is not as nice as France. I plan on returning to Paris in the spring, going by way of the Riviera, Marseilles and Avignon. I will see a little of this countryside. Please give my most sincere regards to Mrs. Hochedé [sic] and to her girls, and send me news of yourselves. It seems that it is quite cold there this winter.

Very sincerely yours,

Theodore Robinson

Frascati—Province of Rome, Italy

Claude Monet to Theodore Robinson
Giverny/Vernon (Eure)
26 February 1891

Dear Mr. Robinson,

I am really sorry and mad at myself for not having answered your letter sooner but everyday brings a new problem I hadn't counted on. Well, I am giving you some excuses (bad ones, no doubt), hoping that you'll be kind enough to forgive me for the procrastinating.

I was very happy to hear from you, it was really thoughtful of you. Although you don't mention if you are in good health, I suppose this is a good sign and that you will soon be back here "frisky" and eager to start working again. I hope you'll bring back plenty of studies of the beautiful places you described in your letter.

Here we just had a wonderful winter—although very rigorous and quite long—with the sun shining everyday, and needless to point out I have a large supply of new paintings.

I am afraid I don't have any exciting news to bring you. In Giverny all is quiet and the life is slow-paced. The youngsters fully enjoyed the opportunity of skating which was offered to them. Sometimes we see some carefree and colorful people, your compatriots "checking" on the start of the spring. Spring is indeed on its way and I'm sure it won't be long until you come back to your little house here.

Everyone here asked me to give you their best regards and wishes of good health.

Hoping to see you soon and thanking you for your kind letter, I am,

Cordially yours,

Claude Monet

Probably in response to the letter of January 6, 1891

Theodore Robinson to Claude Monet
New York, New York
22 March 1892

Dear Mr. Monet,

If I return to France this year, which is very possible, I thought that there would be perhaps some things that I could bring you—a plant or flower of this country. I do not know much about them, but I know that there are some florists, and if you give me some names, I will try to find them. I had a fairly tranquil winter in New York. I have been only somewhat bothered—when it becomes too much, I escape to the countryside at a painter friend's home—an hour by train from the city. It is a property quite well arranged, with pretty motifs everywhere, without leaving his place. It is an interesting region—woods everywhere and especially many rocks everywhere, from which the barriers are made—and there are many. When it snows, it is charming— even though it is much colder than in Giverny and there is almost always blinding sunshine. Nevertheless, I have seen pretty things. I even worked a little.

There is much interest in your paintings in New York. I think that it is increasing among people of taste—I think that there is intelligence—and a great desire to learn. (I am not talking of the dealers, but the New Yorkers in general). At Mr. Sutton's, I saw some superb Monets that I did not know. [Speaks of his article on Monet and its illustrations] "Monaco" is in the process of being engraved . . . nothing could be done with the painting of Mr. Fuller . . . It takes a long time to make things happen. Articles sometimes are kept for quite a long time. The inconvenience is that one will express oneself very differently (if one does not change one's mind) in 5 or 6 years. Oh well, I hope it will appear over the course of next summer. I saw Mr. Jaccaci who visited you—the day after my departure I think. He has an article in the works also.

I see fairly often the Beckwiths—I think that Mme. B. has spoken so much of Giverny that you will see her friends this year. We are having quite a good time at their home. It is a place where there is much gaiety, almost French with the music, etc. and a fairly funny, cosmopolitan group of people. One speaks a lot of the Exposition in Chicago—that they will do it on a very big scale. There will be perhaps many things—especially scientific and curious. One speaks a bit too much about the splendor of the buildings, which does not interest me very much. Next week, I am going to Boston with Mr. Wendel. We have a small exhibition of our work at a dealer of that city. It is the first time I am trying this. It is often done in Boston—here one is modest, or at least there is something that prevents so many expositions by the lesser known people. I was told the other day at Knoedler's that they sold a painting by Mlle. Blanche. Please send my best to Mme. Hoschedé and her girls, as well as to Mr. Dechonchy if you see him.

I am always grateful,

Th. Robinson

Theodore Robinson to Claude Monet
New York, New York
17 August 1893

Dear Mr. Monet,

For six weeks I have been in the mountains—not very big, about 3 hours from New York. It is a region that is a bit primitive . . . the people, costumes, etc. and as for the countryside, I have found very beautiful things, that interest me enormously. At first, everything was a little new for me who has not passed a summer at home for ten years, and ultimately there is a fairly large variety of motifs, the mountains, the valley, a very rapid river, as there always are in regions like this. A canal traverses the valley, and one finds charming things, like line and color. The life of the boatman is also very amusing; the mules and horses pull large boats, where a whole family lives sometimes, babies, large dogs, etc., or sometimes Negroes. The children assist seated on the horses or running along side. One sees the red coverings on the ears of the mules. All in all, many picturesque details, the reflections in the water, the thin horses like those in Don Quixote. In sum, it is a curious life to see here, where in general, all is so new, and disagreeably new, the telephones, electric lights, etc. Therefore, for the moment, I do not miss France, I want to do things with independence, as much as possible, I am very preoccupied with the whole thing, to see everything in nature and on my canvas, and the hunt for color and for a great accuracy of tone continues. I'd think often of a beautiful thing by Flaubert: "honesty is the first condition of the aesthetic." Anyway, I hope to make great progress this year and the next. And I am happy that all this interests me so much. Otherwise, I am doing well here, it suits me. It is the heat of Africa, but healthy, very dry, no rain for a month now, and the dust as in Naples, everything is covered along the paths. Not much grey weather, but on the seaside, there is more often. I went to Chicago in the spring before the opening of the Exposition. It is a bit shocking, the absence of modernity, of the new, it has the air of being made by good students of the Ecole des Beaux Arts, and one tells you with pride, "It's very large, ten times larger than the exposition of . . . " I will go to see the paintings later, the Exposition of the masters of the century should be very interesting. Miss Hallowell put in a great deal of care. At M. Sutton's there are some things by Besnard that have the air of being done for the Americans. There are some beautiful Monets, a View of Rouen, '72, I think, a canvas with two willows, very pretty, and a marine with nets that I think adorable in color, refined, precise, that makes me dispair. How easy it is to do "approximately" but when one wants to go further, the difficulties are enormous.

I hope to see the Cathedrals this winter in New York. Deconchy has spoken of them to me with enthusiasm. He said to me that Mme. Monet was suffering—I hope that she is doing better now. I have received the birth announcement of little Jacques in the spring; it seems that they are giving him boxing lessons already with the little Hale.

I plan on staying here this year. I will go perhaps to the south, in the winter, but I hope to return to France next year. I am happy to be after all a little bit more successful, I mean regarding monetary affairs. I am selling enough now to live modestly, and I think that it will continue. It is true that I do not have very large expenses. It is agreeable nevertheless to be a bit sure of the future, especially at my age. And I am very grateful to you dear M. Monet, your advice and words have helped me much, and at a time when I had great need. How I regret that I had not known you before, but after all, regrets are futile. Please give my regards to Mme. Monet and to the girls, and write me a word when you have a little time.

Best to you,

Th. Robinson

11 E. 14th Street New York

Theodore Robinson to Claude Monet
Brielle, NJ
25 October 1894

Dear Mr. Monet,

I am at the seashore, a rainy day that keeps me from going out—it is in the state of New Jersey, to the south of New York City—a beach fairly frequented in the summer but now tranquil enough. I continue, as always, in the hope of finishing certain things already begun—and to do others, if there is . . . We had a superb summer, a lot of nice weather and quite a bit of heat—which doesn't displease me. I remember thinking at Giverny that I would do a lot at home if there was less rain and bad weather. But I find that I do perhaps less—one does not appreciate the sun when one has it every day. I make it my business to do something new, as much as possible, to avoid a certain kind of picturesqueness, more banal than that of Europe—finally to find beauty everywhere and in the things nearby. But, after all, I am afraid that this has less charm than some motifs over there. I remember my "Valley of the Seine"— the hillside, the beautiful days of June—eh well, that gives me more pleasure than anything that I have seen here. I will see however one of these days, places more sympathetic. Here, one sees charming things, in color, atmosphere, but almost always less graceful in line, and this is something indispensable. Autumn is very beautiful, less brilliant here because of the trees, but very colorful. The grass still quite green, and the landings, houses, etc. often of a pretty grey, because of the nearness of the ocean.

I have little news of Giverny, some one has told me that there is much rain this year. I hope that you have done good things, and that we will see some canvases in New York done at Rouen. I have not been to Durand-Ruel for a long time. As soon as I return to New York, I will go. I hope that all is well with you and yours, and that I will see you next spring—Imagine that I have not seen France for almost two years. Here the crisis continues, one cannot buy much—I do not think that the tariff makes much of a difference, but the principle seems good to me. I mean no duties on paintings. Write to me as before to the address below, and I remain your devoted friend and always grateful, dear Mr. Monet.

Th. Robinson

11 East 14th Street, New York

Claude Monet to Theodore Robinson
Christiana, Norway
26 March 1895

Dear Mr. Robinson,

I am writing you this short note from Norway to explain my long silence. I wanted to write you a long time ago, but you know the way things go when one is traveling.

I was glad to hear from you especially since you let me understand you may come to France this summer.

I write you these few lines mainly to thank you for your letter of March 2 which I just received.

I came here partly to visit Jacques who is staying in Christiana to learn Norwegian, and also to see this country I had dreamed of for a long time. I already saw wonderful things, but I can't really work here since I can't stay much longer. However, I have already decided to come back some day.

I plan to be back in Giverny in a few days from now: I must get busy with the preparation of my exhibition of the "Cathedrales" as well as a few other new paintings. I'll have to close this letter now, I have to rush.

<div align="center">With my warmest regards and friendship...</div>

<div align="center">Claude Monet</div>

See you soon in Giverny!

Theodore Robinson to Claude Monet
New York, New York
6 February 1896

Dear Mr. Monet,

I sent you—some days ago—a copy of *Scribner's Magazine* with an engraving of your painting the "View of Rouen." The original, which is very fine, was sold last winter for 2500 dollars . . . M. Jaccaci who is in charge of art affairs at *Scribner's Magazine*, went to much trouble for the engraving and it seems to me it isn't too bad although it is almost impossible to convey the charm of such a painting with wood engraving. M. Jaccaci left some days ago for Le Harve. Perhaps you will see him. He goes for gallery business. I saw one of the cathedrals at Sutton's recently, which appeared to me very charming with one other canvas of Vernon—effect of mist. He told me that he will soon have an exposition of fifteen or so of your paintings—with several of the cathedrals. One of my friends also saw one of them in Philadelphia. I can hardly wait to see them all at Sutton's.

Here, the crisis continues—one thinks that an improvement will start soon, but I am not expecting much. What is important is to be able to work tranquilly—I await the spring to return to the state of Vermont (Verd mont—so name by the French explorers in the seventeenth century). I will go perhaps in the month of April when there is still snow. One makes sugar each year—there is a special tree (sugar maple) of which the syrup is quite sweet—for one month one harvests this and reduces it to sugar by boiling it. It is very good, of a clear brown color, with an unusual taste— quite agreeable. All of it is done in the forest—the snow falling and you can imagine for yourself the quite picturesque scenes, the people of the region, the sleighs, the oxen, etc. a blue sky.

I am very upset to hear the bad news of the health of Mme. Butler—I hope that she is doing better, as well as Mme. Monet. I received a New Year's card from Jacques Hoschedé at Christmas—it said that the "kids" have become men—how time passes. I really hope to see you one of these days, but when? First it is *necessary* that I do something here. So while waiting until that day, I will tell you good-by and I ask you to give my best regards to your family.

Yours very sincerely,

Th. Robinson

Theodore Robinson, "Claude Monet"
Century Magazine, September 1892

CLAUDE MONET.

WHEN the group of painters known as impressionists exhibited together for the first time twelve or fifteen years ago, they were greeted with much derision. In fact they were hardly taken seriously, being regarded either as mountebanks or as *poseurs* who served the purpose of furnishing the quick-witted but not infallible Parisians with something to laugh at once a year. But they have seen their influence increase steadily in a remarkable manner, first, as is always the case, with the painters, and latterly with the public. It is a very superficial observer who sees in the impressionists only a body of bad or inefficient painters who would attract attention at any cost except that of study. The sum total of talent represented by MM. Manet, Degas, Monet, Pizarro, Caillebotte, Sisley, Renoir, Mlle. Berthe Morisot, and the American Miss Cassatt, not to mention others, is very considerable. Of course there have appeared the men of small talent with their little invention, who have tacked themselves on to the movement, notably the genius who imagined the fly-speck or dot *facture*, while streaks and stripes have been considered a part of the new school's baggage. All this does not take away from the fact that the influence of the movement has been a healthy and much-needed one. It is to be thanked first, of course, for its independence and revolt from routine, the *chic* and *habileté* of the schools; next for its voice in behalf of pure, bright color and light, things of which painters as well as the public are more or less afraid. That refined color must necessarily be dull color; that one should not paint up too near white; that one should "husband his resources"; and that if any qualities must be sacrificed, let those be color and air — all these theories have been stoutly and efficiently combated by the impressionists.

Of them all M. Claude Monet is the most aggressive, forceful painter, the one whose work is influencing its epoch the most. If he has not, as M. Guy de Maupassant says with enthusiasm,

"discovered the art of painting," he has certainly painted moving waters, skies, air, and sunlight with a vividness and truth before unknown. Though occasionally painting indoors, he is, in my opinion, most original as an open-air painter, and he has scored his greatest success in that line. No one has given us quite such realism. Individual, and with the courage of his opinions from the first, his work, while remaining substantially the same in intention, has become larger and freer. In the beginning there was a visible influence of Corot, and certain mannerisms which have disappeared with increasing years. Superbly careless of *facture*, or at least with no preoccupation in that direction, he has arrived at that greatest of all *factures*, large, solid, and intangible, which best suggests the mystery of nature. And all painters working in the true impressionist spirit, absorbed by their subject, must feel that neat workmanship is not merely not worth the while, but is out of the question. "No man can serve two masters," and this noble indifference to *facture* comes sooner or later to all great painters of air, sea, and sky.

Most painters have been struck by the charm of a sketch done from nature at a sitting, a charm coming from the oneness of effect, the instantaneousness seldom seen in the completed landscape, as understood by the studio landscape-painter. M. Claude Monet was the first to imagine the possibility of obtaining this truth and charm on a fair-sized canvas with qualities and drawing unattainable in the small sketch. He found it attainable by working with method at the same time of day and not too long, never for more than an hour. Frequently he will be carrying on at the same time fifteen or twenty canvases. It is untrue that he is a painter of clever, large *pochades*. The canvas that does not go beyond the *pochade* state never leaves his studio, and the completed pictures are painted over many times.

Though these details may be of some interest, it is, of course, the spiritual side of the painter's work that is really worth dwelling on. M. Claude Monet's art is vital, robust, healthy. Like Corot's, but in more exuberant fashion, it shows the joy of living. It does not lack thought, and many of his pictures are painted with difficulty; but there is never that mysterious something

696

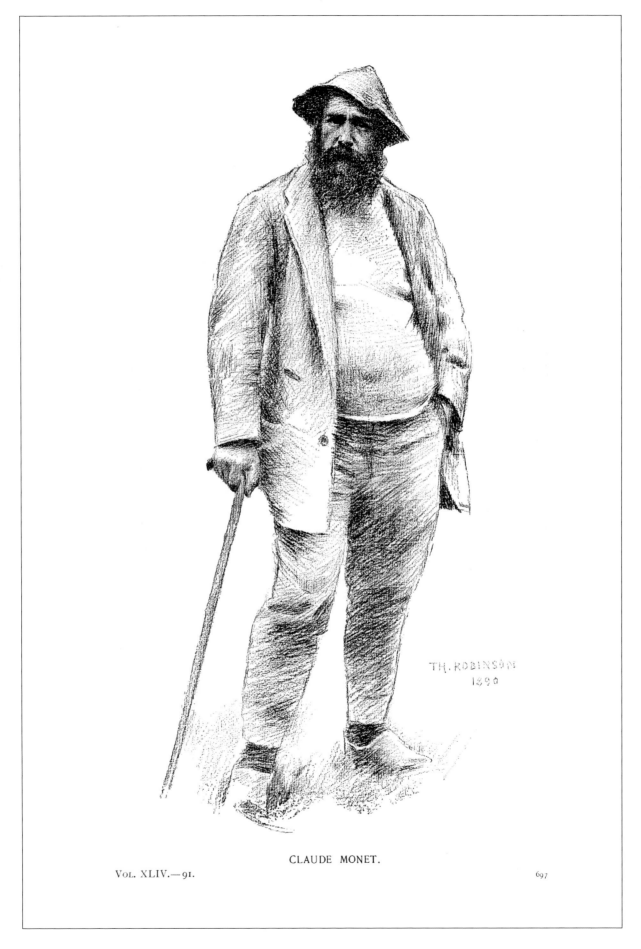

CLAUDE MONET.

DRAWN BY THEODORE ROBINSON.

THE HOME OF MONET AT GIVERNY, EURE.

which often gets into a picture and communicates itself to the spectator, a sense of fatigue, or abatement of interest in the motive. There is always a delightful sense of movement, vibration, and life. One of his favorite sayings is "La Nature ne s'arrête pas." Clouds are moving across the sky, leaves are twinkling, the grass is growing. Even the stillest summer day has no feeling of fixedness or of stagnation; moving seas, rivers, and skies have a great charm for him.

The exhibition at the Rue de Size last summer was a surprise to many from the variety, rare in a collection of pictures by one painter. Those who knew M. Claude Monet only as a painter of sunlight saw him in a new vein in the somber, rocky hillsides of La Creuse. There were Paris streets and gardens, gay in movement and color, railway-stations, Holland tulip-fields, and Normandy winter landscapes. One, of grainstacks in the early morning, with a thin covering of snow, was a most extraordinary piece of realism. Then the sea, for which he has a lover's passion, seen from the Normandy chalk cliffs dazzling in sunlight, blue and green shadows chasing one another across its surface, or the stormy waters and black rocks of Belle Isle. And his " Essais de Figures en Plein Air "—

what charm of color and life! how they belong to the landscape in which they breathe and move! To my mind no one has yet painted out of doors quite so truly. He is a realist, believing that nature and our own day give us abundant and beautiful material for pictures: that, rightly seen and rendered, there is as much charm in a nineteenth-century girl in her tennis- or yachting-suit, and in a landscape of sunlit meadows or river-bank, as in the Lefebvre nymph with her appropriate but rather dreary setting of " classical landscape "; that there is an abundance of poetry outside of swamps, twilights, or weeping damosels. M. Claude Monet's work proves this fact, if there be need to prove it: that there is no antagonism between broad daylight and modernity, and sentiment and charm; that an intense lover and follower of nature is not necessarily an undiscriminating note-taker, a photographer of more or less interesting facts. Beauty of line, of light and shade, of arrangement, above all, of color, it is but a truism to say that nowhere except in nature can their secrets be discovered.

M. Claude Monet's art leaves few indifferent. There is a whole gamut of appreciation, from the classicists who abhor him,—as Ingres is said to have spat at the sight of a Dela-

croix,—to M. de Maupassant, whose judgment I have already given. He is often aggressive, sometimes wilfully so, and you feel that he takes a delight in making the "heathen"—*i.e.*, Philistine—"rage." There is always need of such work and such painters. His work is quite as often sane and reasonable, and should interest all who love nature. His painting, direct, honest, and simple, gives one something of the same impression, the same charm, that one gets directly from the great mother—Nature—herself.

One cause of the popular prejudice against impressionism is the supposed wilful exaggeration of color. No doubt restrained, negative

and colors than we; that they had, in fact, a simpler and more naïve vision; that the modern eye is being educated to distinguish a complexity of shades and varieties of color before unknown. And for a comparison, take the sense of taste, which is susceptible of cultivation to such an extraordinary degree that the expert can distinguish not only different varieties and ages of wine, but mixtures as well; yet this sense in the generality of mankind, in comparison, hardly exists. In like manner a painter gifted with a fine visual perception of things spends years in developing and educating that sense; then comes the man who never in his life looked at nature but in a casual and patro-

FROM THE PAINTING BY CLAUDE MONET, IN POSSESSION OF JAMES F. SUTTON.　　　　ENGRAVED BY M. HAIDER.

BORDIGHERA.

color pleases better the average mind, and only a colorist and searcher can use pure, vivid color with good effect, as Monet certainly does. That there is more color in nature than the average observer is aware of, I believe any one not color-blind can prove for himself by taking the time and trouble to look for it. It is a plausible theory that our forefathers saw fewer tones

nizing way, and who swears he "never saw such color as that." Which is right, or nearest right?

Another cause has been its supposed tendency toward iconoclasticism and eccentricity. But in reality, while bringing forward new discoveries of vibration and color, in many ways the impressionists were returning to first principles. Manet's "Boy with a Sword" and

CLAUDE MONET.

the much discussed "Olympia" may claim kinship with Velasquez for truth of values, and for largeness and simplicity of modeling, while the best Monets rank with Daubigny's or, to go farther back, with Constable's art in their self-restraint and breadth, combined with fidelity to nature.

While the movement is much in sympathy with the naturalistic movement in literature, yet I should rather insist on its resemblance to that brought on by Constable. In independence of thought and intense love of nature, in the treatment received from public and critics, and in their immediate influence on the younger painters of their day, there is a remarkable similarity between Constable and M. Monet. In Leslie's " Life " Constable preaches

Perhaps the sacrifices I make for lightness and brightness are too great, but these things are the essence of landscape."

In 1824 some of his landscapes exhibited in Paris made a sensation. The French artists " are struck by their vivacity and freshness, things unknown to their own pictures — they have made a stir and set the students in landscape to thinking. . . . The critics are angry with the public for admiring these pictures. They acknowledge the effect to be rich and powerful, and that the whole has the look of nature and the color true and harmonious; but shall we admire works so unusual for their excellencies alone — what then is to become of the great Poussin ? — and they caution the younger artists to beware of the seduction of these English works."

FROM THE PAINTING BY CLAUDE MONET, IN POSSESSION OF JAMES F. SUTTON. ENGRAVED BY M. HAIDER.

ON CAPE MARTIN, NEAR MENTONE.

againt *chic*, then called *bravura*, "an attempt to do something beyond the truth. Fashion always had and always will have its day, but truth in all things only will last and can only have just claims on posterity." "The world is full enough of what has been already done." "My execution annoys the scholastic ones.

But a few years later the younger artists began to profit by Constable's ideas, and the noble school of 1830 appeared, carrying the art of landscape-painting another step in advance.

It is not perhaps too soon to prophesy that in the same manner the influence of M. Claude Monet on the landscape art of the future will

Reprint: Theodore Robinson, "Claude Monet," Century Magazine 44

FROM THE PAINTING BY CLAUDE MONET, IN POSSESSION OF F. H. FULLER.

THE ORCHARD.

be strongly felt. Imitation can go but a little way, and is always without value, although its appearance is no argument against the art imitated — witness M. Trouillebert. But as the young Frenchmen of 1830 profited by the example of Constable, his discovery of breadth and values as we understand them to-day, so will the coming landscape-men use the impressionist discoveries of vibration and the possibilities of pure color, and, while careful to "hold fast that which is good," will go on to new and delightful achievement.

Theodore Robinson.

TWO POEMS.

AN IMPULSE.

THE silent little glen I often seek,
　Moist, dark : a tiny rivulet runs through
The lush, wet grass, so small a silvery thread
That one might take it for a line of dew.
The trees have shut it in a sylvan room
Full of chill earthy scents. Diana might
Choose such a spot to don her huntress garb,
Or stretch her cold, chaste body there at night.
And yet to-day, thou thing of Eastern suns,
The very contrast of the place to thee
Made me look up, and through the undergrowth,
With the wild dream that thou hadst come to me !

MELODY.

WHEN the land was white with moonlight,
　And the air was sweet with May,
I was so glad that Love would last
　Forever and a day.

Now the land is white with winter,
　And dead Love laid away,
I am so glad Life cannot last
　Forever and a day.

Anne Reeve Aldrich.

Selected Bibliography

Unpublished Materials

Theodore Robinson/Thomas Perry Correspondence. In "Thomas Sergeant Perry Papers." Special Collections, Miller Library, Colby College, Waterville, Maine.

Katherine Kinsella/Philip Leslie Hale Correspondence. In "Philip Leslie Hale Papers." Archives of American Art, Smithsonian Institution, Washington, D.C.

Theodore Robinson/Richard Watson Gilder Correspondence. In "The Century Collection." Manuscript Division, New York Public Library.

Theodore Robinson/Kenyon Cox Correspondence. In "Kenyon Cox Papers." Avery Library, Columbia University, New York.

Theodore Robinson/Hamlin Garland Correspondence. In "The Hamlin Garland Collection." The University Library, Special Collections, University of California, Los Angeles.

Theodore Robinson/Claude Monet Correspondence. In Archives of the History of Art, The Getty Center, Los Angeles.

Theodore Robinson/Claude Monet Correspondence. In Frances Mulhall Achilles Library, Archives, Whitney Museum of American Art, New York.

"James Carroll Beckwith Papers." In Archives of American Art, Smithsonian Institution, Washington, D.C.

"John I. H. Baur Papers." In Archives of American Art, Smithsonian Institution, Washington, D.C.

"Weir Family Papers." In Department of Archives and Manuscripts, Harold B. Lee Library, Brigham Young University, Provo, Utah.

"Registre Pour Inscrire Les Voyageurs, 1887–1899, Hôtel Baudy, Giverny, France." In Department of Prints, Drawings, and Photographs, Philadelphia Museum of Art, Philadelphia.

Robinson, Theodore. "Diary 1892–1896." Frick Art Reference Library, New York.

Published Materials

American Impressionists, New York: Hirschl and Adler Galleries, 1968.

Antes, Mrs. R. J. "Artist's Biography." *Evansville [Wisconsin] Review* (February 4 and 11, 1943).

Baur, John I. H. "Photographic Studies by an Impressionist." *Gazette des Beaux-Arts* ser. 6, 30 (October–December 1946): 319–30.

———. *Theodore Robinson, 1852–1896*. New York: The Brooklyn Museum, 1946.

Brinton, Christian. "American Paintings at the Panama-Pacific Exposition." *International Studio* (August 1915).

"Brooklyn Honors Memory of Theodore Robinson." *Art Digest* (15 November 1946): 9.

Burroughs, Bryson. *Catalogue of Paintings*. 9th ed. New York: The Metropolitan Museum of Art, 1931.

Campbell, Pearl H. "Theodore Robinson: A Brief Historical Sketch." *Brush and Pencil* 4 (September 1899): 287–89.

Catalogue Deluxe of the Department of Fine Arts for the Panama-Pacific International Exhibition. San Francisco, 1915.

Catalogue of the Collection of Foreign and American Paintings Owned by George A. Hearn. New York, 1908.

Clark, Eliot. "Theodore Robinson." *Art in America* 6 (October 1918): 286–94.

———. "Theodore Robinson: A Pioneer Impressionist." *Scribner's* 30, no. 6 (December 1921).

———. *Theodore Robinson: His Life and Art*. Chicago: R. H. Love Galleries, 1979.

Claude Monet and the Giverny Artists. New York: Charles E. Slatkin Galleries, 1960.

Coke, Van Deren. *The Painter and the Photograph*. Albuquerque, NM: New Mexico Press, 1972.

The Cone Collection. Rev. ed. Baltimore: The Baltimore Museum of Art, 1967.

Cone Collection of Baltimore, Maryland. Baltimore: Etta Cone, 1934.

Dawson-Watson, Dawson. "The Real Story of Giverny." In *Theodore Robinson: His Life and Art*, edited by Eliot Clark, 65–67. Chicago: R. H. Love Galleries, 1979.

Fink, Lois Marie. *American Art at the Nineteenth-Century Paris Salons*. Washington, D.C., and Cambridge: National Museum of American Art, Smithsonian Institution and Cambridge University Press, 1990.

"First and Last U.S. Impressionists: Theodore Robinson and A. C. Goodwin." *Art News* 45 (December 1946): 20–21.

Garland, Hamlin. "Theodore Robinson." *Brush and Pencil* 4 (September 1899): 285–86.

Gerdts, William H. *American Impressionism*. New York: Abbeville Press, 1984.

———. *Lasting Impressions: American Painters in France, 1865–1915*. Evanston, IL: Terra Foundation for the Arts, 1992.

———. *Monet's Giverny: An Impressionist Colony*. New York: Abbeville Press, 1993.

Giverny en cartes postales anciennes. Zaltbommel, Netherlands: Bibliothèque Européenne, 1992.

Gomes, Rosalie. *Impressions of Giverny: A Painter's Paradise, 1883–1914*. San Francisco: Pomegranate Artbooks, 1995.

Guillaud, Jacqueline and Maurice, eds. *Claude Monet at the Time of Giverny*. Paris: Guillaud Editions, 1983.

Handbook of Paintings, Sculpture, Prints and Drawings in the Permanent Collection. Andover, MA: Phillips Academy, 1939.

Harrington, Bev, ed. *The Figural Images of Theodore Robinson, American Impressionist*. Oshkosh, WI: Paine Art Center and Arboretum, 1987.

Harrison, Birge. "With Stevenson at Grèz." *Century Magazine* 93, no. 2 (December 1916): 306–14.

Hoopes, Donelson F. *The American Impressionists*. New York: Watson-Guptill Publications, 1972.

House, John. *Monet: Nature into Art*. New Haven, CT: Yale University Press, 1986.

Huth, Hans. "Impressionism Comes to America." *Gazette des Beaux-Arts* 29 (1946): 225–52.

Johnston, Sona. "Looking for Giverny in America: Theodore Robinson and His Impressionist Watercolors." *Master Drawings* 40, no. 4 (2002): 332–44.

———. *Theodore Robinson, 1852–1896*. Baltimore: The Baltimore Museum of Art, 1973.

Joyes, Claire. *Claude Monet: Life at Giverny*. New York: Vendôme Press, 1985.

———. *Monet at Giverny*. London: Mathews Miller, Dunbar, 1975.

Killie, Robert J. "A New Look at Theodore Robinson's Giverny Mill Views." Typescript, January 1987.

Lately, Thomas. *A Pride of Lions: The Astor Orphans*. New York: William Morrow and Company, Inc., 1971.

Les Artistes Américains à Giverny. Vernon, France: Musée Municipal A. G. Poulain, 1984.

Levy, Florence N. "Theodore Robinson." *Bulletin of the Metropolitan Museum of Art* 1 (July 1906): 111–12.

Lewison, Florence. "Theodore Robinson, America's First Impressionist." *American Artist* 27 (February 1963): 40–45, 72–73.

———. "Theodore Robinson and Claude Monet." *Apollo* 78 (September 1963): 208–11.

———. *Theodore Robinson, the 19th Century Vermont Impressionist: An Exibition of Paintings*. Manchester: Southern Vermont Artists, 1971.

Love, Richard H. *Theodore Earl Butler: Emergence from Monet's Shadow*. Chicago: Haase-Mumm Publishing, Co., 1985.

Low, Will H. *A Chronicle of Friendships, 1873–1900*. New York: Charles Scribner's Sons, 1908.

Martindale, Meredith et al. *Lilla Cabot Perry: An American Impressionist*. Washington, D.C.: The National Museum of Women in the Arts, 1990.

Mather, Jr., F. S. "American Paintings at Princeton University." *Records at the Museum of Historic Art* (Fall 1943).

Mayer, Stephanie. *First Exposure: The Sketchbooks and Photographs of Theodore Robinson*, Sources. Giverny: Musée d'Art Américain Giverny, 2000.

Meixner, Laura L. *An International Episode: Millet, Monet, and Their North American Counterparts*. Memphis, TN: The Dixon Gallery and Gardens, 1982.

Monet's Years at Giverny: Beyond Impressionism. New York: The Metropolitan Museum of Art, 1978.

Morgan, H. Wayne, ed. *An American Art Student in Paris: The Letters of Kenyon Cox, 1877-1882*. Kent and London: The Kent State University Press, 1986.

Murray, Joan, ed. *Letters Home, 1859–1906: The Letters of William Blair Bruce*. Moonbeam, Canada: Penumbra Press, 1982.

Oil Paintings and Studies by the Late Theodore Robinson. New York: American Art Galleries, 1898.

Paintings in Oil and Pastel by Theodore Robinson and Theodore Wendel. Boston: Williams & Everett Gallery, 1892.

Paintings in the Art Institute of Chicago: A Catalogue of the Picture Collection. Chicago: Art Institute of Chicago, 1961.

Perry, Lilla Cabot. "Reminiscences of Claude Monet from 1889 to 1909." *The American Magazine of Art* 18 (March 1927): 119–125.

The Phillips Collection Catalogue. Washington, D.C.: Thames and Hudson, 1952.

Phillips, Duncan. *A Collection in the Making*. New York: E. Weyhe, 1926.

Pollack, Barbara. *The Collectors: Dr. Claribel and Miss Etta Cone*. Indianapolis-New York: The Bobbs-Merrill Co., Inc., 1962.

Renoir, Jean. *Renoir, My Father*. Translated by Randolph and Dorothy Weaver. Boston-Toronto: Little, Brown and Company, 1962.

Richardson, E. P. *A Short History of Painting in America: the Story of 450 Years*. New York: Crowell, 1963.

Robinson, Theodore. "Claude Monet." *Century Magazine* 44 (September 1892): 696–701.

———. "Jean-Baptiste-Camille-Corot." In *Modern French Masters: A Series of Biographical and Critical Reviews by American Artists*, edited by John C. van Dyke. New York: The Century Company, 1896.

———. "A Normandy Pastoral." *Scribner's Magazine* 21 (June 1897): 757.

Scharf, Aaron. *Art and Photography*. Baltimore: Allen Lane, The Penguin Press, 1969.

Seitz, William C. *Claude Monet*. New York: Harry N. Abrams, 1960.

Sellin, David. *Americans in Brittany and Normandy, 1860–1910*. Phoenix: Phoenix Art Museum, 1982.

Sherman, Frederic Fairchild. "Theodore Robinson." C. 1928, Frick Art Reference Library. New York.

Stuckey, Charles F. *Claude Monet: 1840–1926*. Chicago: The Art Institute of Chicago; New York: Thames and Hudson, 1995.

———, ed. *Monet: A Retrospective*. New York: Hugh Lauter Levin Associates, 1985.

Theodore Robinson. New York: Florence Lewison Gallery, 1962.

"Theodore Robinson." *Scribner's Magazine* 19 (June 1896): 784–85.

Theodore Robinson: American Impressionist, 1852–1896. New York: Kennedy Galleries, Inc., 1966.

Toulgouat, Pierre. "Skylights in Normandy." *Holiday* 4 (August 1948): 66–70.

Truettner, William H. "William T. Evans: Collection of American Paintings." *American Art Journal* 3, no. 2 (Fall 1971).

Tucker, Paul Hayes. *Monet in the Nineties: The Series Paintings*. Boston: Museum of Fine Arts; New Haven, Conn: Yale University Press, 1989.

Tully, Judd. "The Art Students League of New York." *American Artist* (August 1984).

Watson, Forbes. "American Collections, No. 1—the Ferdinand Howald Collection." *The Arts* (August 1925).

Weitzenhoffer, F., and J. Rewald, eds. *Aspects of Monet*. New York: Harry N. Abrams, 1984.

Wildenstein, Daniel. *Monet, Biographie et Catalogue Raisonné*. 4 vols. Lausanne, Switzerland: Bibliothèque des Arts, 1974–85.

Yarnall, James L. "John La Farge's Portrait of the Painter and the Use of Photography in His Work." *The American Art Journal* 18, no. 1 (1986): 4–20.

Young, Dorothy Weir. *The Life and Letters of J. Alden Weir*. New Haven: Yale University Press, 1960.

Index